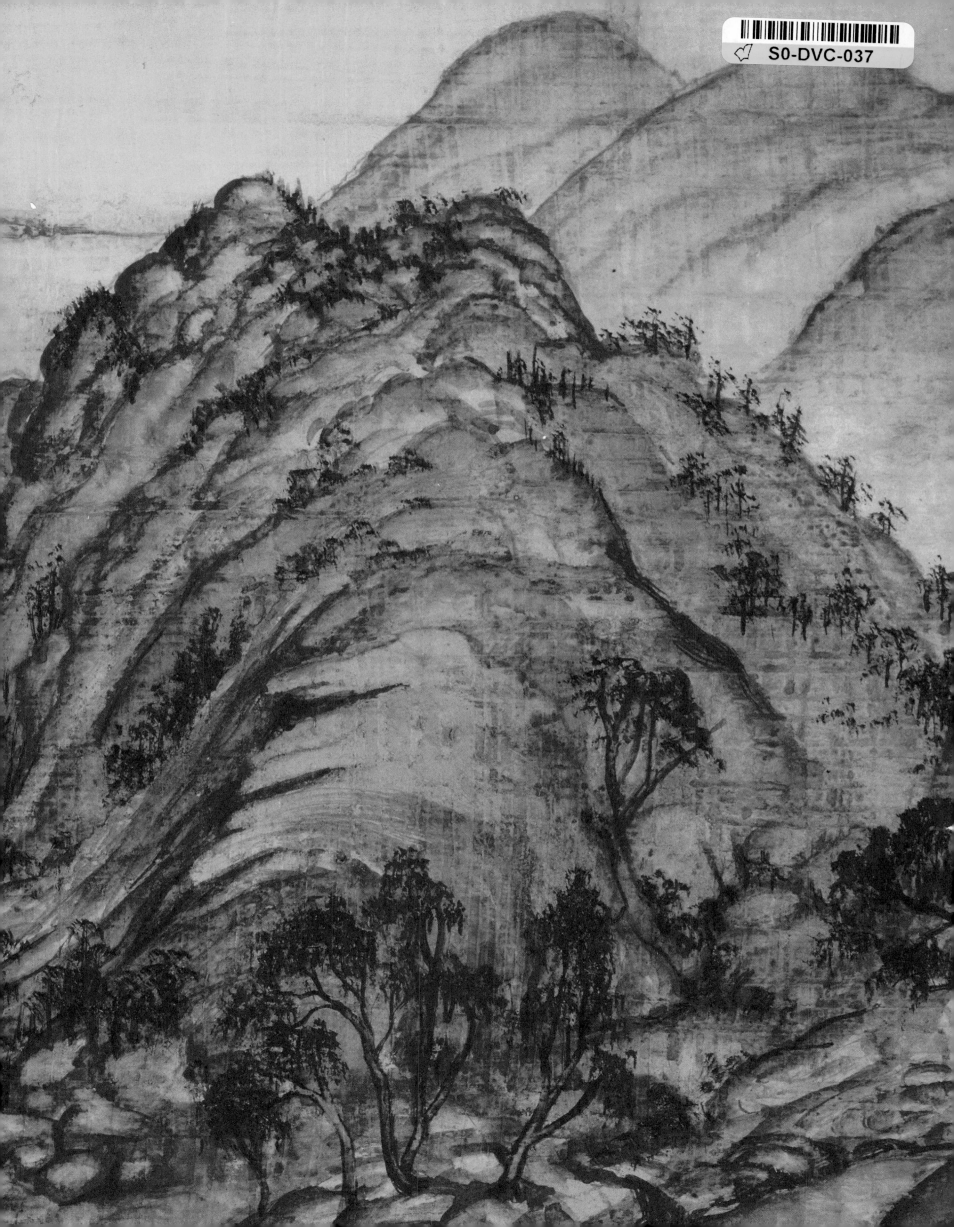

A DISNEY EDITIONS CLASSIC

A Welcome Enterprises Book

LOS ANGELES • NEW YORK

THE ART OF

MuLan

TEXT BY JEFF KURTTI

FOREWORD BY THOMAS SCHUMACHER

Endpaper: **Visual development**

by Sean Sullivan.

Page 1: **Calligraphy by David Wong.**

Preceding pages: **Visual development**

by Hans Bacher.

Opposite: **Visual development by**

Disney Studio Artist.

Page 190: **Visual development**

by Hans Bacher.

For information address Disney Editions, 1200 Grand Central Avenue, Glendale, California 91201.
Editorial Director: Wendy Lefkon
Senior Editor: Jennifer Eastwood
Senior Designer: Lindsay Broderick
Managing Editor: Monica Vasquez

Produced by Welcome Enterprises, Inc.
6 West 18th Street, New York, New York 10011
Project Director: H. Clark Wakabayashi
Art Director / Original Design: Gregory Wakabayashi
Design assistant: Sylvia Wakabayashi

This book's producers would like to thank
Alicia Chinatomby, Alison Giordano, Andrew Elmers, Andrew Sansone, Ann Hansen, Becky Cline, Caitlin Dodson, Dale Kennedy, David Lott, David Wang, Ed Squair, Elena Blanco, Elke Villa, Fanny Sheffield, Fox Carney, Jackie DeLeo, Jennifer Black, Jennifer Chan, Jody Silverman, John Hanley, Ken Shue, Kevin Breen, Kevin Kern, Kim Knueppel, Kori Neal, Lia Murphy, Lyssa Hurvitz, Marybeth Tregarthen, Masanobu Ogata, Megan Granger, Meredith Lisbin, Michael Freeman, Michael Stern, Monique Diman, Onil Chibás, Pam Waterman, Rachel Rivera, Robin Friedman, Rudy Zamora, Sara Baysinger, Sarah Sullivan, Scott Petrower, Scott Piehl, Seale Ballenger, Stacie Iverson, Terry Downes, Tim Lewis, Tim Retzlaff, Tom Kennedy, Vicki Korlishin, Warren Meislin, Yuzo Hasegawa, and Zan Schneider.

Original ISBN 978-0-7868-6388-4
Limited Edition ISBN 978-0-7868-6466-9
A Disney Editions Classic ISBN 978-1-368-01873-9
FAC-038350-19319
Printed in China
First Edition of the Original and Limited Editions, June 1998
First Edition of A *Disney Editions Classic*, February 2020
10 9 8 7 6 5 4 3 2 1

Visit www.disneybooks.com

The Official Disney Fan Club

D23.com

CONTENTS

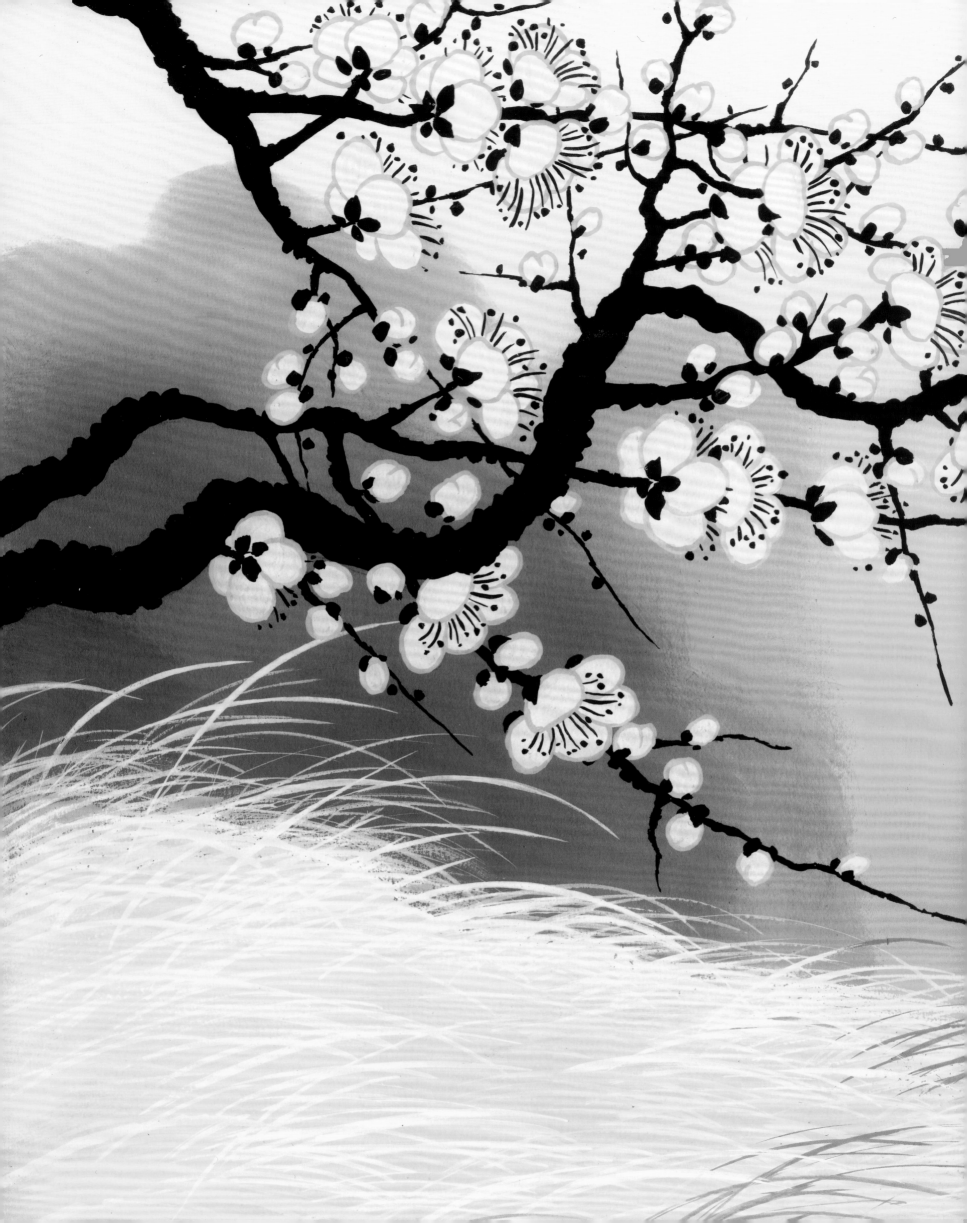

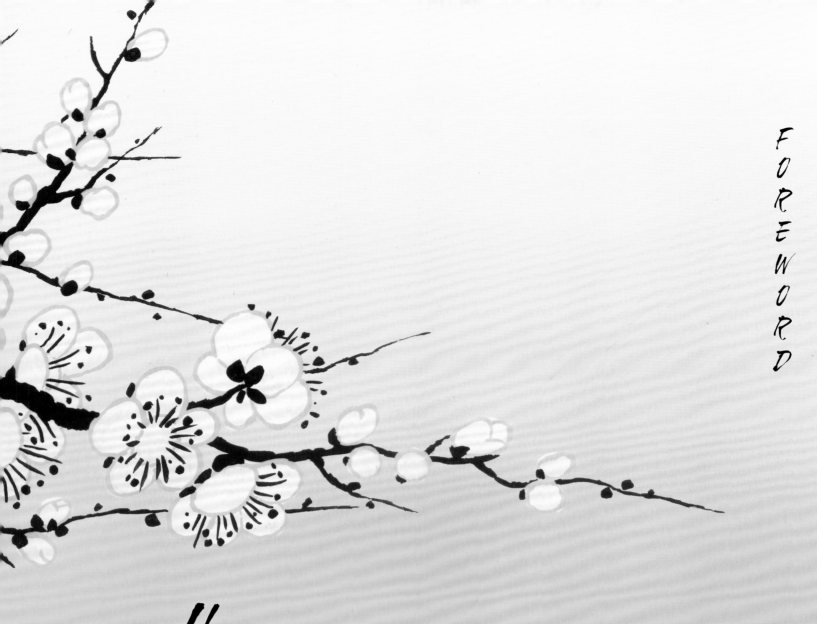

Holding my original copy of Jeff Kurtti's brilliant 1998 work *The Art of Mulan*, I'm reminded why over these past 20-plus years I've referred to this as the best book ever written on the making of an animated film. It captures the art, the process, and the artists in stunning and accurate detail.

Having spent a significant portion of my career working on some 21 Disney animated films, plus a handful of shorts and direct-to-video features, I learned that everything great in those films—from the stories to the art to the music—was directly from the hearts of extraordinary *people*. Artists, one and all, who were each starting from a blank page, or paper, or screen, or board. Life and its heartbeat were conjured from the heavens. Or so it seemed.

Visual development of

blossoms by Production

Designer Hans Bacher.

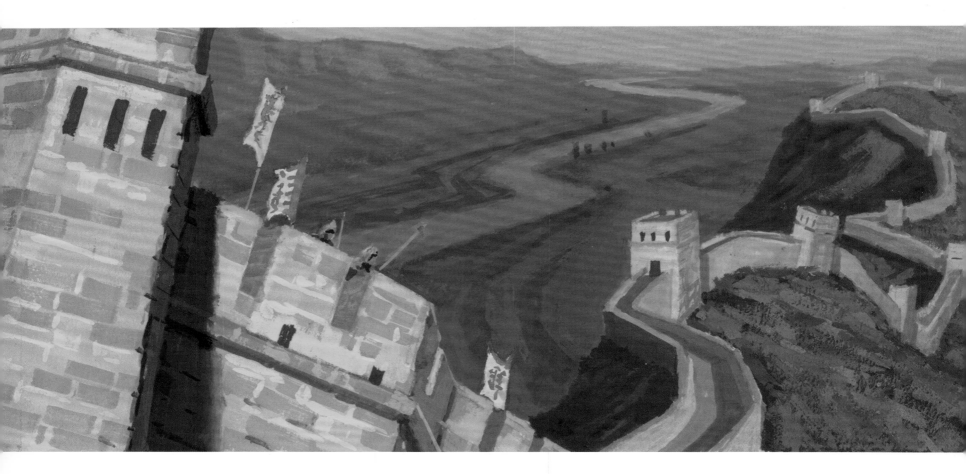

This book captures the remarkable artistry—from visual development and story sketch, through layout and rough animation, to backgrounds and glorious final images. The artistry of the design team, led by Ric Sluiter and Hans Bacher, still knocks me out. The stunning animation of Mulan herself, from the legendary Mark Henn, and the work of the most astonishing collection of animators I can remember created living, breathing characters from a time and place so very far away from our studio in Orlando, Florida.

This book allows us to dive into Chen-Yi Chang's delicious character art and revel in the story brought to us by Chris Sanders and the story and screenwriting team. True animation connoisseurs will even find the delicate touch of animation legend (and Disney Legend) Joe Grant in these pages.

Matthew Wilder and David Zippel's songs have become Disney classics. "Reflection" is an anthem in itself and has become something of a standard in that genre. Jerry Goldsmith's erudite and resonant score, composed as a favor from a master late in his career, still gives all audiences a thrill in both its scale and delicacy. Any fan of the animated film will hear this unforgettable music in their mind as they look through these pages.

None of this book, and of course the beloved film that it chronicles, would have happened without the artistic guidance of directors Barry Cook and Tony Bancroft. My boundless and unending respect for the leadership of first-time producer Pam Coats is based not only on her extraordinary achievement in keeping this project alive, but also on her doing so in the face of complications more profound than anyone could have imagined.

It comes as no surprise that when we first encountered the late Robert San Souci's book *Fa Mulan: The Story of a Woman Warrior*, we were on a path to a different kind of Disney movie.

Writing this from the end of the second decade of the century after the film was created, it is hard to remember that the notion of a Disney animated musical, based on an unconventional woman who strikes out on her own, risks her life by disguising herself, seeks and gets training, reveals her true identity, and goes on to save her country—all while simply trying to protect her father from certain death as a soldier himself—was an idea *profoundly* out of step with animation tradition, and even the narratives of its time.

Add to that the component of placing it in a location that was mostly a mystery to the intended audience, and you have a story for which we had to fight. "Why would she make this sacrifice with no intended gain?" "Does it *have* to be a musical?" "Where is the man who will save her?" "What do you mean she doesn't get rescued?" "Where's the wedding scene?"

Today—more than ever—it is clear to me why the film has become a favorite of so many members of the generation who grew up with it.

What we didn't know back in the mid-1990s was that Disney as a company would eventually make bold moves to open a theme park in Hong Kong, and then follow that with a pioneering resort in Shanghai. For me, standing along the "Main Street" in our Shanghai park and watching a parade float based on our animated *Mulan* pass by was something I could never have imagined. (And yes, I was misty-eyed.) What moved me was not just the journey of our particular telling of this tale, but the journey of *all* the brilliant people who were part of making it—and the countless young people who, within it, have found so much inspiration.

Disney has always been a company of dreams: telling them, planting them, fostering them. In these pages, it becomes abundantly clear how the filmmakers of *Mulan* fulfilled all of that: through artistry, commitment, reaching beyond what's traditional and comfortable—and fundamentally telling a story with rich meaning, with some of the most stunning artwork ever created at the company.

— *Thomas Schumacher*

Thomas Schumacher currently serves as President & Producer of Disney Theatrical Group, where he oversees the development, creation, and execution of Disney's legitimate stage entertainment around the globe, including Broadway, touring, and licensed productions. His career at Disney began in Walt Disney Feature Animation, producing the animated classic *The Rescuers Down Under.* He was ultimately named President and oversaw some 21 animated features, including *The Lion King, Tim Burton's The Nightmare Before Christmas, Pocahontas, The Hunchback of Notre Dame, Mulan, Hercules,* and *Lilo & Stitch,* and worked closely with Pixar on their first five films.

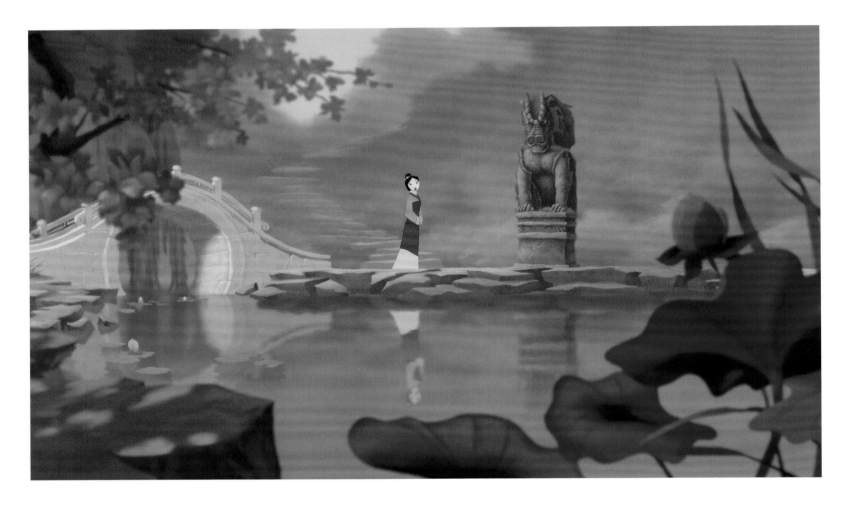

In the family garden, Mulan sings "Reflection." Production still. Background art by Barry Kooser. Layout by Richard Livingston, cleanup layout by Peter DeLuca.

Walt Disney Feature Animation began a journey in 1934 that has yet to end.

That was the year that Walt Disney and his creative group began pre-production on *Snow White and the Seven Dwarfs,* and initiated the creation of an all-new art form—the animated feature.

Disney Animation—now under the supervision of Roy E. Disney and Peter Schneider—continues to travel the path that Walt carved out more than 60 years ago. They have made it their mission to guard the tremendous legacy he left behind and expand upon it for a new generation. They have returned from their many voyages with such features as *The Little Mermaid, Beauty and the Beast, The Lion King,* and *The Hunchback of Notre Dame,* which have not only joined the ranks of their classic predecessors, but have educated a whole new audience in the art of animation and broken new ground in storytelling, art and design, filmmaking technology, and music.

Every new project constitutes an excursion for its creators. After so many of these trips, it would seem logical that the course would be made easier. But often, the way is made more difficult by the desire to make a fresh statement, to use new techniques, and to avoid simply repeating the formula of preceding successes.

This book is the story of another journey for Walt Disney Feature Animation, not only a journey of a new animated feature with a new story and characters, but an excursion into new cultural territory, with a new team, in a new studio facility.

It is not just the story of the mythic travels of a wandering heroine named Mulan, but the chronicle of the development of the Mulan tale for film, and a physical journey through China that yielded discovery and insight for the Disney creative team.

It is also an account of the coalescence of that group, and how the integrity and spirit of a character they created produced a unanimity of thought that led them to a fervently shared vision.

Finally, it is the story of the creation of the varied, eloquent, and beautiful art that was, in many ways, only a by-product of a much greater endeavor.

The uniqueness of *Mulan* is not just in the time-honored tale, but in the way it entwines so many tales, ancient and contemporary; so many lives, past and present.

The legend of Mulan has spoken to hundreds of generations over the centuries. The legend of Mulan spoke deeply to the Walt Disney Feature Animation team that came together expressly to tell her story.

Now, from their efforts—and hers—Mulan will continue to speak to a wider audience than ever before, and for generations to come.

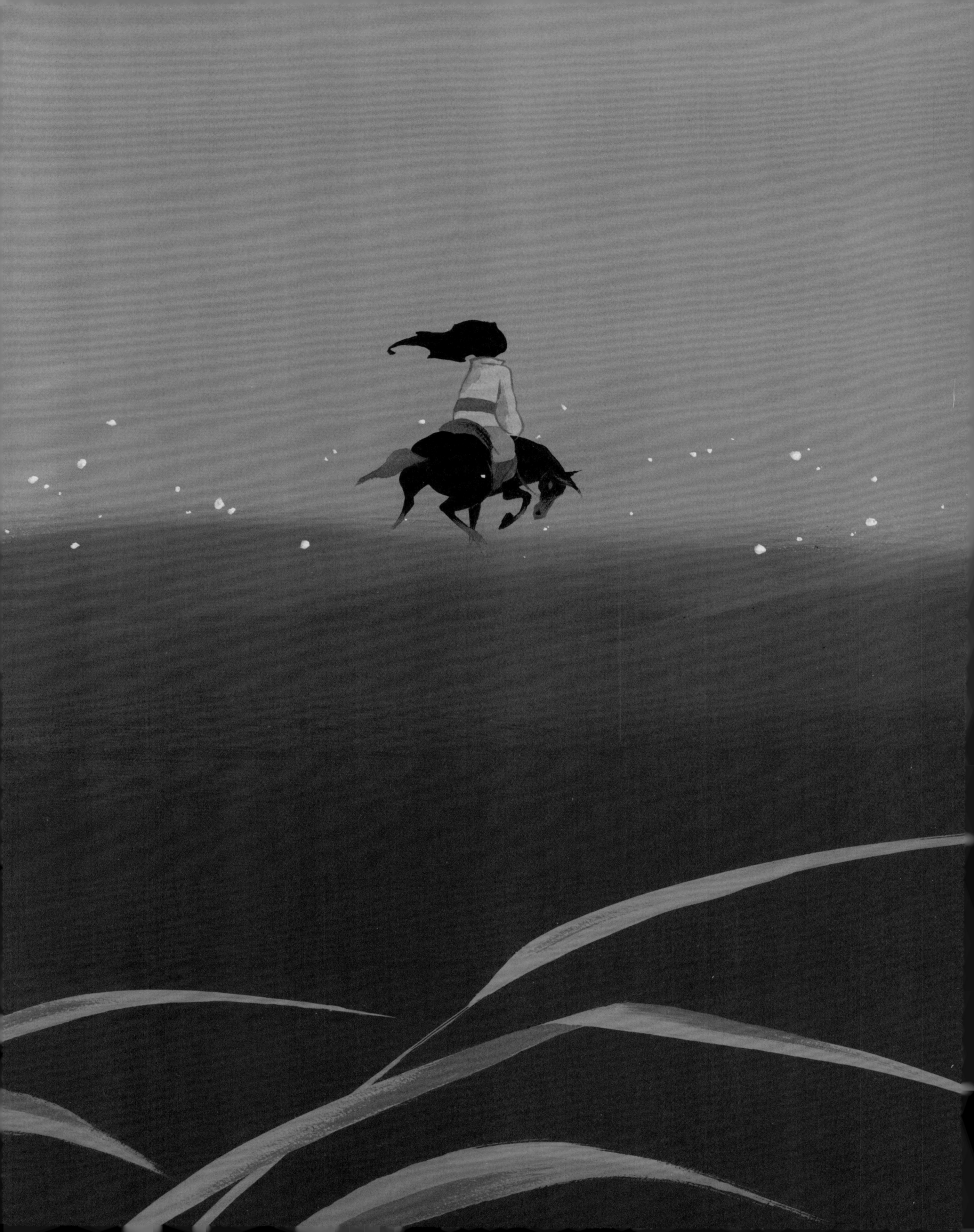

"A journey of a thousand leagues
begins with a single step."

— LAOZI (LAO-TZU)

Daode Jing Ching (The Way and Its Power)

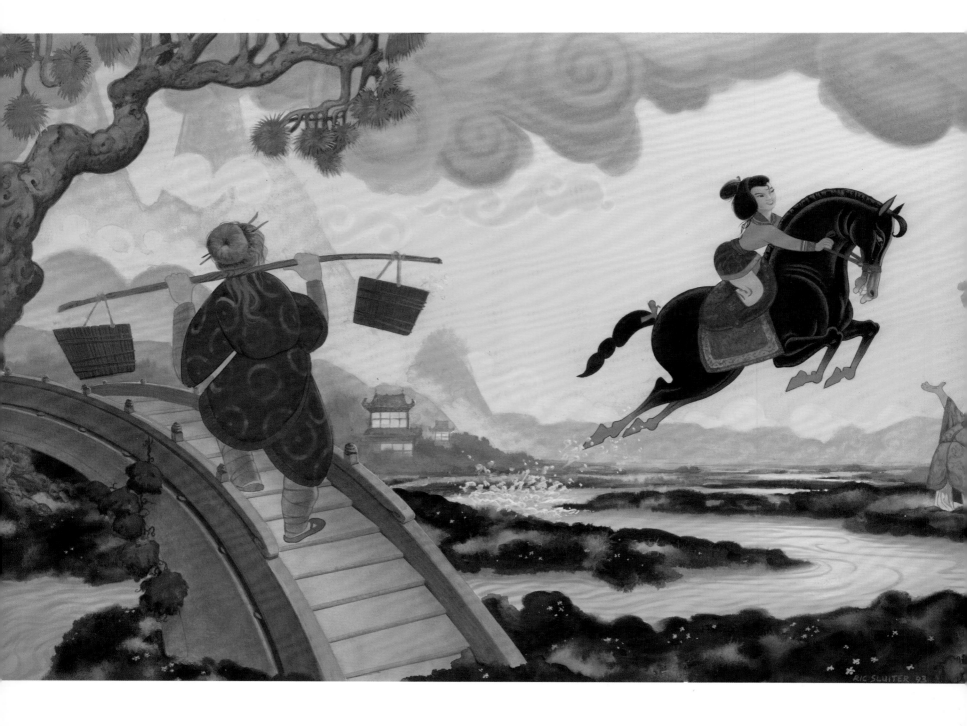

Preceding pages: Visual development
by Hans Bacher.

Above: Visual development by
Ric Sluiter.

Right: Background art by Barry
Kooser. Layout by Jeff Dickson,
cleanup layout by Yong Hong Zhong.

In mythology, the journey of a hero is an ancient and universal theme.

Since the dawn of recorded history, in every clan, in every culture—from ancient Greece, to China, Egypt, the Americas, and Polynesia—heroes have embarked on life-altering journeys. Literature records tales from the ancient Jason and the Argonauts myth and *Epic of Gilgamesh* to the modern *The Wonderful Wizard of Oz* and *The Lion, the Witch, and the Wardrobe*.

On all these journeys, heroes pursue such disparate goals as a far-off city, a golden fleece, the Holy Grail—even guidance to the way to get *home* from the journey. But no matter the varied purposes for their journeys, in the end, these heroes share the same destination: "Whether the hero happens to gain a princess, a kingdom, a healing medicine, a talisman, or some other reward appears immaterial," concludes mythologist Alexander Eliot. "He actually earns self-integration, balance, wisdom, and spiritual health."

One of the most venerable, renowned, and beloved of these "wandering heroes" is a young woman named Mulan. In Asia, the story of Mulan is as well-known as the story of Cinderella is in Western culture—the fable of this daring woman has been told through the centuries, providing inspiration for artists, poets, writers, and composers. In China, the name "Mulan" has long been synonymous with the word "heroine."

Reflecting upon the timeless relevance of the Mulan tale Walt Disney Feature Animation President Peter Schneider says, "I think we always search for who we are—the search for self is an ever-ongoing process. The minute we find ourselves, we then question whether it's the *right* self. We keep changing. I think that's what makes life interesting."

Visual development of Mulan by Mark Henn. The artists continually referred back to this pose because it captured the character's strength, dignity, and determination.

Mulan's love for her father and

her fear for his life lead her to a

portentous decision.

Below: Visual development

by Peter DeLuca.

Bottom: Color key

by Barry Kooser.

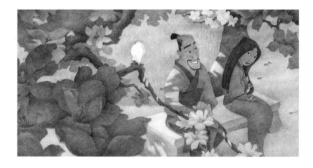

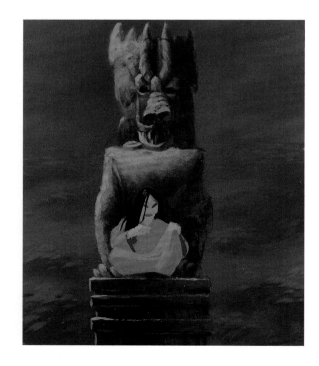

erhaps the most widely circulated retelling of the Mulan legend is a poem, usually known as *The Legend* or *The Ballad of Mulan*, which has been popular for generations in China. The poem, by an anonymous writer of the Southern and Northern dynasties (c. A.D. 386–581), was collected in *Yuefu*, the Song dynasty compendium of lyrics, songs, and poems.

THE LEGEND OF MULAN

Click click, and click click click,
By the doorway Mulan weaves.
When all at once the shuttles cease,
A sigh is heard with solemn grief.
"O my daughter who is on your mind?
O my daughter who is in your heart?"
"I have no one on my mind,
I have no one in my heart.
But last night I read the battle roll,
A roll consisting of twelve scrolls.
The Khan is drafting an army of awe,
My father's name on each beadroll.
Alas Father has no grown son,
Alas Mulan has no elder brother.
But I will buy a saddle and a horse,
And join the army in place of Father."

In the East Market she buys a steed,
From the West Market she buys a saddle.
In the North Market she buys a long whip,
From the South Market she buys a bridle.
At dawn she bids her family farewell,
At dusk she camps by the Yellow River.
She no longer hears her parents calling,
Upon her pillow the waters whisper.
At dawn she departs the Yellow River,
At dusk she arrives at Black Mountain.
She no longer hears her parents calling,
But Tartar horses wailing from Yen Mountain.
She gallops ten thousand miles,
For the war she has to honor.
She crosses lofty hills,
Like an eagle soaring over.
From northern gusts, through biting chills,
Echoes the watchman's clapper.

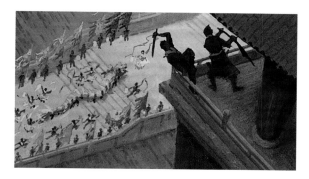

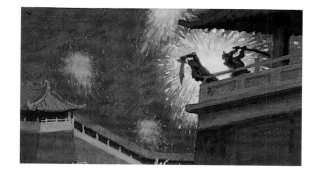

Mulan's brave sacrifice and

military adventures ultimately

lead her to an intense battle

atop the Imperial Palace, where

her selfless courage saves the

Emperor, and all of China.

Above: Color keys

by Sai Ping Lok.

With wintry glow, of icy hue,
Light glimmers on her armor.
Generals die in a hundred battles,
Our warrior's back, how ten years fly.
Upon her return she is summoned to see the Emperor.
In the Hall of Light, she receives the highest honor.
She is awarded a promotion to top rank.
The Emperor bestows hundreds of thousands in prizes.
The Khan asks her what she desires.
"Mulan has no use for a Minister's post,
Mulan has no other extravagant want.
I wish to borrow a swift-footed mount,
To take me back to my home."

When Father and Mother hear she's coming,
They watch by the gate, bracing each other.
When Elder Sister hears she's coming,
She runs to her room, and dabs on rouge powder.
When Little Brother hears she's coming,
He whets his knife, flashing like a light,
And prepares pig and sheep for dinner.

"O let me push open the door to East Chamber,
O let me sit on my bed in West Recess.
So swiftly comes off the warrior's vesture,
And silently I put on my old-time dress.
Beside the window, I dress up my hair,
In front of a mirror, I rouge my face.
And when I walk out to meet my compeers,
They are perplexed and amazed."

"For twelve years, we fought as comrades-in-arms,
The Mulan we knew was not a lady of charm!"

They say to choose a hare, you pick them up by the ears,
There are telling signs to compare:
In air the male will kick and strike,
While females stare with bleary eyes.
But if both are set to the ground,
And left to bounce in a flee,
Who will be so wise as to observe,
That the hare is a he or she?

Left: Mulan's identity is revealed in this painting by Zhang Shiming, one of the Chinese artists whose work was commissioned to provide early visual inspiration for the Mulan project.

Opposite: Visual development of the countryside by Sai Ping Lok.

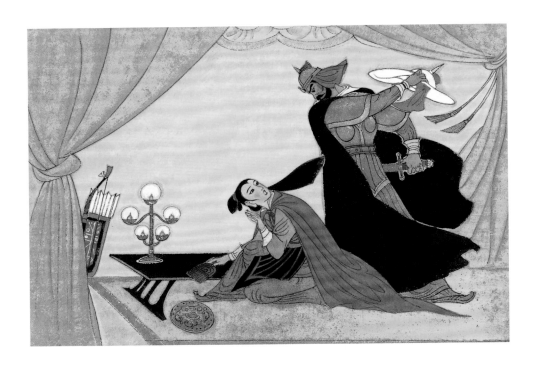

CHINESE HISTORY AND MYTHOLOGY

"I used to feel extremely happy to know that I was born in a country whose history had already lasted 5000 years," wrote Dr. Li Chi of the National Taiwan University in his *The Beginnings of Chinese Civilization*. The Chinese civilization is surely the oldest still existing on earth, and possesses the longest continuous written history of any nation. Dr. Li Chi also noted, however, that the history of China has been the subject of substantial official revisionism. As Mythologist Joseph Campbell states, "[It] is amazing how little we know of the writings of the Chinese before the period of Confucius (551–478 B.C.). And what to some will perhaps be still more amazing is the fact that from the period of Confucius onward there was such a doctoring of texts that even the most learned scholarship, whether of Europe, Japan, or China, has been at a loss, up to now, to reconstruct with assurance even the work of Confucius himself—not to mention whatever wisdom, mythic, philosophic, or other, may have gone before." Chinese mythology has certainly been subject to this revisionism. Campbell likens the mythology of China to jewelry, with gems lifted from their primitive settings, then polished and remounted in the appropriate dynastic style.

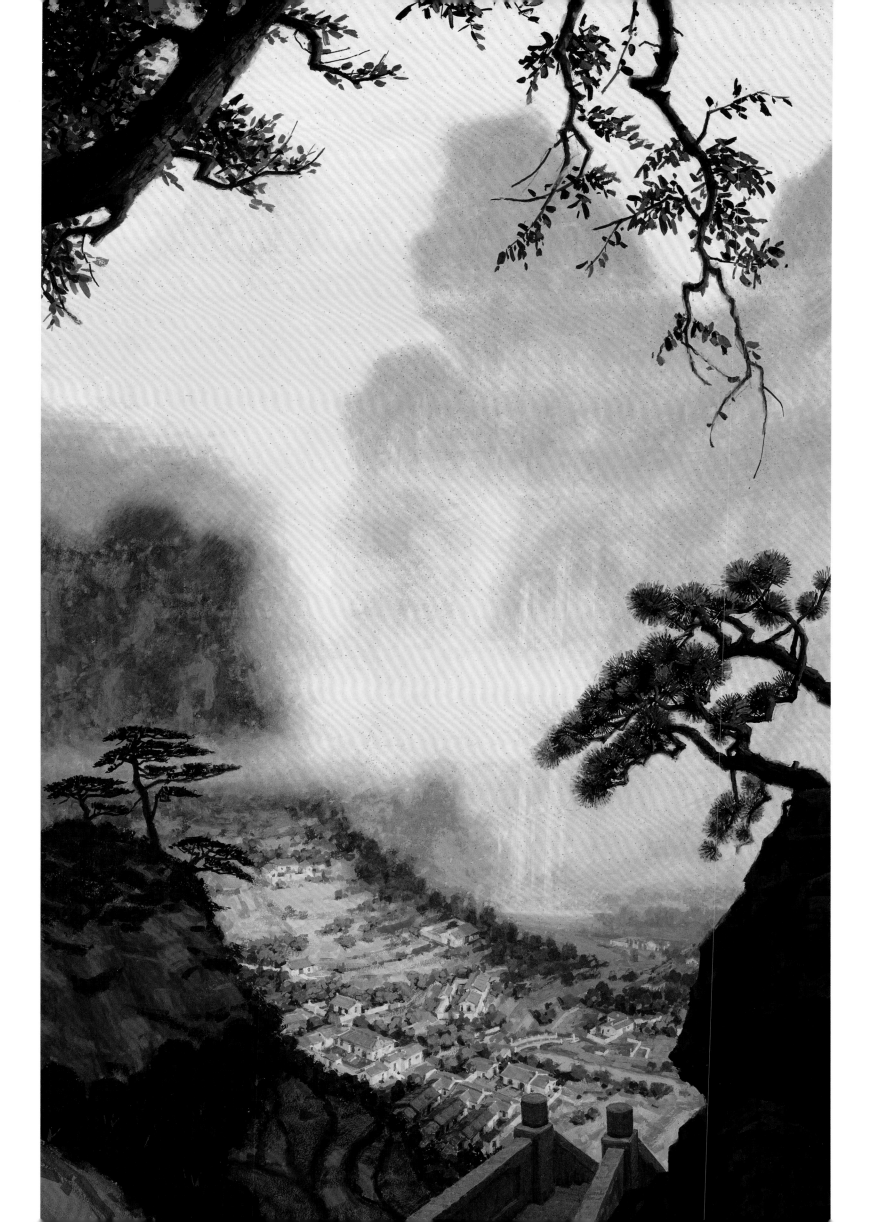

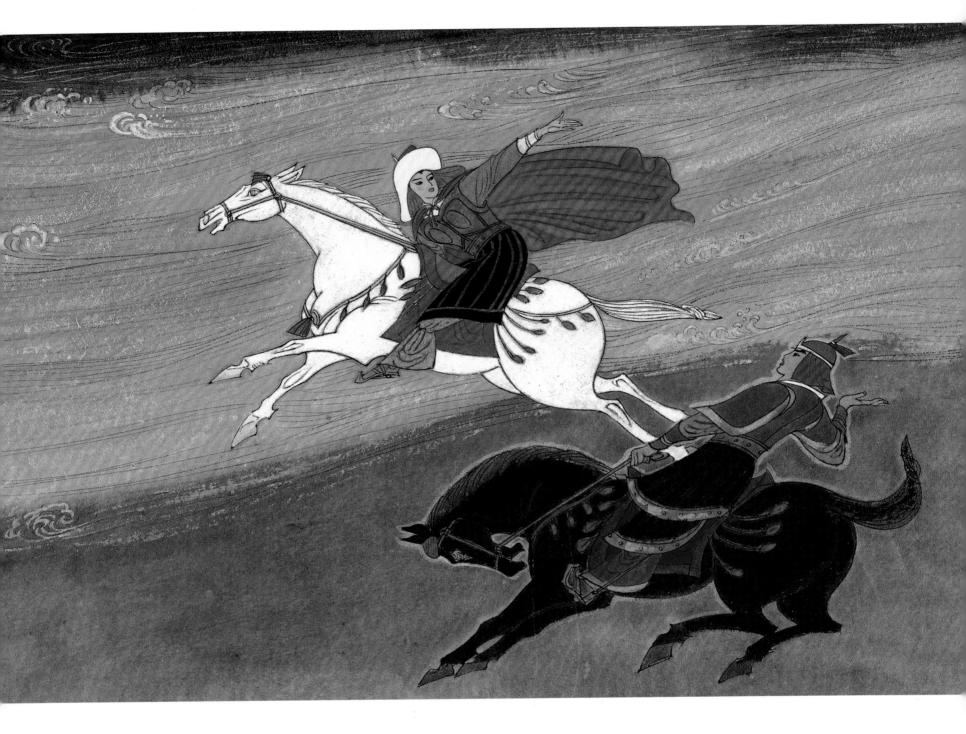

Above: Visual development
by Zhang Shiming.

Right: Mulan saves Shang
during the avalanche. Production
still. Avalanche-effects
animation by Joseph Gilland.

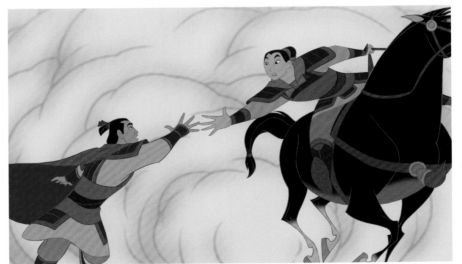

The Chinese myth of creation, for instance, is not the standard oriental tale of cosmic dissolution, but belongs to a solidly cosmopolitan culture. It concerns Nuwa, a half-woman, half-snake, who is said to have created China's primeval ancestors from mud. The society which invented this creation myth, however, did not usually exalt women—as mortals or as goddesses. For centuries, Chinese women who sought to control their own lives and destinies were forced to make harsh and often fatal choices.

Women who escaped Chinese social convention included scholars, warriors and revolutionaries. During the time of the Song dynasty (A.D. 960–1279), such heroines were epitomized by the assassin Hongxian and the military general Lady She Saihua. Later, women like the military commander Hong Xuanjiao and the revolutionary Qiujin gained fame for shattering their gender convention. (Many others, naturally—teachers, poets, and politicians—are remembered and revered for their virtuous *adherence* to Confucian social ethics.)

Given the social standing of women in Asian cultures, it is not surprising that the unconventional story of Mulan, "the secret soldier," with its issues of gender deception and denouncement of conventional bias, has been popular for centuries. These issues, married with the central themes of filial piety and duty to country and countrymen, have sustained the poem's fame.

Below: Visual development by Bao Hong Cheng.

Overleaf: Mulan puts on her father's armor. Visual development by Bao Hong Cheng.

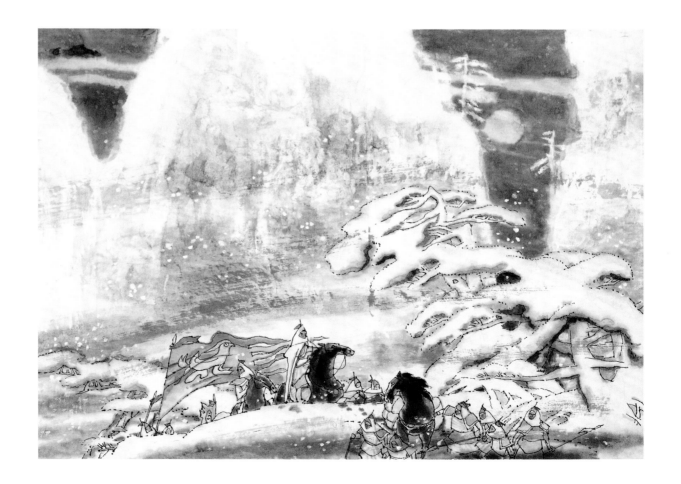

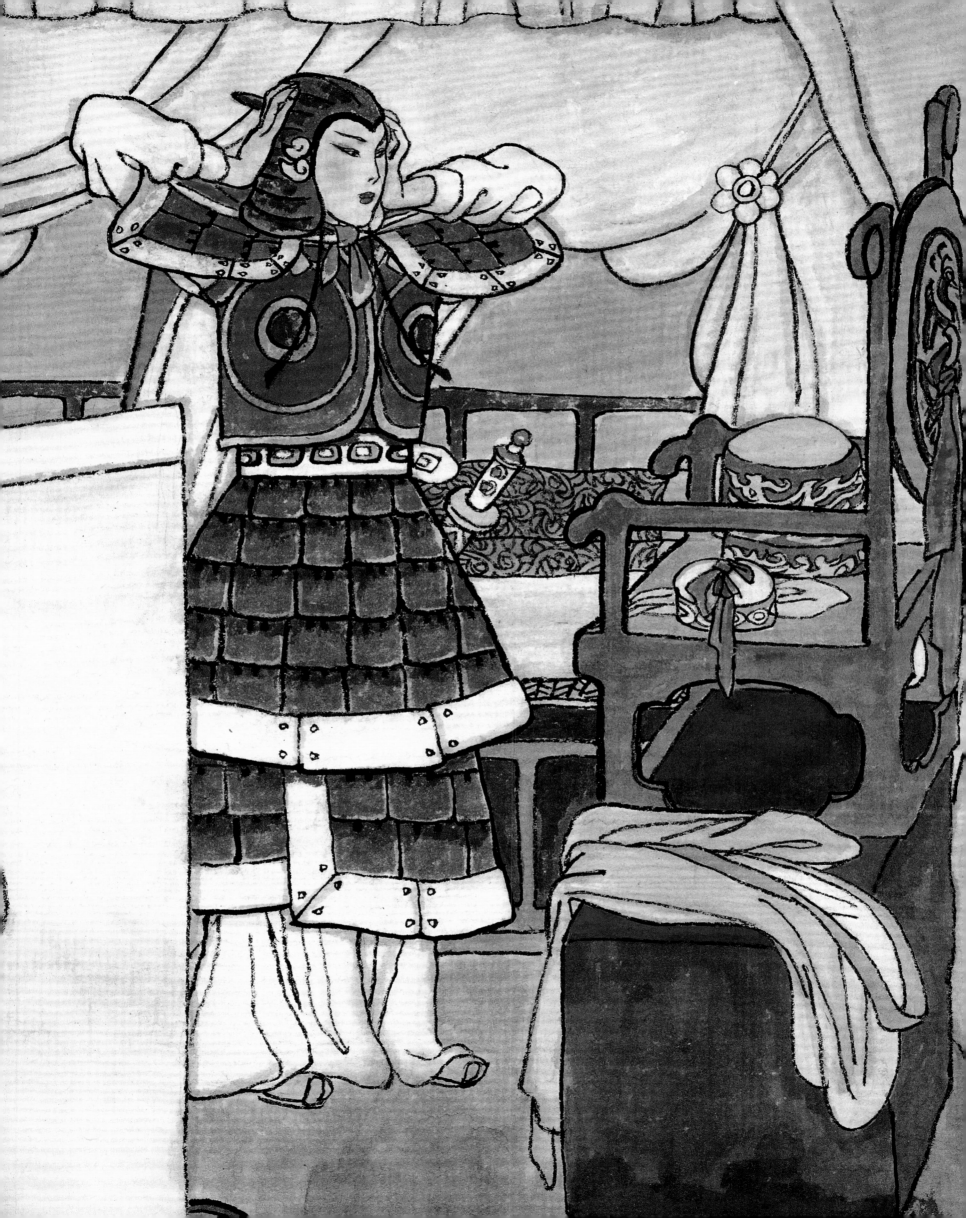

There is no official record of the achievements of Mulan in any Chinese chronicle prior to the Song dynasty. Indeed, there is no proof that Mulan was a real person at all.

First, there is disagreement about Mulan's birthplace and the geography of her adventures. Some say she hailed from the Wan County in Hebei, others believed she inhabited the Shangqiu province in Henan, and still others believe she was a native of the Liang prefecture in Gansu.

This disagreement was brought firsthand to the *Mulan* creative team when they visited China. "Everybody there had a different story," recalls Director Barry Cook. "And everybody we asked about Mulan would say, 'This is the story of Mulan and this is how it really happened, because she was from my village, and I know.' She's from 20 villages. She's from 20 cities. She's from 20 different regions. Everybody wants to claim her, proudly, and say, 'Mulan, she was a northern girl.' 'Oh, no, she was a southern girl.' It's that kind of thing. It's such an old story that no one could be proven right.

"We did meet one professor who said, 'We think that we have found her grave site. We know she was a real person.' A professor from another town might have told us a different story, but with the same gusto. So, it's hard to sort it all out—but it was inspiring." In the end what became very clear to the team was that all Chinese people wished to claim Mulan because of what she stands for."

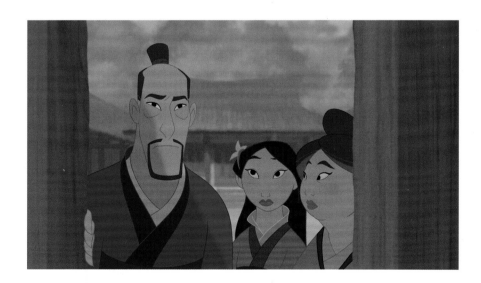

Above: Mulan with her father

and mother, Fa Zhou and

Fa Li. Production still.

Left: Visual development

by Mark Henn.

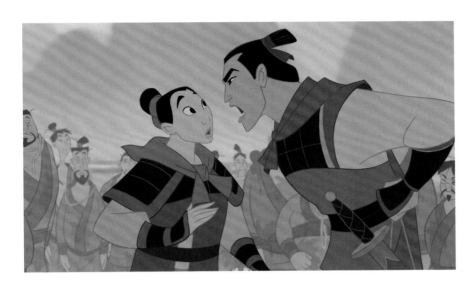

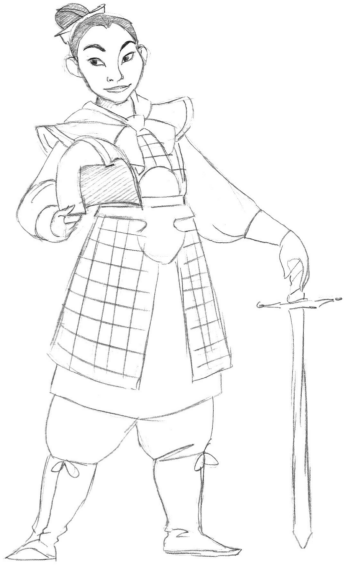

Above: Mulan struggles to

maintain her masculine disguise

in the face of her exacting

military commander, Shang.

Production still.

Right: Visual development

by Mark Henn.

There is also debate about the era in which Mulan lived. Cheng Dachang of the Song dynasty recorded that Mulan lived during the Sui and Tang dynasties. Song Xiangfeng of the Qing dynasty (A.D. 1644–1911) believed that she was of Sui origin (A.D. 581–618). Yao Ying, also of the Qing dynasty, believed she was from the time of the Five dynasties (A.D. 907–960). _Legends of China's Central Plains_ attest to a belief that Mulan lived before the Tang dynasty (A.D. 618–907).

Finally, there is even disagreement about the heroine's name. "Mulan" translates to "magnolia" ("Mu" by itself means "wood," and "Lan" means "orchid"). According to the annals of the Ming dynasty (A.D. 1368–1644), Mulan's family name was Zhu. The annals of the Qing (A.D. 1644–1911) say it is Wei. In his play, _Mulan Joins the Army for Her Father,_ Xu Wei gives the heroine the surname Hua ("flower"). The Chinese Pinyin method (a transliteration system devised by the People's Republic of China to standardize spelling of Chinese in Western languages) and the Wade-Giles method (an earlier traditional transliteration system used by English speakers) spell the name "Hua Mu-Lan," while in the Cantonese translation it is "Fa Mulan" or "Fa Muhk Laahn."

Mulan attempts to conform to

society's norms for her meeting

with the Matchmaker

during the song "Honor to Us All."

Production still.

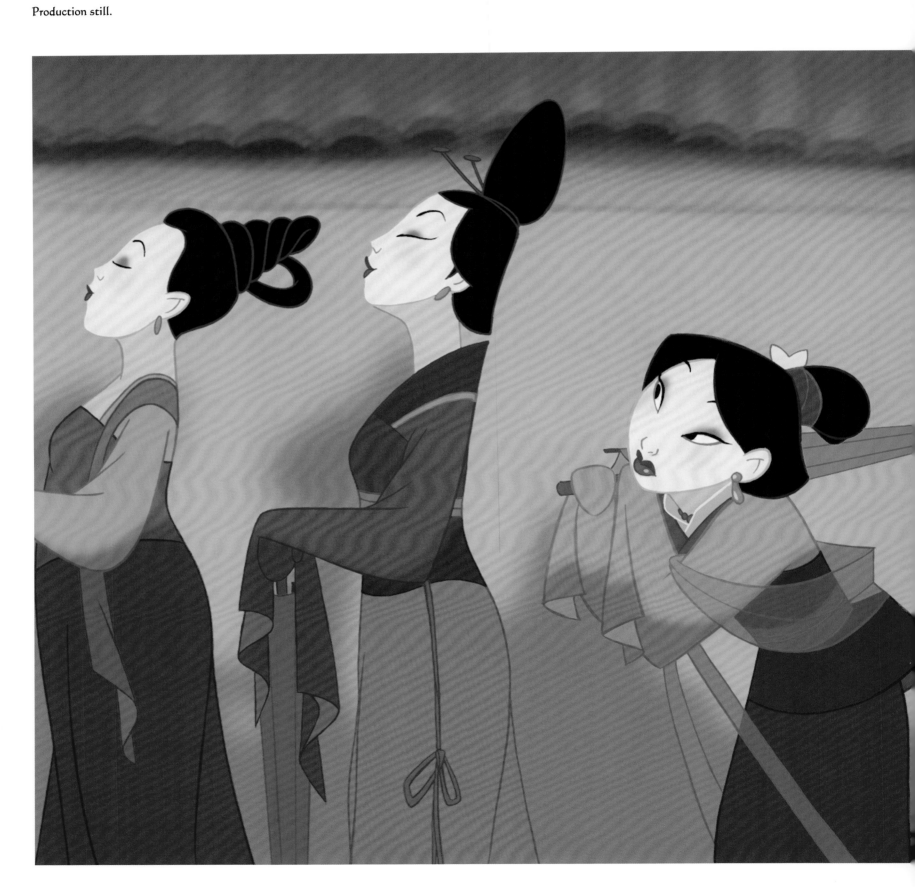

"**F**or us, *Mulan* initially presented—as it would continue to present throughout its development and production—a sense of balance," says Peter Schneider. "First there was an unusual and compelling story and distinctive characters. It also contained a universal theme—that often the individual must sacrifice for the greater good, and that the path of important personal discovery lies in that sacrifice. Finally, it was a legend that was developed enough to contain those strong elements, but spare enough to invite further elaboration of character and motivation."

In adapting any story, Disney sets itself up for criticism on the grounds of cultural meddling. Previously obscure folk tales, ambiguous characters, or disputable history suddenly become to the critic sacrosanct—prisoners of a looming and sinister "Disneyfication." The immensity of the Disney organization as a commercial venture is inevitably, and erroneously, intermingled with its corresponding cultural importance. This confusion between commerce and mythology creates a bizarre backlash, no matter what the Disney organization is doing. Critic Greil Marcus notes that ultimately those who instinctively line up Disney—anything Disney—in their critical cross-hairs are (smugly or naively) engaging in "avoidance of complicity with the culture that is in fact one's own."

Disney Feature Animation Executive Vice President Thomas Schumacher makes a similar, if somewhat more blunt, assessment. "Storytellers for all time have taken core story material and adapted and changed it for their audience, their era, and their point of view. Giambattista, the Brothers Grimm, Charles Perrault, Hans Christian Andersen, every storyteller throughout time. To say that we 'Disneyfy' something as a

pejorative in terms of adapting a narrative is to reveal one's complete naiveté about the process and history of storytelling."

Ultimately, whether Mulan was a genuine historical figure or simply a legendary hero didn't really matter to the team at Disney that had inherited her story. Although a determined respect for the original tale had to be part of the Disney adaptation of *Mulan*, Director Tony Bancroft notes that the creative group recognized certain limitations. "We knew we had to respect the material. This is a beloved tale to the Chinese people. We also knew that we weren't going to make a Chinese picture. We couldn't. We're not Chinese. We have a different sensibility, a different storytelling style."

Matthew Wilder, composer of the five songs in *Mulan*, recalls, "Initially the story struck me as a Chinese version of *Joan of Arc*. Yet it quickly became clear that the project was unusual in its concept, different from anything Disney had done before. I soon realized how special this was going to be."

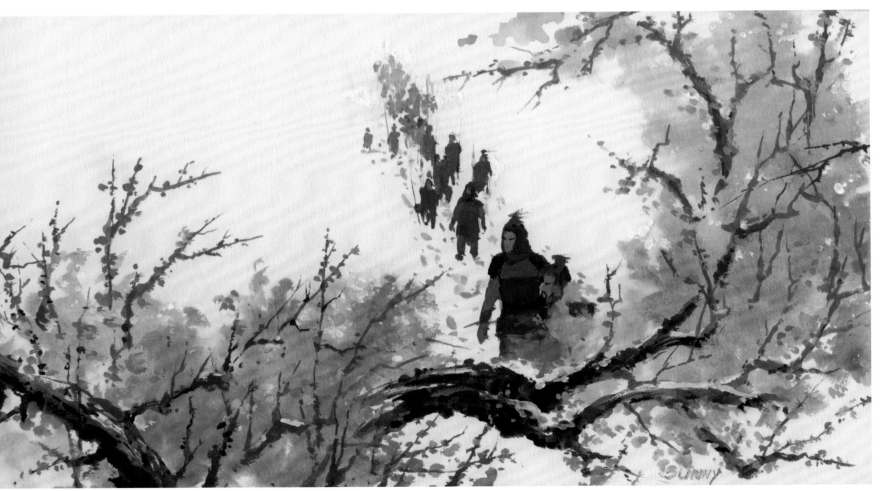

Right: Visual development of the merciless Hun leader Shan-Yu and his feathered companion by Peter deSève.

Opposite top: Visual development of Mulan by Character Designer Chen-Yi Chang.

Opposite bottom: Visual development by Los Angeles Head of Backgrounds Sunny Apinchapong.

Mulan's legendary status was more of a blessing than an encumbrance to the transition from fable to film. "When I discovered the broad history of the legend—the many different versions of the story in China and across Asia, I began to see that there was freedom to enhance and change," Director Barry Cook recalls. "I felt very relieved. I realized it wasn't a historical document. We weren't dealing with something so literal that we couldn't enhance it. That knowledge was liberating. That's when we could let our imaginations kick in."

"I was born in Thailand," states Los Angeles Head of Backgrounds Sunny Apinchapong, "and there we have a version of the Mulan tale. Most people in Asia are familiar with the story. I am sure they will welcome different views, different interpretations—they know it's still her."

Above: Mulan's first encounter with Mushu the dragon. Visual development by Alex Nino.

Right: Character development by Disney Legend Floyd Norman.

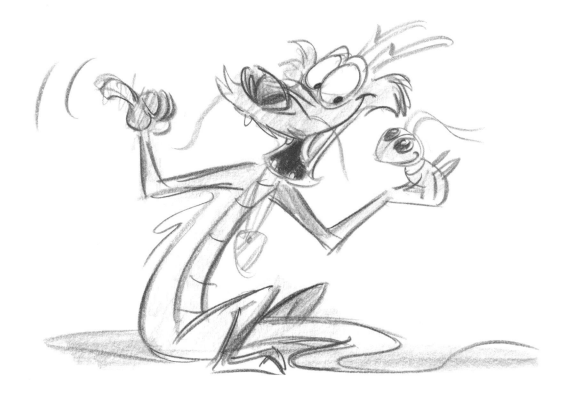

30

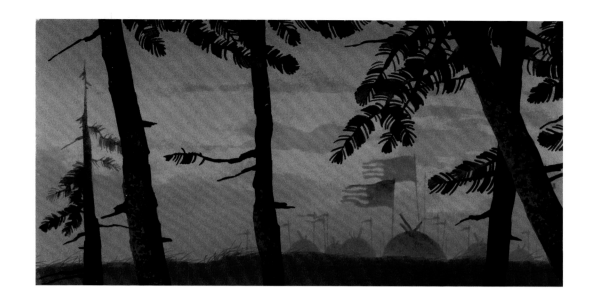

Top right: Visual development

by Hans Bacher.

Overleaf: The Great Wall—

perhaps the most renowned

symbol of Chinese culture—

serves as a dramatic setting

for the beginning of Disney's

interpretation of the story of

Mulan. Visual development

by Alex Nino.

A D A P T I N G T H E S T O R Y

\mathcal{T}he story of Mulan and the milieu of Chinese legend had come to Walt Disney Feature Animation during the early 1990s. "We had been looking at a lot of stories set in the Far East, whether they were Japanese or Chinese or Korean," Thomas Schumacher relates. "We felt that it was a rich and evocative environment and story source, one that we had never really tapped before at Disney."

Schumacher continues, "And although we looked and looked for an Asian story, I was uninterested by anything that we found. Everything seemed to be kind of colonial—'external forces come in to *exotic* country.' Nothing seemed to do justice to the resonance of the culture, or the majesty of the setting. We wanted something that was more faithful to the culture and focused on the native society."

Jay Dyer, who was a Feature Animation executive at the time, had established a consulting relationship with a renowned children's writer, Robert San Souci. The author of 56 books, most of them based on legends, myths and folklore, San Souci was honored with the 1993 Aesop Prize, a prestigious annual award for the children's book that best incorporates folklore in text and illustration.

"We had optioned a few of Bob's books," Schumacher explains, "So we thought, let's just go to Bob and ask him if there are any stories he is still holding onto. He had a manuscript for a children's book of the legend of Mulan, which he had been unable to interest a publisher in. And we said, 'Well, we'll make a movie out of it.'"

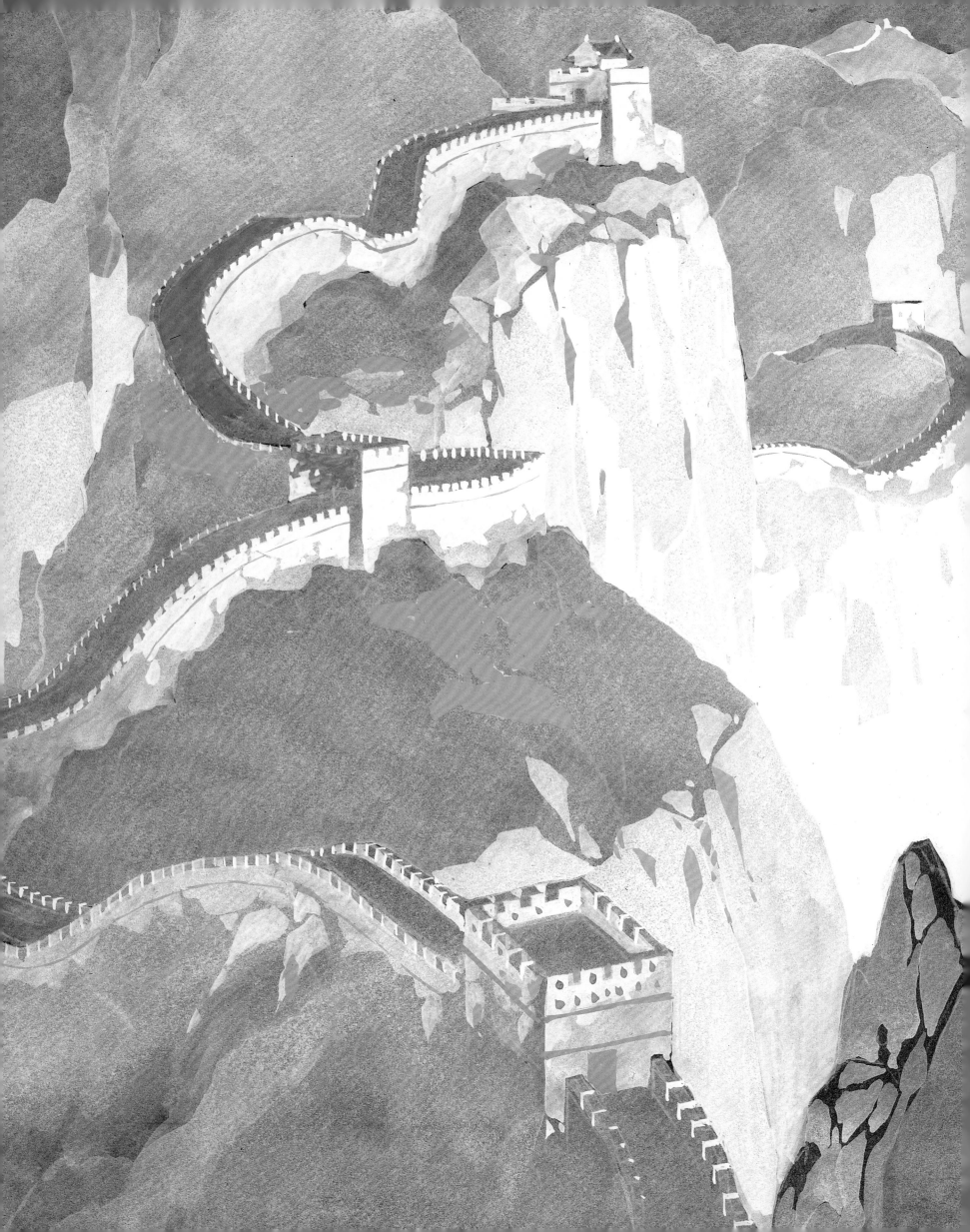

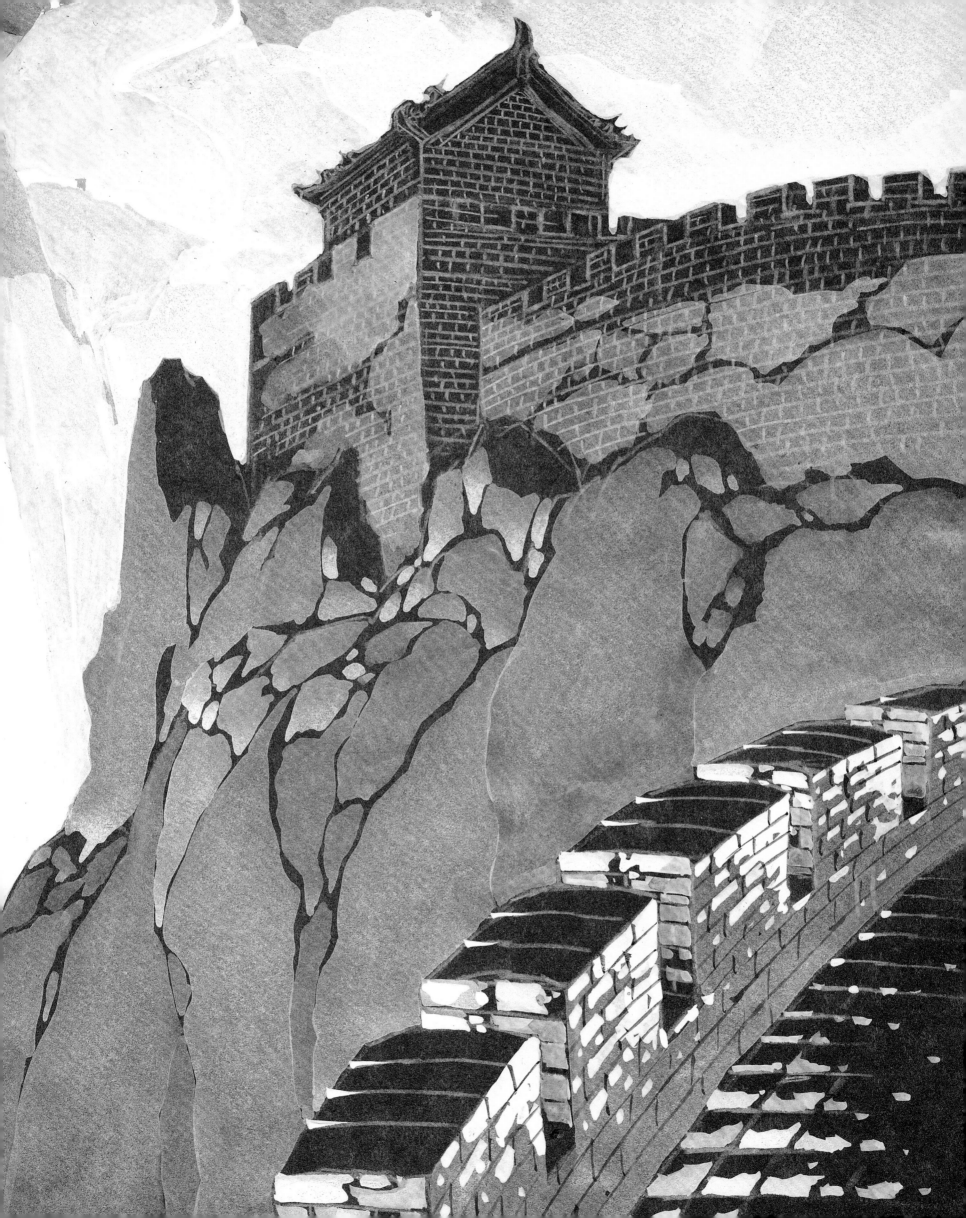

"It must have been late 1992 or early 1993 that Tom and I began constructing a small team to develop this fable," Peter Schneider relates. "The hardest part of making any project is assembling the right team and finding the right balance of people. It's not necessarily true that you need a certain level of experience, or a certain type of person—in the end, it's about the interaction of the people. We started assembling our *Mulan* team with Barry Cook. Barry was an obvious choice, because he had directed before, we knew his work, and we liked it."

Cook, who began the initial work on *Mulan* and would ultimately co-direct the final film, is a 16-year Disney veteran who directed the experimental short—a story of his own invention—*Off His Rockers* (1992) and the Roger Rabbit short *Trail Mix-Up* (1993). Cook had studied film at Columbia College in Hollywood, and had been a lead animator in Disney's Effects Animation Department.

"Tom Schumacher invited me to lunch one day and said, 'We've got two projects we want to develop. One's a Scottish folk tale, based largely around a dragon,'" Cook recalls. "'And the other is a Chinese story about a girl who dresses as a man and goes off to war.' The first thing that occurred to me was that the Scottish tale had been done a million times—and badly, almost every time. So I said, 'I know there are dragons in Chinese mythology. Why don't we just put the dragon in Mulan's story and start from there?' A week later he called me and said, 'Forget the Scottish thing, go with the Chinese thing,' and that was it. I think maybe my enthusiasm about it helped. It seemed unique. It seemed like something we hadn't done before, and something that hadn't been explored much, not only in animation, but in any movie. A Western movie audience wouldn't be familiar with it."

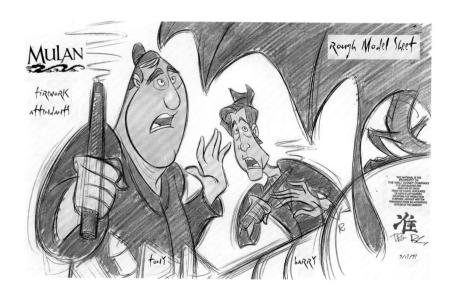

Directors Tony Bancroft and Barry Cook make an appearance in the film as fireworks attendants. Rough model sheet by Head of Cleanup Ruben Procopio.

FIRST ANCESTOR: Mushu awaken!

Left and below: Mushu is brought

to life by the First Ancestor.

Production stills. Effects animation

by Troy A. Gustafson.

Bottom left: Visual development

by Harald Siepermann.

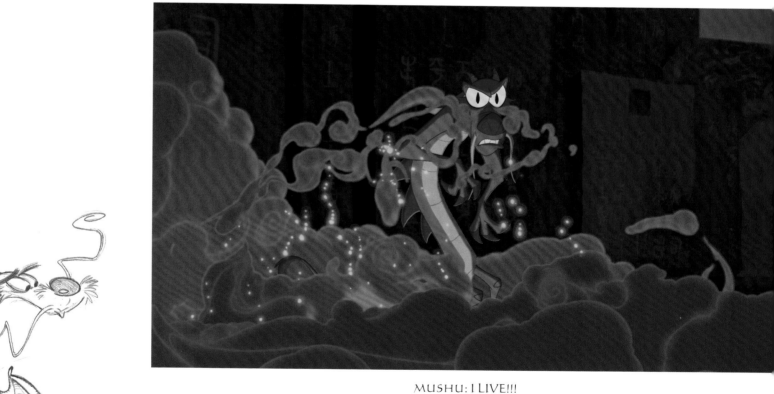

MUSHU: I LIVE!!!
So tell me, what mortal needs my protection, Great Ancestor!
Just say the word and I'm there.

Top and above: **Visual**

development by Ric Sluiter.

Ric Sluiter had been at the Florida studio of Walt Disney Feature Animation since its opening in the Summer of 1989. "For a couple of years I was head of the Background Department, and I worked with Barry Cook on a small project, *Off His Rockers,* which I art-directed. After that, I worked on the Roger Rabbit short *Hare in My Soup,* which was never produced, and then went into development for *The Lion King* and *Fantasia/2000.* When *Trail Mix-Up* came along, Barry Cook, who was assigned to direct, asked me to art-direct."

Sluiter officially began on *Mulan* the Summer of 1993. "When it came time to pick someone for art direction, there were many other art directors available. This was a lot bigger project, so I wasn't assigned to it right away. It kind of just happened after I spent a year in visual development."

Pam Coats was a four-year veteran of Walt Disney Feature Animation. Prior to being selected in the last months of 1993 to produce what was then being called *The Legend of Fa Mulan*, Coats had served as assistant production manager of backgrounds, animation check, and color models on *The Rescuers Down Under* (1990), then as production manager in development. She transferred to Feature Animation's Florida studio for her first stint as producer on the Roger Rabbit short *Trail Mix-Up* (1993). In 1993, she returned to California to serve as executive producer of *Runaway Brain* (1995), the first Mickey Mouse short produced since 1953.

Like many of her colleagues at Feature Animation, including Peter Schneider and Thomas Schumacher, Coats has her roots in live theater. She holds a Bachelor of Fine Arts degree in Performance from Utah State University, and a Master of Fine Arts in Directing from the University of Oregon.

"During the production of *Runaway Brain* I was sitting at my desk, and in walked Tom and Peter," Coats remembers. "They said, 'You know, we have a favor to ask. We need an interim producer to guide the *Mulan* project until we find a producer who will move to Florida.' I said, 'Oh, you guys are good—but you're not getting me to Florida.' I agreed to shepherd *Mulan* only until they could get a producer who was interested in relocating.

"But during that interim period, I fell in love. I fell in love with the creative team, and I fell in love with the story. Then Peter and Tom called to let me know that I was off the hook—they had hired a producer. It was then that I realized I was about to lose something that meant a great deal to me. I asked to stay. Luckily, they were able to reassign the other producer, and I got to stay with *Mulan*."

Below: **Shang and Mulan battle Shan-Yu (left) and the victorious army enters the Imperial City (right). Visual development by Paul Felix.**

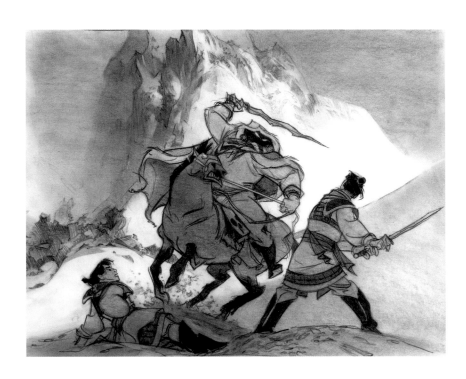

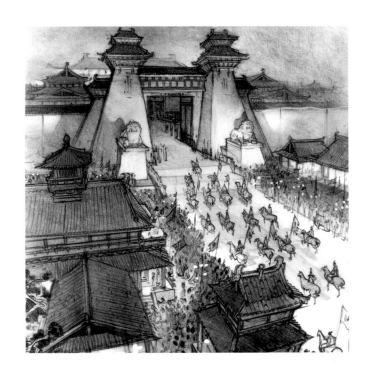

This page: **Mulan returns to her family. Storyboard art by Head of Story Chris Sanders.**

MULAN: Father, I've brought you the sword of Shan-Yu and the crest of the Emperor.

They're gifts to honor the Fa family.

Head of Story Chris Sanders was initially an unwilling recruit to the *Mulan* project. A graduate of California Institute of the Arts, Sanders joined the Development Department at Disney Feature Animation in 1987, at which time he served as a key member of the Story Department for *The Rescuers Down Under*. On *Beauty and the Beast* (1991), he again was a key member of the story team, as well as a contributor to character design. For *Aladdin* (1992), Sanders again headed story development, after which he supervised production design for *The Lion King* (1994).

"I had just finished *The Lion King*, it was in November 1993," Sanders remembers. "I was hoping to go onto *The Hunchback of Notre Dame* (1996). Tom Schumacher dropped by my office and said, 'I want you to work on *Mulan*.' I knew the very barest, faintest thing about it, and all I could hear was 'teenage girl leaves home because she can't fit in,' and something about an evil villain. And I said, 'That's the same thing we've done a million times. I have no new ideas for that.' Tom came back a couple of weeks later and said, 'I really want you to do this.' And it was beginning to sound more and more like 'an offer I couldn't refuse,' if you know what I mean. So I begrudgingly said 'great'—and was really sad, really upset that I had to work on this thing.

"It was probably a month before I started turning around on it. I had read the first scripts, and when I looked at the basic story, I saw an opportunity," Sanders recalls with a smile. "Mulan was quite different from our previous leads. She did not perceive herself to be a misfit, and didn't long for anything beyond her own backyard. Her strength was her selflessness, which was very unusual. The more I looked at it, the more I thought, 'This has a chance of being really great.' Against my will, I fell in love with it. I think Tom Schumacher knew I would."

FA ZHOU: The greatest gift and honor is having you for a daughter.

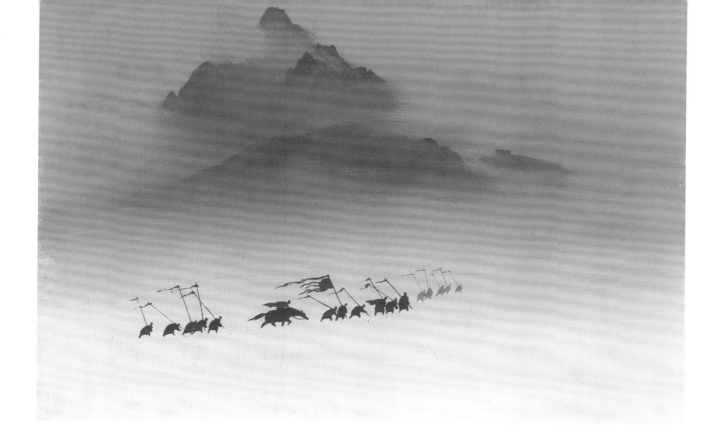

This page: **Visual development**

by Hans Bacher.

Hans Bacher was born in Cologne, West Germany, and is a renowned animator, illustrator, animation director and production designer. Bacher established his Disney connection through Richard Williams, with whom he had worked on *Who Framed Roger Rabbit* (1988). Bacher had lent his design expertise to *Beauty and the Beast* and *Aladdin*. His visual development work on *The Lion King* is revered in the halls of Disney Animation, as is his unwavering focus and almost fanatical devotion to stylistic integrity. Bacher came to the *Mulan* production in stages.

"I was working in London in September 1993, and got a phone call from Los Angeles," says Bacher. "They asked me if I was interested in doing some designs on an upcoming film called *Mulan*. I did some designs in my spare time and sent them over, and they really liked them. That was the first time I was able to do something in a Chinese style, and they looked really similar to my other work.

"I moved to Los Angeles in 1994, and started work on five different projects, one of which was *Mulan*. Then Barry Cook asked me in December if I could come up with a style for the production design. They liked it, so that was it."

"Hans is a genius," Peter Schneider states. "I worked with Hans the first time on *Who Framed Roger Rabbit,* in London. His work was breathtaking. For many years, we tried to get Hans to join us at Disney, and he couldn't for various reasons. We got him here on *The Lion King,* and he gave us that great opening sequence. He then did a little bit of work on *Beauty and the Beast* but never quite jelled with the people on that team. He fell in love with *Mulan,* however, and has brought a tremendous sense of beauty and depth to it."

9.9-711

9.9-712

This page: **As the Huns charge down on the greatly outnumbered Imperial army, Mulan devises a way out. Storyboard art by Dean DeBlois.**

9.9-715

A young story artist named Dean DeBlois was also assigned to *Mulan.* A Canadian native and a layout artist whose work had included the Don Bluth features *Thumbelina* (1994) and *A Troll in Central Park* (1994), DeBlois happily cites as his mentor legendary Disney story man Joe Grant (whose Disney career began in 1937).

"I submitted my portfolio, to work on either *The Hunchback of Notre Dame* or *Mulan,*" DeBlois says. "I was hoping to move into the story area from layout, but I was officially hired as a layout artist. When I arrived, layout didn't need me quite yet, so I got my wish. They put me to work on storyboards. Finally, after several months, Pam Coats came to me and said, 'We need to have a layout artist, but we like you in story—shall we make this story job official?' It was a fortunate set of circumstances."

This page: **Visual development**

by Chen-Yi Chang.

Chen-Yi Chang was a young artist who had served an internship at Walt Disney Feature Animation in Florida, and had been involved in creating characters for the highly stylized *Batman* animated series for Warner Bros. Television. Animator Anthony Wong sent a letter to Cook, introducing Chang and suggesting that his style might suit the developing *Mulan* project. Cook asked to see his portfolio. After Cook and Ric Sluiter reviewed his work, Chang was brought on board. Peter Schneider thinks of Chang as "the authority, the man who knows what it should look like. Chen-Yi has a very strong sense of design and a real sense of what it should look like in terms of a non-Western style. Chen-Yi was very influential in that."

Chang was enthusiastic about the opportunity presented by *Mulan*. "I knew Hans Bacher before he came on the project, and I liked his stuff a lot," Chang says. "I think if two people have similar tastes, then artistically they can work together. Hans was convinced you can do a film without too much detail that still looks 'real.' It's the same in a lot of Chinese art, especially the landscape paintings, in which everything is kept very simple. A lot of mountains are high in the mist, so details are omitted and your imagination fills them in. Character-wise, that was my thinking as well. When a character is in action, you are not supposed to pay attention to the details. I knew that I could bring that same style, that same thinking, to *Mulan*."

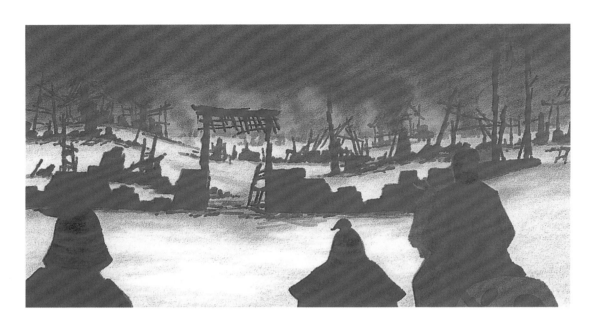

The Imperial soldiers come
upon a village destroyed by
the Huns. Tonal layout art
by Andy Harkness.

Director Tony Bancroft was one of the last to come to the core *Mulan* creative group, in early 1995. A team of two directors is often established on Disney features, to share both the work load and creative challenges. Peter Schneider explains, "It makes it easier in the creative process if there are two people, so one person doesn't perpetually feel attacked or criticized. It creates an exchange, so that individual problems can become shared problems. What we tried to establish with Tony was a balancing act with Barry—somebody who could add to the diversity and the conversation in the room, so we could heighten the efficiency of the creative process."

Another CalArts grad, and an eight-year Disney veteran, Bancroft had served as an assistant animator on *Roller Coaster Rabbit* (1990) and an animating assistant on *The Rescuers Down Under*. He animated Cogsworth on *Beauty and the Beast*, and Iago on *Aladdin*, before supervising Pumbaa for *The Lion King*. Bancroft was performing initial work on *The Hunchback of Notre Dame* when he was approached to join the *Mulan* production.

"I came onto the project late. I had been a supervising animator on *The Lion King*. I animated Pumbaa, and had a lot of fun. I felt like my career was

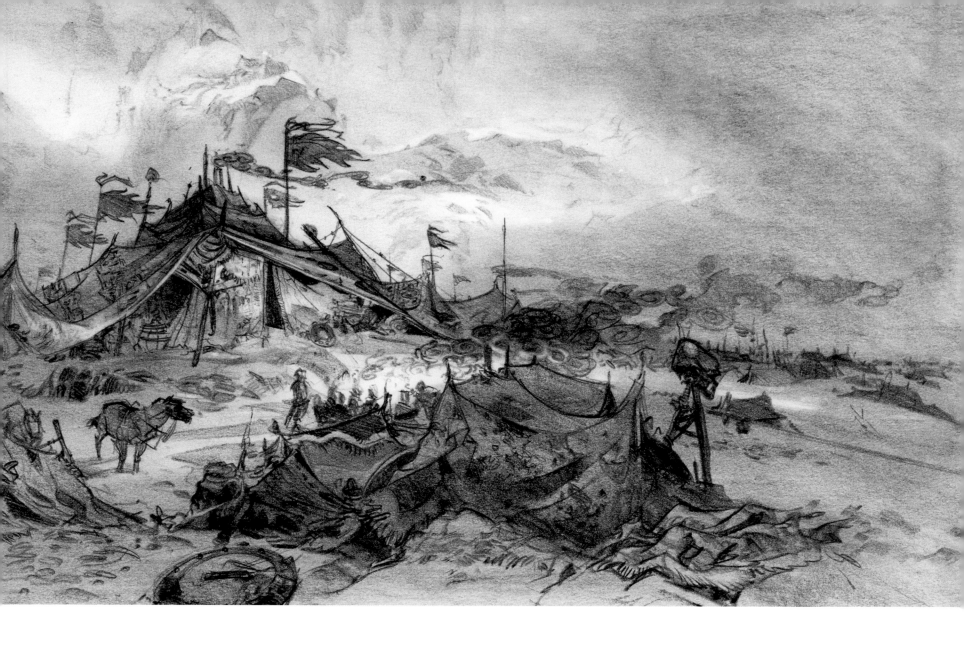

Visual development of the

Hun camp by Paul Felix.

going in the right direction. I always aspired to be a supervising animator, and a good one at that.

"I went on to *The Hunchback of Notre Dame* and started off supervising two of the gargoyle characters. So, when I first started, that was my goal, to animate these characters and do a better job artistically than I did on Pumbaa. I didn't really know much about the story of *Mulan*. I knew it was about a girl in the army. Out of the blue, Tom Schumacher asked if I wanted to join Barry as the second director on *Mulan*. It really took me by surprise. Although, when I had told my wife that morning that I had a meeting with Tom Schumacher, I said, 'What if he asks me to work on *Mulan*?' My wife said, 'No, no, no. We are not going to Florida!'"

But they were. They all were. Whether they were fully aware of it or not, the *Mulan* production team was setting out on its own journey—a journey that would lead to the first-ever feature-length animated film produced in the Walt Disney Feature Animation facility at Disney-MGM Studios in Florida.

Although the animation studio was planned in the mid-1980s as a "display" facility for visitors to the Disney-MGM Studios, the ambitious

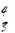

Left: Color key of the Stone Forest by Michael Kurinsky.

Below: Sensing the presence of Imperial scouts hiding in the nearby forest, Shan-Yu directs his men to capture them. Background art by Barry Kooser. Layout by Franc Reyes, cleanup layout by Kevin Proctor.

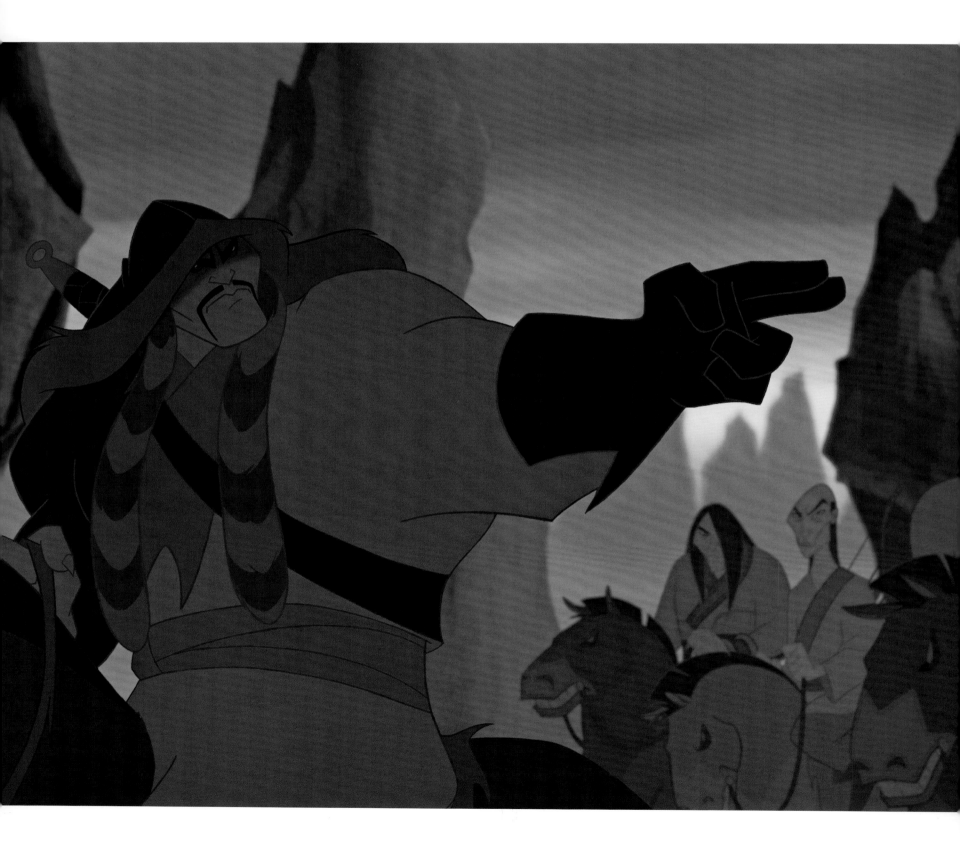

Visual development of Mulan

by Ruben Procopio.

growth of Disney Feature Animation soon necessitated a satellite studio facility. On May 1, 1989, *Walt Disney Feature Animation Florida* opened, with 73 full-time staffers, producing the Roger Rabbit short *Roller Coaster Rabbit*. Shortly after opening, the Florida animation staff was asked to assist the Burbank studio by completing several minutes for *The Rescuers Down Under*. Since then, the Florida team has contributed segments to the Mickey Mouse featurette *Prince and the Pauper*, and the features *Beauty and the Beast*, *Aladdin*, and *The Lion King*, and would also support *Pocahontas*, *The Hunchback of Notre Dame*, and *Hercules*. In addition, the Florida team created the short subjects *Off His Rockers* and *Trail Mix-Up*, and segments of *Runaway Brain*.

Naturally, the animation talent to staff this studio had to come from somewhere. Since 1989, the Florida facility has trained 200 interns, 148 of whom have been hired, with 110 remaining in positions at the Florida studio and the rest moving to Disney's studios in Burbank.

With The Walt Disney Company's strategy to release three new animated features every two years, and the addition of new animation ventures at the Florida studio, the animation staff had increased from its original 73 members to more than 350. The facility was also expanding from its original 15,000-square-foot headquarters to a complex of buildings that would ultimately total 92,000 square feet.

In a trailer village on the Disney-MGM Studios back lot, in the growing shadow of an all-new state-of-the-art Feature Animation facility under construction across the road, another epic journey would begin. First-time Feature Producer Pam Coats, first-time Feature Directors Barry Cook and Tony Bancroft, first-time Supervising Animators Pre Romanillos, Tom Bancroft, Broose Johnson, T. Dan Hofstedt, Alex Kupershmidt, Jeffrey Varab, and seasoned Supervising Animator Mark Henn began producing both the first Disney animated feature to use an Asian legend as its story source, and the first complete feature produced in the Florida studios of Walt Disney Feature Animation.

But before that journey could begin, there was an altogether different kind of excursion in store for the *Mulan* production team.

PART 2 THE JOURNEY OF DISCOVERY

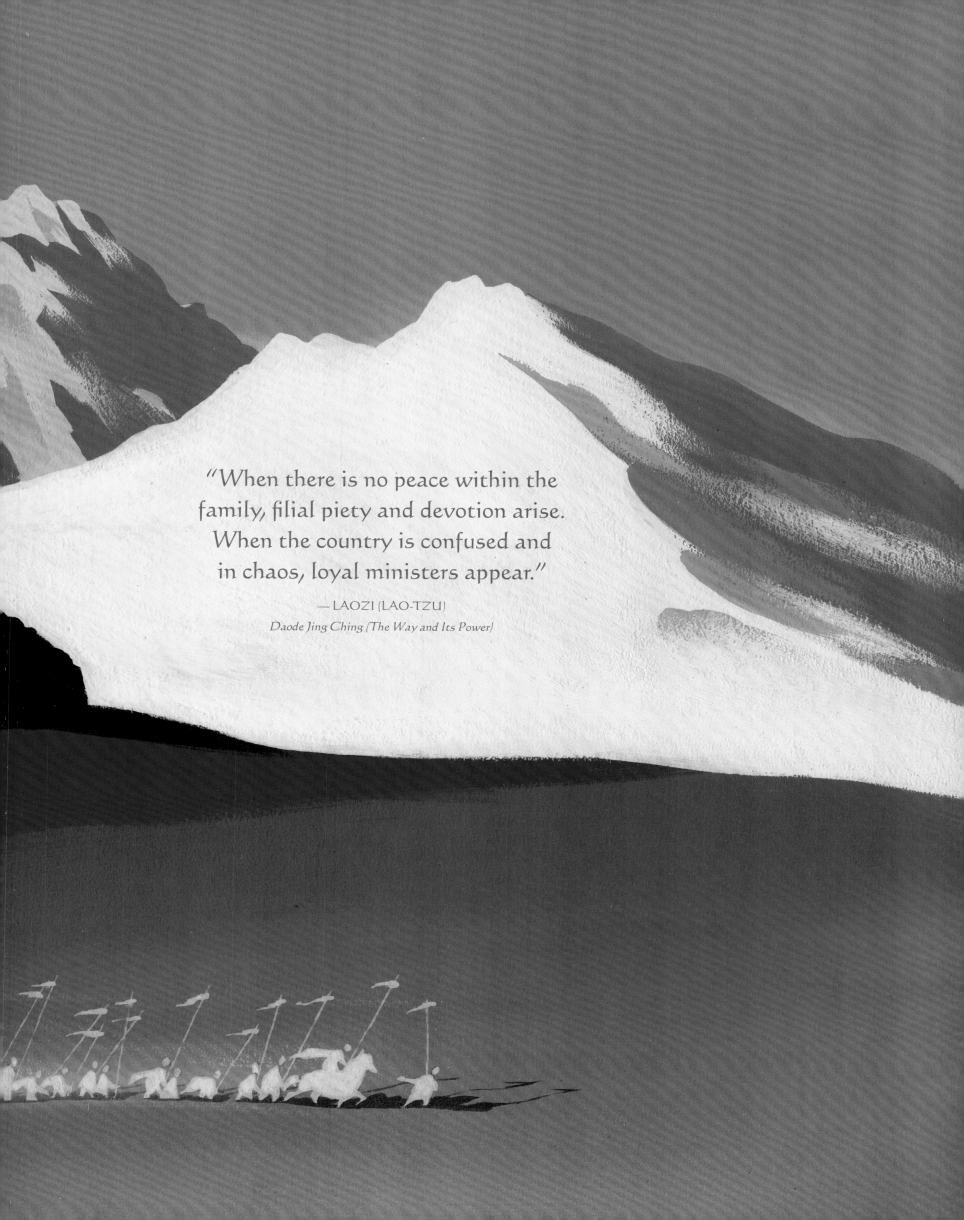

"When there is no peace within the family, filial piety and devotion arise. When the country is confused and in chaos, loyal ministers appear."

— LAOZI (LAO-TZU)

Daode Jing Ching (The Way and Its Power)

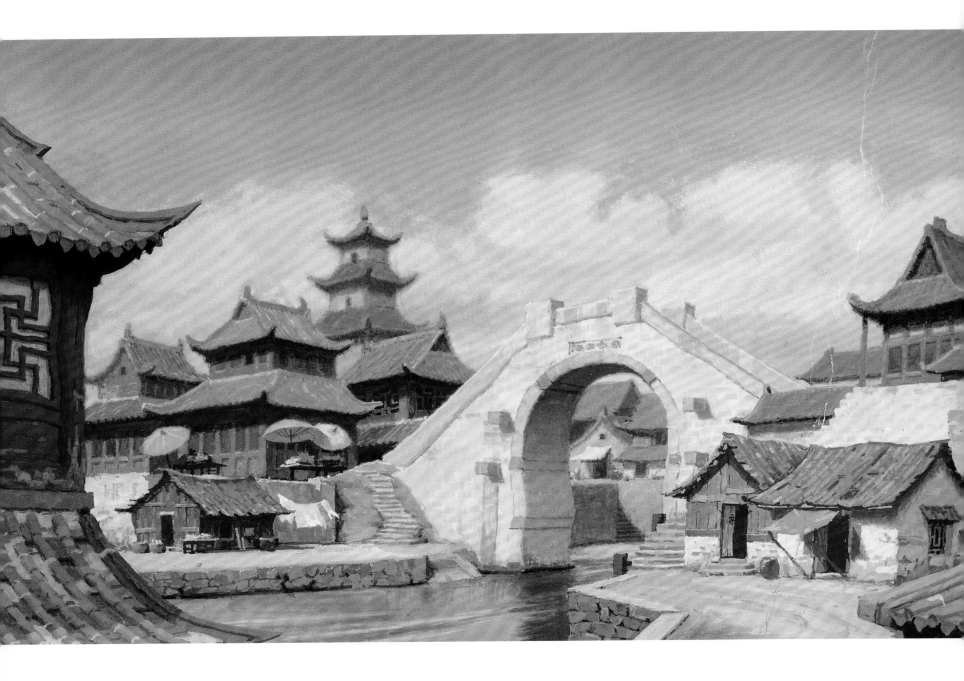

Preceding pages:

Visual development

of the mountains by

Hans Bacher.

A
N
O
T
H
E
R

J
O
U
R
N
E
Y

*O*ne of the first steps toward the creation of a screen version of *Mulan* entailed a journey, this time a physical one. Key members of the creative team at the time—Pam Coats, Barry Cook, Ric Sluiter, Robert Walker, and Mark Henn—were invited to travel to China, to get a feel for the landscape, the people, the history—the very character of the country at the heart of the *Mulan* legend.

"I actually invented these field trips, when I first came to Disney almost ten years ago to do *The Rescuers Down Under*," Thomas Schumacher says. "I thought we should go to Australia. And everyone said, 'Why in the world would you go to Australia? It's an animated movie—just draw it.' I knew that when we were there we would discover things that you

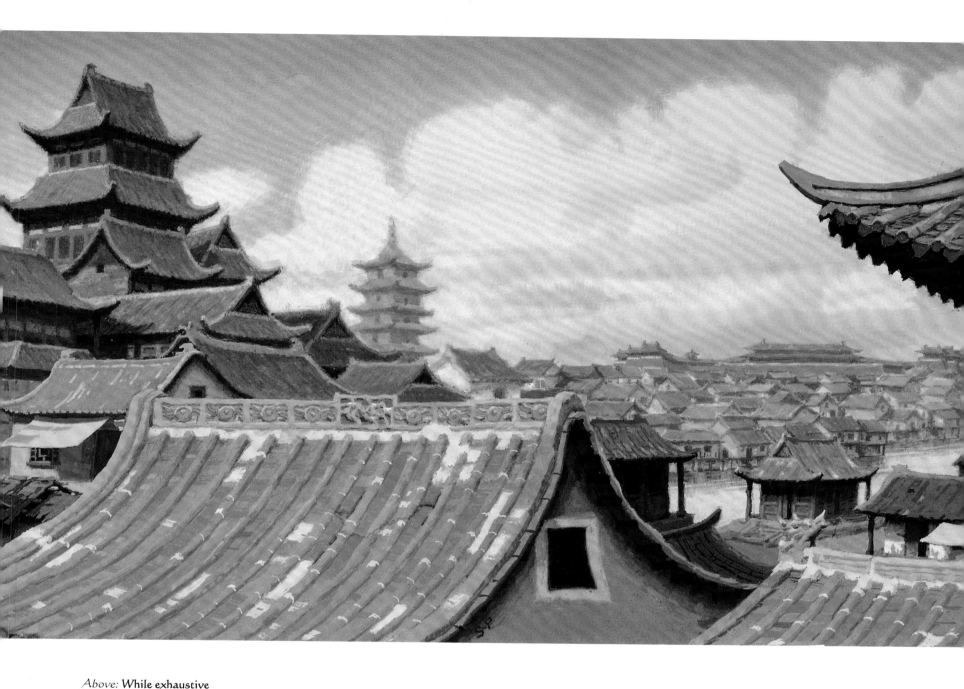

Above: While exhaustive research went into producing visual accuracy for *Mulan,* the production team's China visit became a crucial guide in creating an emotional and cultural authenticity as well. Sometimes the team's discoveries were then paired with a creative liberty, as in this visual development by Sai Ping Lok that depicts Fujian *tulou*-like structures that aren't commonly found in northern China.

would never find if it wasn't in your experience. Stuff will appear to us. Feel it, taste it, smell it. You have to be there. We'll go for a few weeks."

That trip to Australia established a pattern, and now each Disney Feature Animation creative group goes to visit the actual location of their screen stories whenever possible. In doing so, the rewards have been myriad and valuable. When *The Lion King* team visited Africa, they came back with an instinctive feel for the land and a distinctive visual style, as well as a silly little phrase—'Hakuna Matata'—courtesy of a local guide.

Schumacher adds, "Now we wouldn't think about *not* taking these trips. It's part of our filmmaking process."

Above: A page from Ric
Sluiter's sketchbook.

Below: Background art by
Charles Vollmer. Layout by
Armand Serrano, cleanup
layout by Peter DeLuca.

The *Mulan* journey to China began on June 17, 1994, with a flight from Los
Angeles to Beijing. "We flew into Beijing and stayed there the first day,
recuperating from enormous jet lag," Pam Coats recalls. "One of the first
things we did was to go to the Great Wall, outside Beijing."

Although a concise and detailed itinerary had been set in place, there
was some feeling of "flying blind" among the travelers. Part of this
apprehension was due to the state of the story development at that time,
relative to knowing what to look for. Barry Cook explains, "The strangest
thing was trying to find out where to go, and sort of wondering, 'I hope we
don't miss something.' But how do you go to China for only three weeks and
not miss something? We just had to wing it and say, 'Our minds are made up!
We're going to go here, here, here, here, and here, and this is what we're going
visit and this is what we're going to do.'"

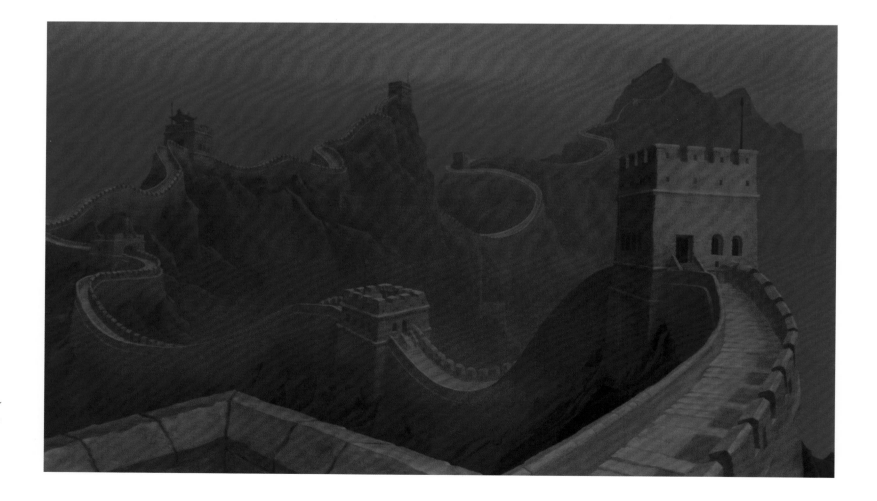

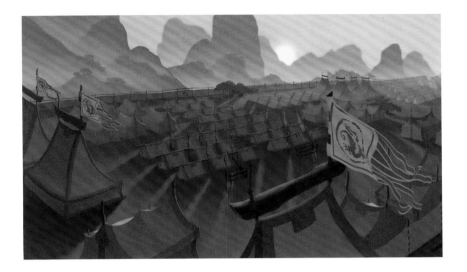

Ric Sluiter remembers being overwhelmed simply by being there. "It was very impressive to see something on the other side of the world that looks so different from what we are used to seeing here. It's just such a cultural shock." His first reaction was to reach for his art materials. "I told Pam," Sluiter continues, "'just drop me off in the mountains. I want to sit on the Great Wall and set up my easel and paint. Just leave me.' They said, 'No, no. We've got to move around.' It was such a tight schedule, and we were popping all over. There wasn't time to do much painting. Although I was able to do a few sketches and paintings here and there."

Coats also remembers an experience on the Great Wall. "It was a beautiful day and we had just made our first trip to the Great Wall. The skies were blue, it was sunny, and the wind was blowing. We heard the sound of flags. Barry turned to me and said, 'Oh, man, get that on tape!' That was our first flag inspiration. We used our video camera and took all of these shots of the flags waving in the wind as they dotted the Great Wall. Images like that were invaluable."

Above: **Production still.**
Computer-generated imagery (CGI) of the flags by Darlene Hadrika and Mary Ann Pigora.
Right: **Visual development of the Imperial army camp by Marcello Vignalli.**

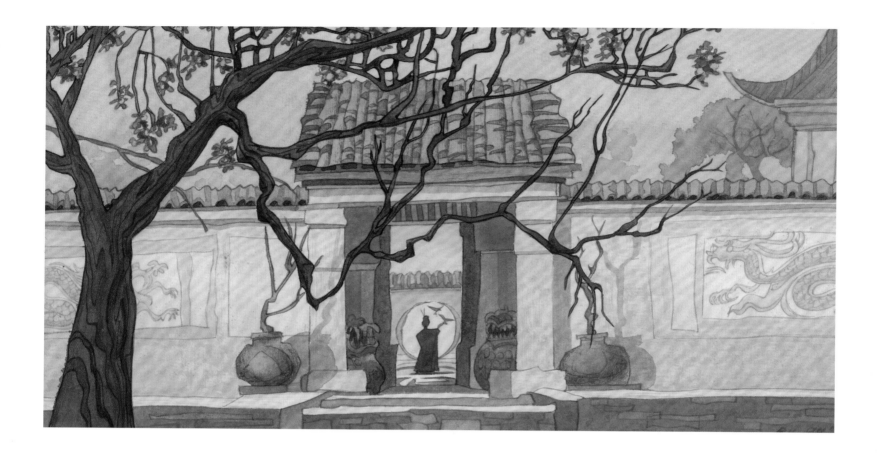

Above: The Datong countryside.

Top: Visual development by

Ric Sluiter.

DATONG

*T*he *Mulan* company boarded an overnight train on June 21. Their destination was Datong, in the Shaanxi province of northeast China, where they would spend one day exploring the picturesque countryside and observing life in the small adjacent villages. They also visited the 1,500-year-old Buddhist grottoes in the Yungang Valley 10 miles west of Datong, before making the eight-hour return trip to Beijing.

Mark Henn recalls being confronted with the essential age of the Chinese civilization. "It was hard to imagine, sometimes. It was really my first time in a culture that was that ancient, that had that kind of depth to its past. Our country is such a baby in comparison to the history and the culture in China. It was fascinating to hear, 'This is a 4,000-year-old temple,' it's hard to process. Americans are used to historical sites that date back a few hundred years, at most."

Images of various grottoes brought back by their colleagues inspired the imaginations of many of the Disney artists.

Near right: The grottoes in the Yungang Valley.

Far right: This particular statue served as the inspiration for the character design of Chien-Po, one of the three soldiers who befriend Mulan in the army.

Below: Visual development by Ric Sluiter.

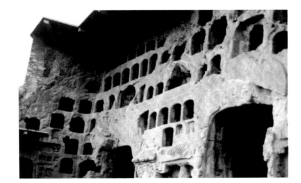

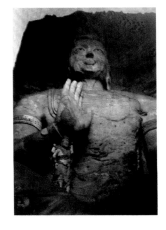

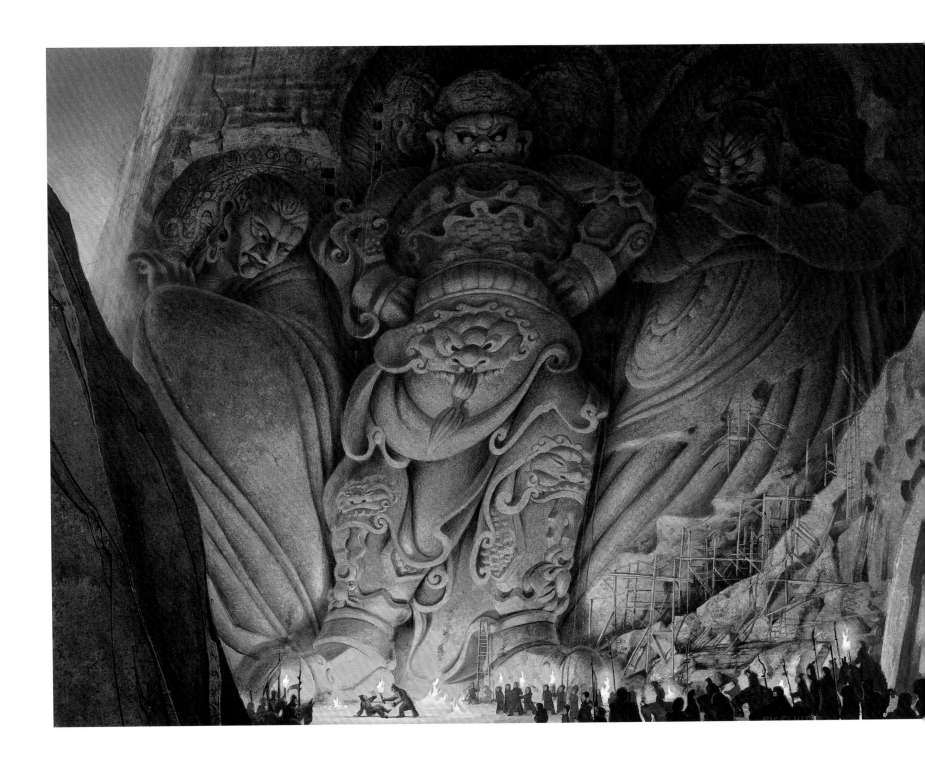

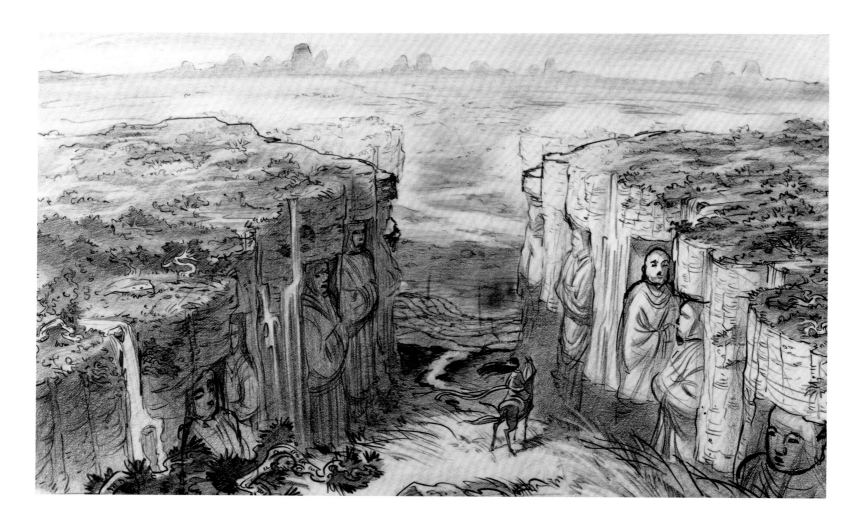

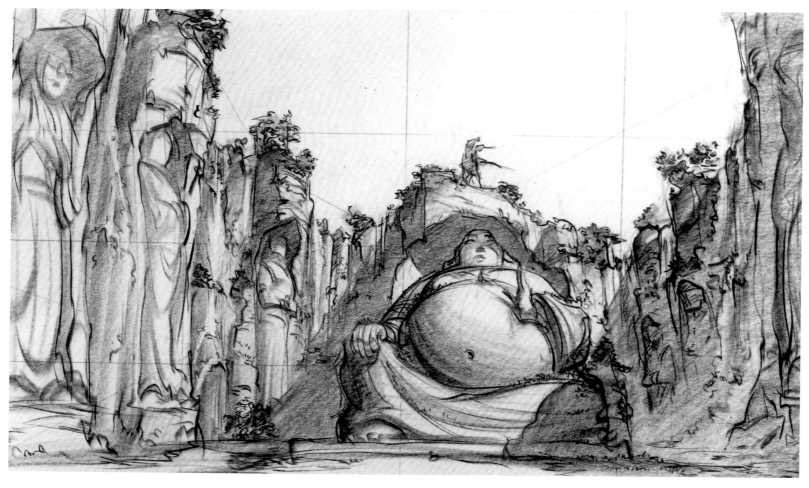

5
4

LUOYANG

*O*n June 24, the *Mulan* team would be transported back to the very beginnings of Chinese culture. A charter flight took them from Beijing to Luoyang, in the Henan province on the eastern side of central China. Situated on the north bank of the Luo River, Luoyang is acknowledged as the heart of ancient China. Split by two rivers that flow into the Luo—the Chan on the east and the Jian on the west—the Luoyang area was populated as far back as the Neolithic Era (6000–5000 B.C.), and was the capital of the Bronze Age Shang dynasty. One of the Zhou kings established a temporary capital at Luoyi, near Luoyang. Settlements in and around Luoyang were important capitals through a period of more than 3,000 years, until A.D. 937.

Eight miles south of Luoyang, high cliffs on either side of the Yi form a pass, once known as "The Gate of the Yi River," which later became known as the "Dragon Gate," after a Sui dynasty emperor who was worshipped as a dragon. The location is now best known as the Longmen Caves. Craftsmen began work on Buddhist grottoes there in A.D. 494, when an emperor of the Northern Wei moved the capital from what is now Datong to Luoyang. At Longmen, there are 1,300 caves, 40 small pagodas, and almost 100,000 Buddha statues, ranging in size from one inch to 57 feet in height. The work within Longmen Caves represents seven dynasties.

"I saw certain images that I thought were beautiful, and could bring meaning to the film if they were used in the right spot," Barry Cook says. "The Longmen Caves had these tall, tall statues by a river, and all these willow trees. Someone mentioned that Mulan may have lived nearby here, or that she may have gone by this way when leaving home. But I could see her, maybe at night, or early in the morning, with rain coming down, going past these willow trees, very apprehensive. These caves were something that inspired me."

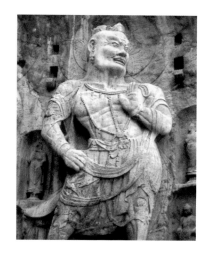

Above: A close-up of a statue at the Longmen Caves near Luoyang.

Top: Color key by Peter Moehrle.

Opposite: Visual development by Marcello Vignalli.

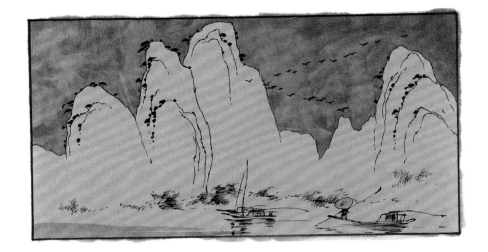

The serenity and simplicity of the Chinese countryside made a lasting impression on the Disney creative team.

Left: Visual development by Hans Bacher.

Below: Visual development by Robh Ruppel.

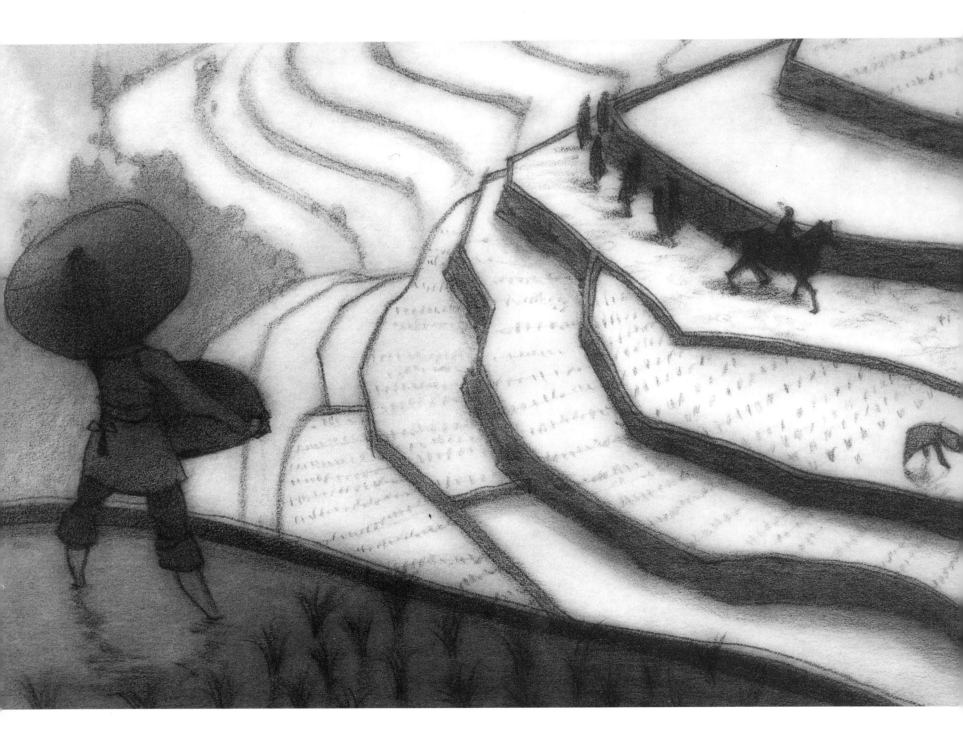

As they changed locales from urban centers to rural villages, the company was also beginning to get an overall feel for the people of China. Mark Henn feels, "There was kind of a down-to-earth quality to their life, the people outside of the big cities in particular. There's just such a frankness to their lifestyles."

Ric Sluiter agrees: "There is a wholesome lifestyle in China. It is pure and simple, and some of it so barren, too. Beijing is different, that's a big city, but when you're in the countryside, there is a peacefulness to it. When you look at the countryside, you just want to relax and absorb the beauty."

Cook remembers the Chinese as "very peaceful, most of them. Very sincere, and very proud of their country. But it was such a wide mix. It's like traveling around the United States and saying, 'How did you find the people?' If I'm in Times Square, or I'm in Tennessee, I find the people to be very different in each place. So, there's no way to classify or to categorize the people of China as one way, except to say that the people I encountered were very hospitable—and very eager to tell us about Mulan."

Henn began to notice characteristics of the people that would eventually make their way into the character of Mulan. "I guess the thing I see in China is that the people have a great sense of humor—there is a 'funness' to them. And certainly, in our version of the story, Mulan began to develop a really good sense of humor. I was also very surprised at the physical diversity in the people. I was looking at their physical aspects, too, because I was thinking, 'I've got to go home and start designing a character.'"

Left: The terraced landscape near Datong.

Overleaf: Visual development of the Fa family temple by Sai Ping Lok.

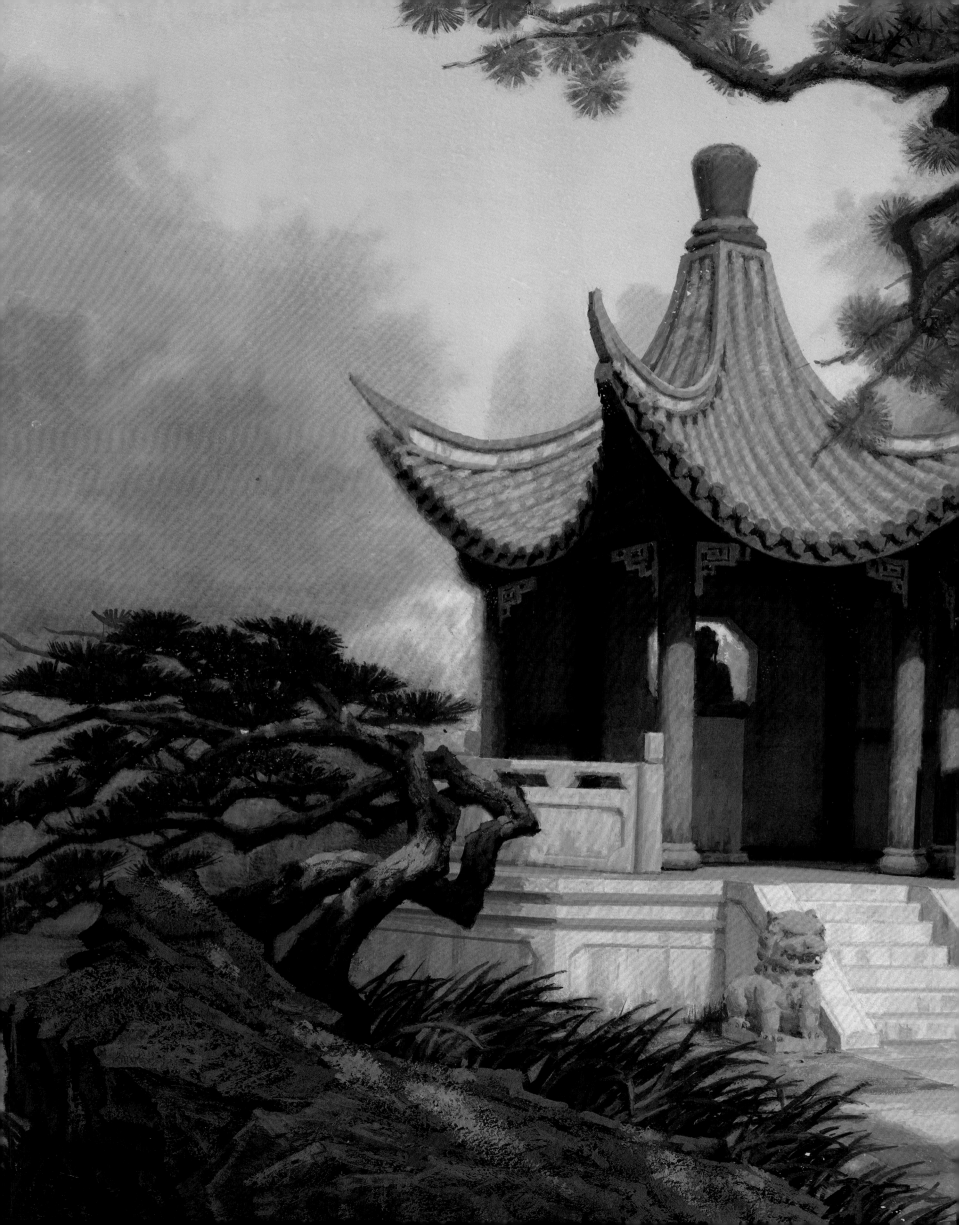

XI'AN

On June 26, the group made a seven-hour train trip to the city of Xi'an in the eastern region of central China.

Located between rivers and mountains in the center of the fertile Guanzhong Plain in the Shaanxi province, Xi'an marked the beginning of the famous "Silk Road" that linked China with central Asia and the Roman Empire. (For more than a thousand years, from the second century B.C., China's silk was transported from Xi'an to central Asia and Europe.) Xi'an served as the first capital of a unified China, and was the capital of 11 dynasties from the 11th century B.C. to the early 10th century A.D. In ancient times, Xi'an was known as Changan, "The City of Everlasting Peace."

Above: Many of the objects seen in the film were directly inspired by authentic cultural relics. Color key by Ric Sluiter.

Top: The Xi'an city wall.

The breadth of historic sites visited by the *Mulan* group while in Xi'an included the Neolithic site at Banpo, a few miles from Xi'an. The Banpo people settled there 6,000 years ago and lived as a primitive clan. Five excavations there since 1954 have uncovered a village of 45 houses, Stone Age pottery, tools, and bones.

At the Shaanxi Provincial Museum (The Forest of Stele), located on the site of the ancestral temple of the Tang dynasty, the team observed ancient architecture, cultural relics, and antiquities.

Left: Tonal layout art by Andy Harkness.

Bottom left: The famed terra-cotta warriors of the Mausoleum of Qin Shi Huang.

Bottom right: Model sheet of miscellaneous characters by Ruben Procopio, whose designs were inspired by the terra-cotta warriors.

Finally, they visited one of China's most famous and important historical sites, the Museum of the Qin and Mausoleum of Qin Shi Huang, the founding emperor of the Qin dynasty. In 1974 and 1976, three massive army vaults were discovered at this site, on the south bank of the Wei River, three miles east of the country town of Lintong. In the largest of these, 6,000 life-size terra-cotta figures of armed warriors and horses were buried. The vivid life-size soldier figures are clad in armor or short gowns belted at the waist, with leggings and tightly lashed boots, and holding real weapons—bows and arrows, swords, and spears. An underground feat of civil engineering, the mausoleum was built in 347 B.C., and more than 700,000 people were employed in its 36-year construction. The inner mausoleum itself has not yet been excavated.

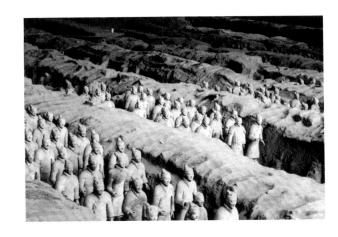

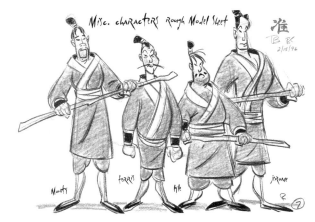

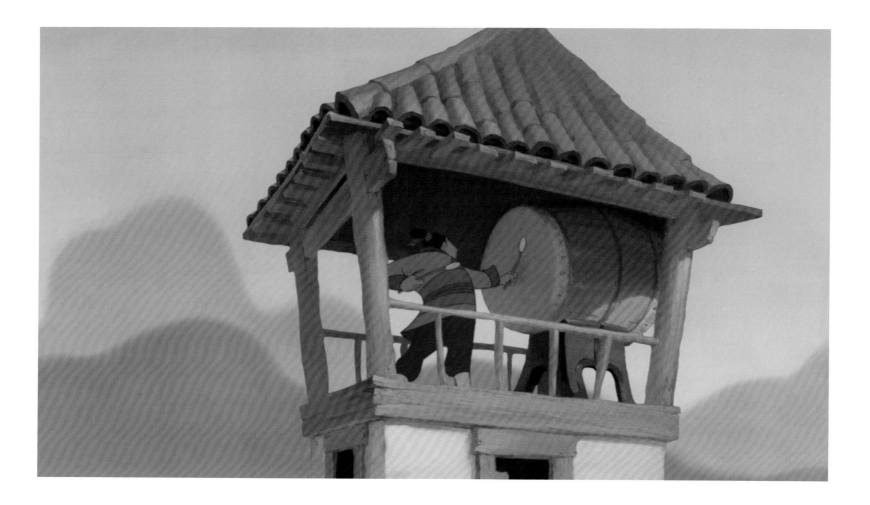

JIAYUGUAN

*O*n June 28, the *Mulan* company arrived in Jiayuguan, in the Gansu province of China's north central region, once a major depot on the Silk Road. The city's Drum Tower, erected in A.D. 343, was once known as the "Night Watchman's Tower," and was situated on the east city gate. As the city expanded, the tower was soon located in the inner city, and its name was changed to "Drum Tower." It is the only remaining structure there of the many described in the writings of Marco Polo.

Pam Coats remembers the tower. "In the film, when the war news comes to Mulan's village, there's a shot of a drum tower, inspired by the tower in Jiayuguan."

The team also visited the last battlement on the western end of the Great Wall, a few miles away from the city in the Jiayuguan Pass. (The Great Wall once terminated at Yumen, 50 miles to the west of Jiayuguan, before the pass was abandoned during the Ming dynasty.) The terrace of the gate tower here offered them views of the wall, meandering for miles along the mountain ridges. To the south, they saw the snowcapped Qilian Mountains, and to the west, the vast Gobi Desert.

Above: Layout art

by Scott Caple.

Top: A herald atop the drum

tower in Mulan's village conveys

the report of the declaration of

war. Production still.

DUNHUANG

*L*ater that day, the group arrived in Dunhuang, in the Gansu region of northern central China—known as Shazhou in its distant days as an important outpost on the Silk Road. The Shazhou prefecture was established in 111 B.C., and served as a pivotal crossroads of culture and trade during the Han and Tang dynasties. In Dunhuang, travelers could proceed along two different westward routes. The northern route, starting from the Yumen Pass, proceeded west via Turpan and Kuqa. The southern route, starting from the Yangguan Pass, stretched westward through the Luobu Lake region. Dunhuang was also the first stopover for eastbound travelers by way of the two passes.

The famous Mogao Grottoes, among the oldest of their kind in China, are located in a valley 16 miles southeast of Dunhuang. First excavated in A.D. 366, additions and repairs made in the 1,000 years from the Northern Wei to the Yuan dynasties resulted in a honeycomb of grottoes containing a range of dynastic artistic styles. There are 54,000 square yards of murals, more than 3,000 painted statues, and five wooden buildings constructed in the Tang and Song dynasties.

Ric Sluiter had looked forward to seeing this site. "The caves were about to be closed, and it was the last time for the public to see them. So, I went into this cave that was begun in A.D. 366, and it had artwork in it from the Northern Wei dynasty, which was around Mulan's time. It was the only authentic artwork of the period that still exists. The colors were really limited, because they were using phosphates from stones and things like that. They used only three colors. I went into these caves, and I had a flashlight in my mouth while I was sketching. I had to look up at the cave and get the light on the wall, since there was no light inside the caves. I was there for three hours doing these sketches. Eventually a guard came in and held the light for me."

Below left: A page from Ric Sluiter's sketchbook inspired by his visit to the Mogao Grottoes.

Below right: Ric Sluiter's sketch of the camel he rode in Dunhuang.

GUILIN

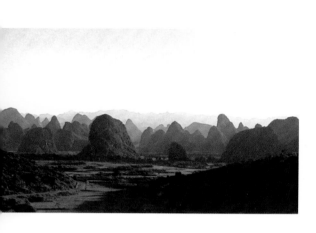

Above: The picturesque scenery surrounding Guilin.

Below: Visual development by Ric Sluiter.

*W*ith their senses overloaded, and their energy flagging, the *Mulan* company began the final leg of their research trip on July first, with a flight from Dunhuang back to Xi'an, then on to Guilin, in the Guanxi Zhuang Autonomous Region of southern China.

Founded in the Qin dynasty in 314 B.C., Guilin is renowned for its beauty, and has inspired painters and poets for centuries. An old Chinese saying goes, "Guilin overshadows all other cities of China for scenery."

Among the noted picturesque locales are Guilin Peak, a hill standing in solitary grandeur in the city's center; the city's symbol, Elephant Trunk Hill (Xiangbishan), named because of its resemblance to an elephant sipping water from the Lijiang River; Piled Festoon Hill, its rock strata exposed like piles of fancy garlands; and Crescent Hill, named for its moon-shaped cave opening.

After two weeks of travel through China, the Disney entourage noted some of its unique, and often kinetic, characteristics. "Rhythm is something that comes to mind," Pam Coats remembers. "There is rhythm in Chinese artwork that mirrors a unique sense of rhythm and movement of the countryside and people. It's hard to describe, but it felt very different from what I am used to. When we were in Xi'an, our tour guide had us out at 6:00 in the morning, riding bikes with the people to give us a 'feel' of the city. I caused more accidents in that half-hour bike ride than they'd probably see in a month, because I couldn't fit into the rhythm. I kept fighting the flow, instead of becoming a part of it."

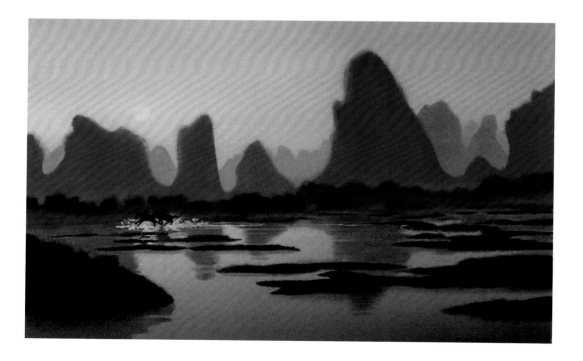

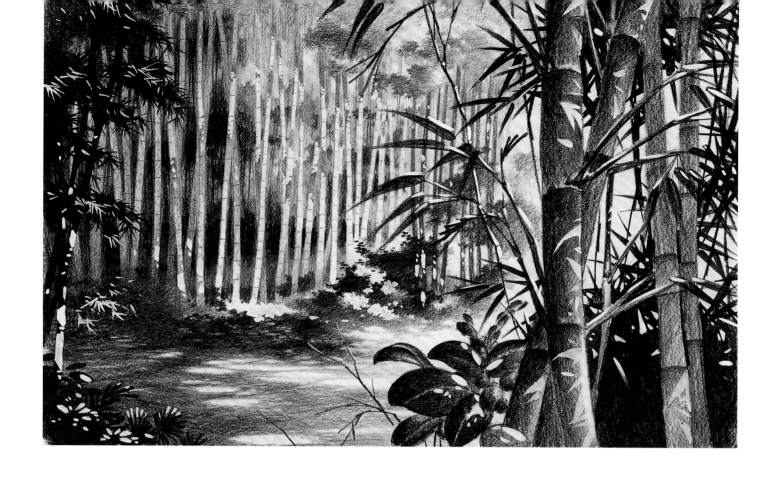

Above: Visual development
by Hans Bacher.

Top: Visual development
by Alex Nino.

From Guilin, the *Mulan* group took a 30-mile boat trip downstream along the Lijiang River to Yangshuo. From their launch, they could see Elephant Trunk Hill; then Baotashan Hill, with its Ming dynasty pagoda on top. East of that, Chuanshan, or "The Hill with the Hole." Nearing the Erlang Gorge, they spotted a huge cliff, known as "Picture Hill," which is said to resemble horses of different colors in different positions.

After passing Picture Hill, the river widened and flowed gently past Yellow Cloth (Huangbu) Beach. Here they saw the seven graceful peaks, sometimes called the Seven Maidens, for their resemblance to seven young girls standing shoulder to shoulder. Further downstream is the fabled ancient town of Xingping, with Caishi Hill looming in front, and thick bamboo groves soaring behind.

This almost otherworldly cruise ended at the colorful market town of Yangshuo. Head of Layout Robert Walker remembers, "There were places there that were so foreign that I thought I was on another planet."

Heading back to Guilin on an overland bus, the weary group rested and gazed out the windows at the passing countryside. "I looked down and saw a pig's head floating in a barrel," Pam Coats says. "That image never went away in my head. Never. It was something completely alien to me, but in context, it was normal, an everyday oddity, you might say. It was a symbol of resourcefulness—in that small village they use every single part of everything. The pig became this odd icon for me, and I really wanted it in the film as a personal tribute to the country that I fell in love with. I keep pressuring (actually begging and pleading) our Head of Layout, Bob Walker, to find a place for it in the film."

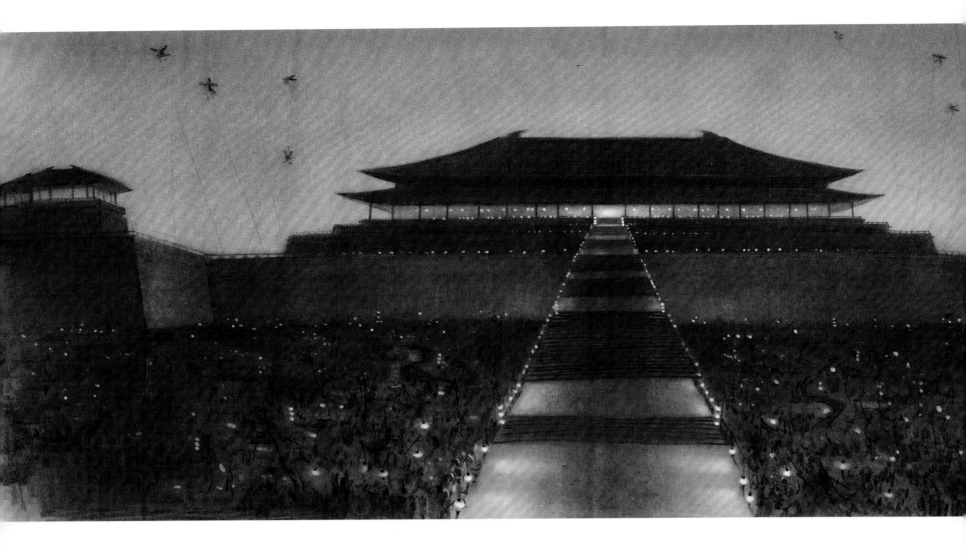

"There's a lot we observed in China that enhanced the visual and story elements of *Mulan*," Pam Coats estimates. "I remember we kept pulling that bus over to take pictures of trees. 'Oh, wait, stop.' And we'd be out there taking pictures of these trees, which are in the film, because of the unique shape and silhouette."

Robert Walker says, "What impressed me the most were the varied landscapes. It just looked completely different from anything I've seen in North America. The different types of shapes and mountains. Obviously, the different types of architecture in the Forbidden City. It was a real bonus going over there because you get to see these things. We can see them in photographs, but they're only two-dimensional. When you see them three-dimensionally, you understand how they work and it helps you construct them better."

Ric Sluiter was influenced by the many intricate details in the architecture, decor, and ornamentation. "I was riding through the cities around

Left: Visual development of the

Imperial Palace by Robh Ruppel.

Below: Visual development of

the Great Wall by Ian Gooding.

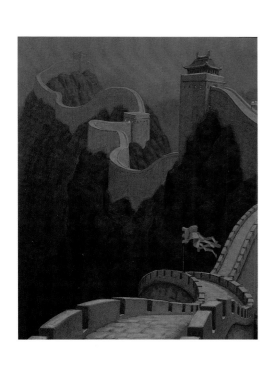

Luoyang, and saw all these small fences designed after foliage, flowers, and leaves. I would be on the bus, and the bus would be bouncing, while I was sketching these railings. There were beautiful little ornate, kind of flowery fence designs which we actually applied to hair designs—it's in the hairdos. You will see these little details they did, that were all based on nature and came from flowers. Every color and shape has meaning. Everything has meaning."

Mark Henn recalls struggling between the desire to be authentic—especially given the significance of all that the group had just experienced—and the desire to accomplish the task at hand. "We knew that as much as we enjoyed the China trip, and the culture, and everything that we saw, we were coming back to make an essentially Western movie. We weren't making a documentary. But I felt very strongly about trying to be as authentic as we could."

Henn naturally focused his attention during the trip on issues of character. The trip, Henn believes, helped to solidify the film's foundational issues of family and honor. "I think we all learned how important honor, the family unit, and the reverence involved with people knowing their place in that structure is. This made Mulan's story so unique, because she is willing to break with that honor, *because* of that honor. It got me to think about how Mulan must *feel.* I tried to understand why she would risk everything—not only to defend her family honor, but why she would be willing to sacrifice herself in order to protect her country. I just tried to immerse myself as much as I could in that kind of thinking."

Overall, the trip to China ended with serendipitous discoveries and a completely unexpected and powerful influence over the final film. "It was very strange in some ways, because we didn't have much story together, at that point," Barry Cook recalls of the beginning of the trip. "We were just trying to go discover something that would help us. We had a few things in mind. And those few things that we had in mind, we ended up never putting in the film, or not for very long."

An important result of the journey through China was the bond that was created between the members of the creative group. Pam Coats relates, "We came back with a really strong desire as a team to translate what we had experienced into the visual design and story."

Back at home, they found that they had a new frame of reference, a new vernacular, which would inform and impact their future work on the film. "It gives people a shared experience," Thomas Schumacher relates, "so that when they begin to forget about what they're working on and why they're working on it, they can recall those experiences."

Ric Sluiter explains, "When we were sitting in meetings, we could always relate back to what it looked like in China. In meetings it comes up all the time. 'You remember that temple? The fog in the early morning, and the ambiance, and the *feeling* we had?' A lot of the atmosphere in the film came from the actual experience of *being* there."

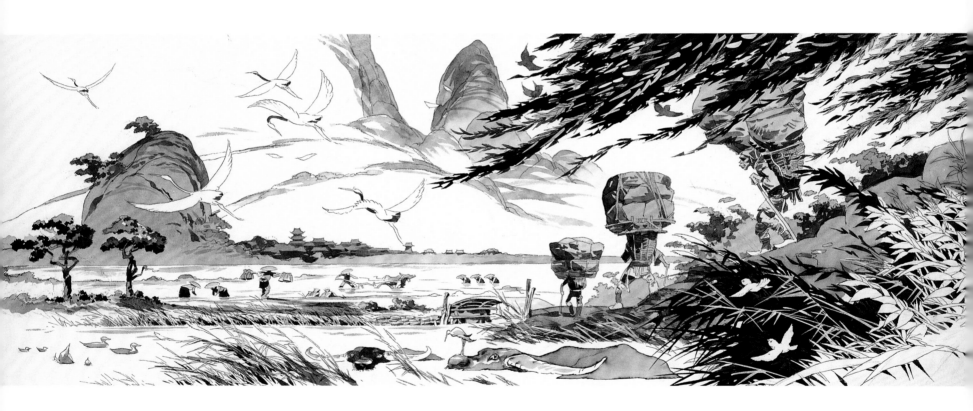

Visual development by Alex Nino.

"Every time I'm asked whether we should go anyplace, I question the value," Peter Schneider says. "Is it really valuable to go to China? Do we have to go to Africa? Do we have to go to Australia? Do we have to go to Greece? Is it important to do these things for the movies? Fundamentally it is a bonding step, which brings the production team together. Secondarily, it is an opportunity to redefine people's perception of the *place*, because we have an impression of what China *might* be, but until you go there, you have no sense of what it is. If one gets only two things out of it, in terms of influence in the movie, it's worthwhile."

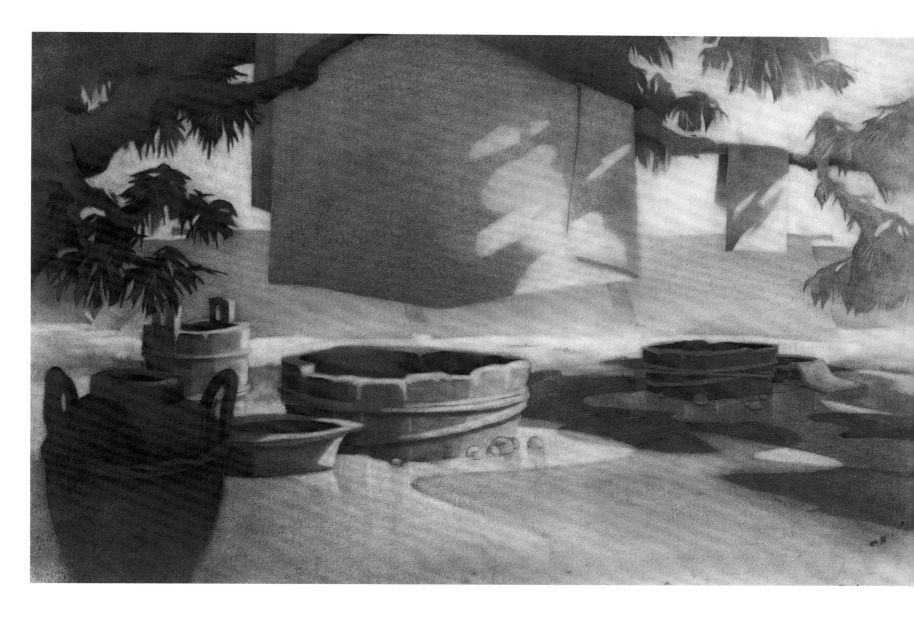

Above: Tonal layout art by

Peter DeLuca.

Below: Visual development

by Ric Sluiter.

*O*n the evening of July 2, the weary but satisfied *Mulan* team boarded a DragonAir flight in Guilin bound for Hong Kong. They would spend two days there before returning to Los Angeles.

They would only return home briefly, for the end of one journey was really just the beginning of another.

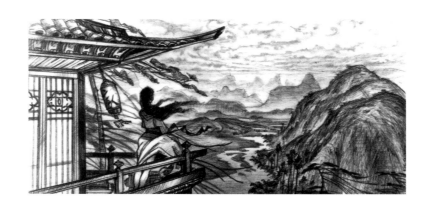

PART 3

THE JOURNEY

OF PRODUCTION

"If I have even just a little sense,
I will walk on the main road and
my only fear will be of straying from it.
Keeping to the main road is easy,
but people love to be sidetracked."

–LAOZI (LAO-TZU)

Daode Jing Ching (The Way and Its Power)

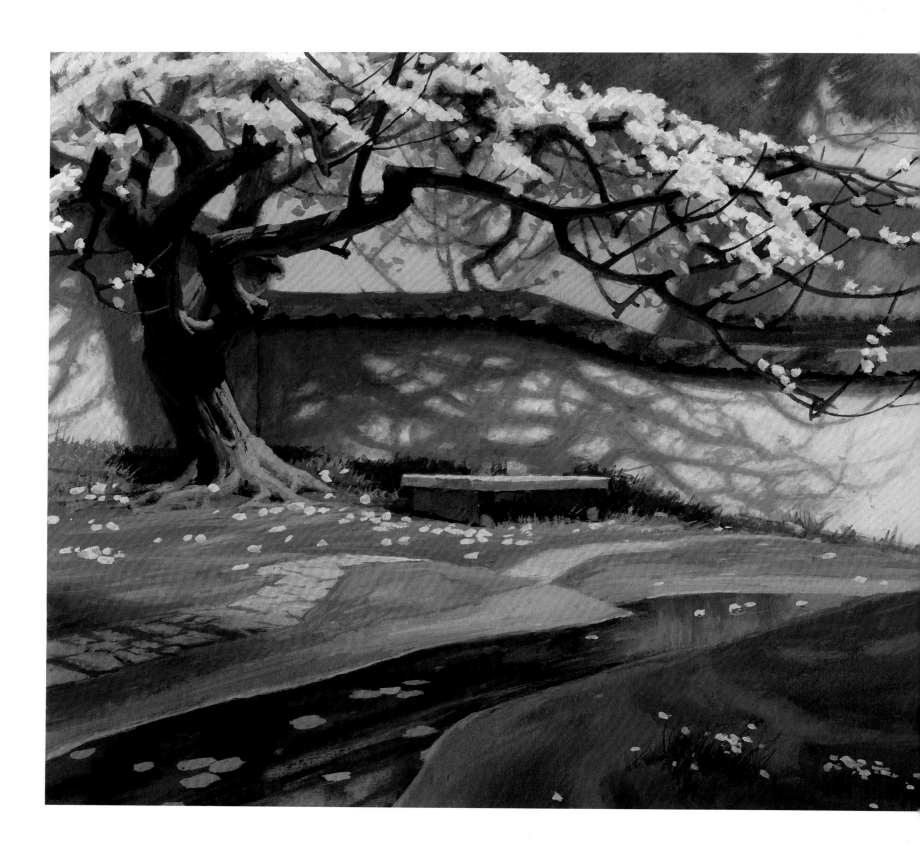

Preceding pages: Visual

development by Hans Bacher.

Above: Visual development

by Sai Ping Lok.

Right: Production still.

Background art

by Barbara Massey.

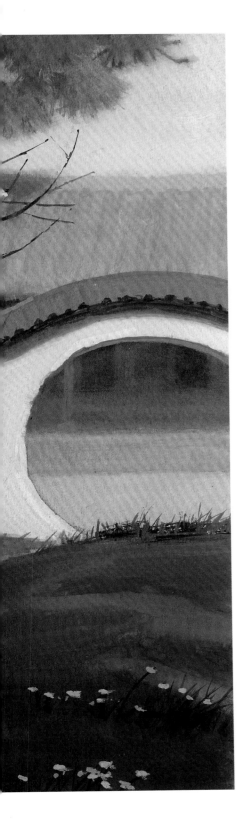

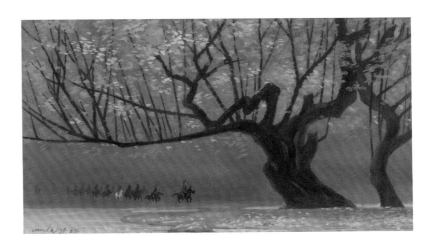

Visual development

by David Wang.

The journey through China had unified the *Mulan* creative team. It had aligned their overall philosophy, it had strengthened their vision of the story, and established their desire to communicate a combination of visual sweep and sophistication with an inherent sense, prominent in Asian art, of overall spareness and simplicity.

"When you look at Chinese art, there are a lot of different styles within that world," Mark Henn explains. "I particularly appreciate the line drawing. There's a simplicity to it. The design elements are tremendous, and I find it very appealing. There are a lot of animated qualities to Chinese art. I always thought that it would be such a natural for us to do in animation. I think there's a richness to that artwork that translates very well."

Alex Kupershmidt, who was assigned to *Mulan* as a supervising animator, immediately noticed the kinship between the basic styles of animation and the film's Chinese art influences. "Actually, I found a lot of common things between the Chinese art, the art that was studied for this film, and the basic principles of Disney animation—clear silhouette poses, strong action lines, negative space, simplification, and a clear line that describes both shape and form. So, to me, it was like coming full circle, looking at principles that established certain basic ideas in our work. I found it utterly familiar."

To achieve a harmonious visual look for the film, Hans Bacher and Ric Sluiter, along with Robert Walker and Head of Backgrounds Robert Stanton, collaborated in finding the proper chronological location for Mulan in Chinese history. Since there is no consensus on the time of Mulan's existence (or whether she actually existed at all), their decision could be solely based on the design elements they desired.

"When we first looked at Chinese art," Sluiter explains, "we went to artwork that we were more familiar with, from the Ming and Ch'ing dynasties, which is really detailed, ornamental, and façade-ish—really overdone. Then we studied the other side, the more simple, poetic side of Chinese art. We were searching for vigor and simplicity of design, breadth and power of form, rather than delicacy of ornamentation."

This Visual development by Hans Bacher exemplifies the kind of poetic influence from traditional Chinese art that the artists sought for *Mulan*.

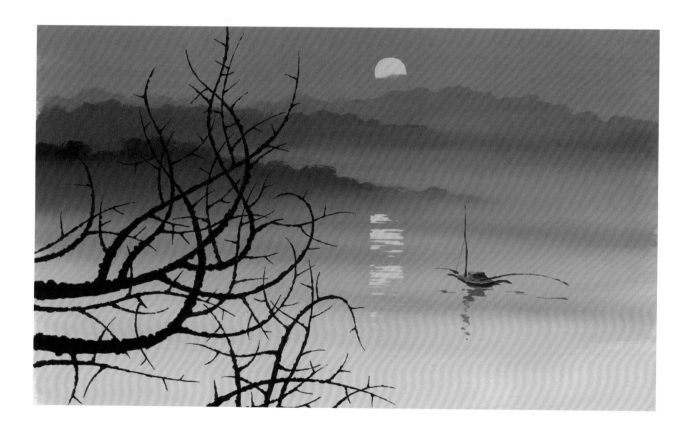

Chen-Yi Chang explains, "Because it's a warring period, like medieval times in Europe, there's a lot of chaos. So I actually used influences from two dynasties, the Han and the Tang, and let them both meet in our film's time period. The art from the Han dynasty is more primitive, and we liked that direct approach a lot. The Tang dynasty provided us with a more flowery feel—a lot of curvy motifs. Also, a lot of sculptures, figurines, and paintings are available for reference from the Tang dynasty, so their recurring design elements became the main resource for the style that was developed for *Mulan*."

While various stylized interpretations were generated for *Mulan's* overall visual look, the production team remained dedicated to preserving the details of Chinese architecture and design.

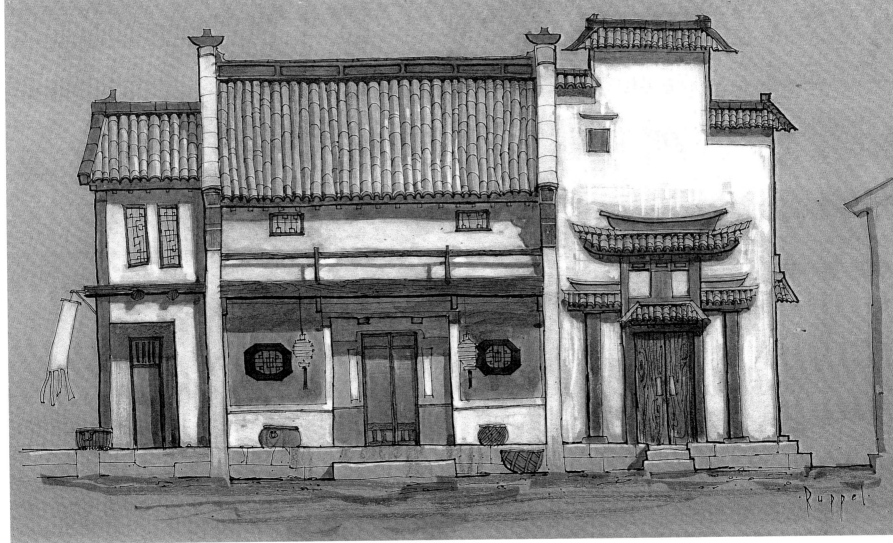

By combining the styles of different historic periods, the *Mulan* designers were able to create a visual reality for the story that combined fantasy with authenticity, a world real enough to be tangible, but with understated anachronism (so understated that it would be apparent only to a scholar) that helps to define it as a unique world belonging *only* to *Mulan*.

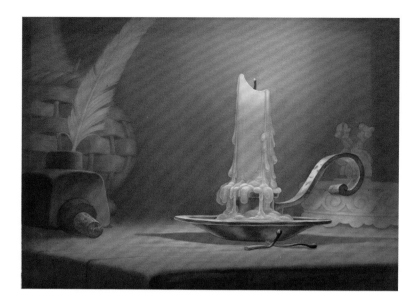

Left: Background art from *Pinocchio* (1940) by Claude Coats.

Below: Visual development for *Sleeping Beauty* (1959) by Eyvind Earle.

Although the artists of *Mulan* were scrupulous in avoiding the conventional, they were not without the influence of certain legendary talents of past Disney animation. Claude Coats was a 54-year Disney staffer, and contributed to the styling and backgrounds of most of the Disney features from *Snow White and the Seven Dwarfs* (1937) and *Fantasia* (1940) to *Cinderella* (1950) and *Peter Pan* (1953). Robert Stanton states, "The work of Claude Coats has been influential. He worked on so many of the films, and carried a beautiful sense of grace—and I think that's what we were trying to get back to."

Eyvind Earle worked briefly at Disney, notably as production designer of the landmark feature *Sleeping Beauty* (1959). "Eyvind Earle influenced us in a graphic sense—his understanding of how to put something down as a silhouette and just *leave* it," Stanton says.

Ric Sluiter agrees. "We were looking at these old films, and these artists, myself included, are used to working on films where we are putting a lot of illustration technique into the background painting. It's real challenging to get a team of artists to really study the old guys and appreciate how they understood filmmaking, and try to re-create that."

"I feel like with *Mulan* we're starting to get back to the greys of nature," Stanton says. "If you can use the greys of nature you can get anything across. And I think that's what we're getting ourselves back to, learning how to use subtle colors and get an idea across. If you hold back, you have a lot more room to go either way, you can have a lot more control."

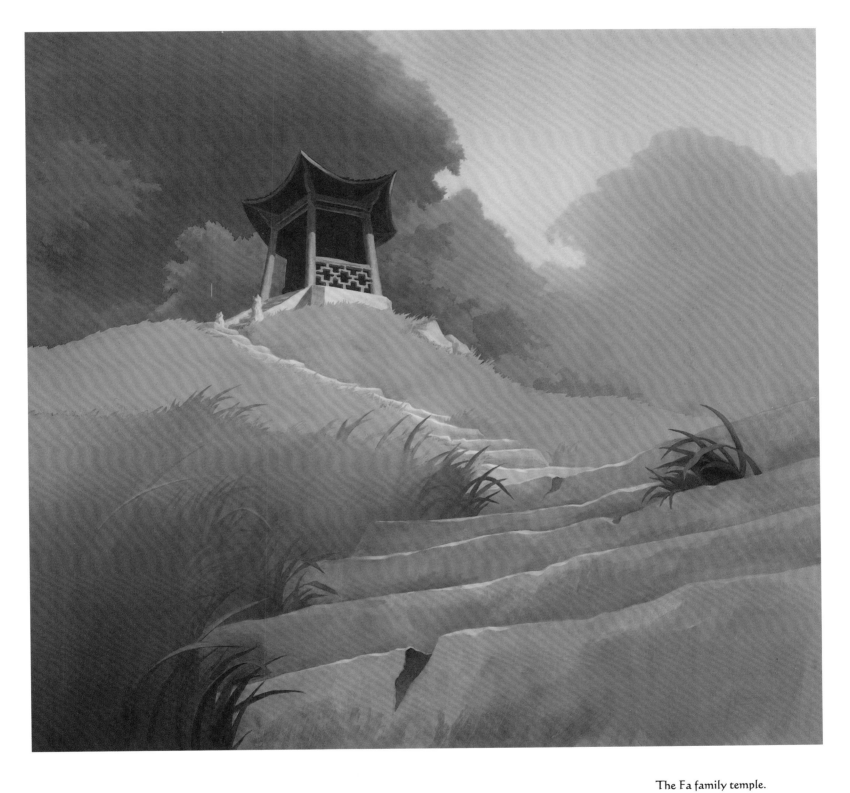

The Fa family temple.

Background art by Xin-Lin Fan.

Layout by Kevin Proctor.

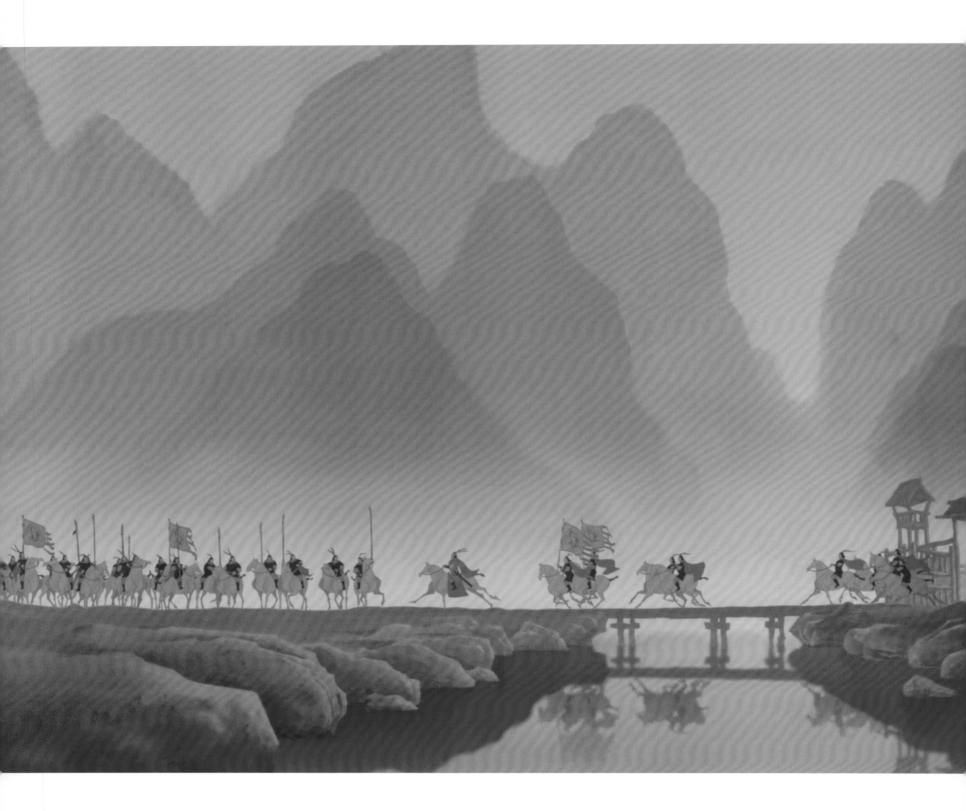

Above: General Li and his troops
leave camp against a mountainous
backdrop modeled on the unique
landscape of Guilin. Production still.
Background art by Charles Vollmer.
Layout by Arden Chan, cleanup
layout by Kenneth Spirduso.

No matter how often they cite the research, the influences, the stylistic precedents, the *Mulan* artists inevitably come back to the same primary force at work in their art. "Because of the emotional content, I feel these characters have a resonance people will connect with," Stanton states. "And I feel that based on seeing them animated without any color. If the crew can get the story that locked down and refined, and the animators maintain the subtly in the drawings on the page, then for me, 90% of the job's been done—now all I have to do is support what they've created."

Tony Bancroft was equally excited about the film's potential potency, an enthusiasm that grew when Hans Bacher began the production design. "It excited me immediately. I knew that the styling for this picture, the visual feel of the film, would be new and fresh, because Hans doesn't do anything half-way, or anything that wouldn't be considered original. He's a unique

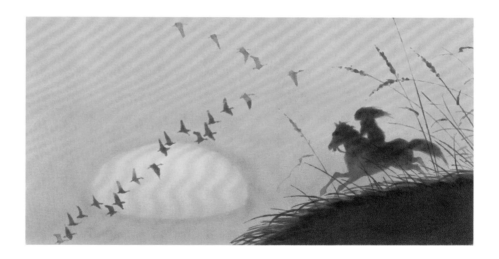

Above right: **Visual development by Hans Bacher.**

personality and his insight to visual concepts is exceptional. I knew that the styles would really meld between what you see in Chinese artwork, and what I saw in his graphic style. I thought if we could just find a combination of those two things, then we would have something truly unique. It really is kind of a yin and yang balance—his style and historical Chinese art."

There was also an epic, mythic approach to the design, Bacher felt. "I think there is something mystical about 'China.' Like, what I think was probably one success of *The Lion King*—'Africa.' You know, everybody kind of likes the *idea* of Africa, it's far away, and there are so many legends, and I think that was the same with China and *Mulan*. I just thought what sweeping landscapes we could do, the vistas, you know—'David Lean' shots—and all the different colors, characters, and costumes."

A key to Bacher's design is the seemingly incongruous combination of sophistication and simplicity—a style that is thoroughly and elaborately refined, but with a resulting overall visual simplicity. Bacher explains, "I noticed over the last years in animation in general that designers have tended to encumber the picture with too much information. They try to make too much of every single scene; they pack so much detail in that sometimes you can't really find the characters."

Part of Bacher's approach to *Mulan* was to look back to classics of Disney animation. "I thought, why don't we go back to *Bambi* or *Pinocchio* or *Dumbo*, and see how they did it? I studied these films, and I found that in composing a scene, they created a 'stage' for the characters, so there was always an empty spot in some area of the background where there was no detail. It acts like a spotlight. In looking at the old backgrounds alone, it was as if there was something missing. And of course there is something missing: the character."

Bacher thought, "'Why don't we do that again, and combine it with what we've discovered about Chinese art?' When I looked at some of the original Chinese artwork—I bought books and tried to get all the information I could find—I got more and more involved in it. They concentrate on the most important information, and then they work detail in, and leave everything else *out*. It's very balanced, with detail/no detail, empty spaces/filled spaces."

Right: **Production still from** *Bambi* **(1942).**

Opposite above: **Background art by Sunny Apinchapong. Layout by Craig Grasso, cleanup layout by Andy Harkness.**

Opposite below: **Khan and Mulan. Production still.**

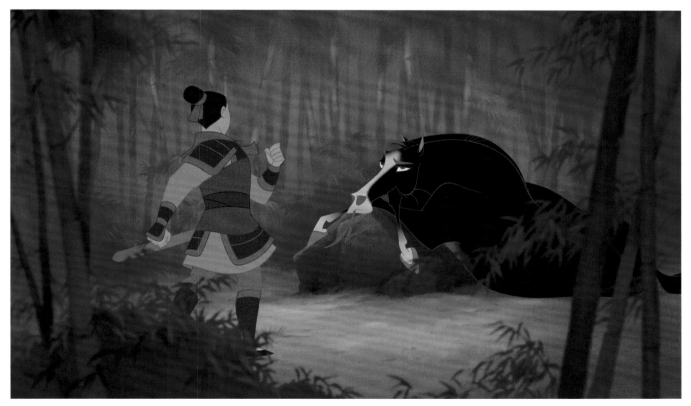

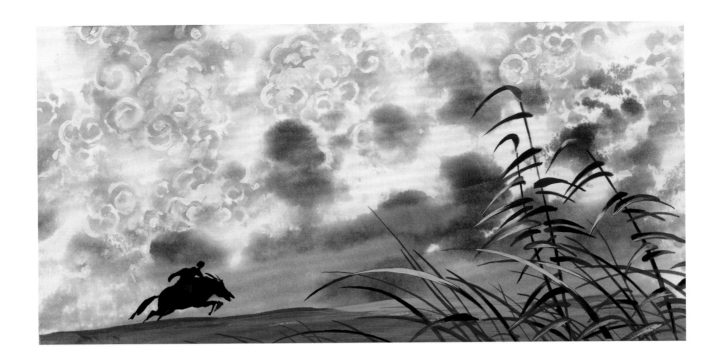

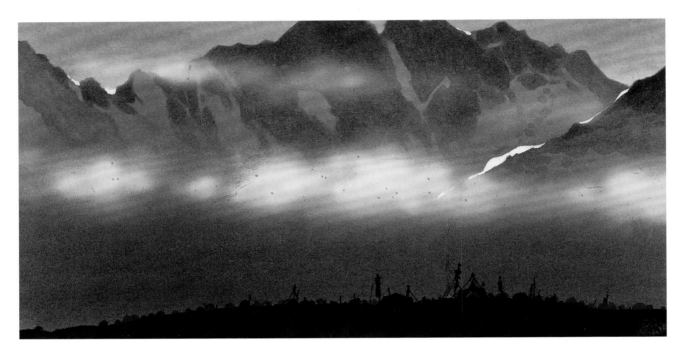

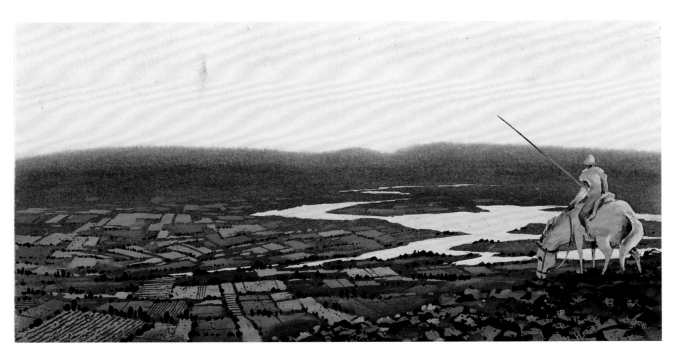

*T*he passion of the stylist and the integrity of the style immediately impressed the makers of *Mulan*. "It's bold and it's confident—and that is what Hans Bacher is," Tony Bancroft asserts.

Barry Cook agrees. "Hans has a perfectionist mentality. For Hans, it's always a desire to get it *right*—and why shouldn't it be right? Why does the composition have to be wrong, when it can be right? And there are *right* ways to do composition. There are certain rules that apply, and he knows the rules, and adheres to them."

Pam Coats recalls, "Barry Cook had a vision in his head, but he couldn't articulate it, nor could he draw it. He could just *feel* it. And when Hans started to produce the work, then it became clear that that was the vision that was in Barry's head."

One might imagine that this zealotry for design would alienate or anger the established and experienced artists who call Disney home, but Bacher's passion created the opposite reaction. The production designer's enthusiasm about the visual world of *Mulan*, and his ability to support his convictions, galvanized all of the *Mulan* artists.

Bancroft elaborates, "We might have had people saying, 'I can't do this. I'm going to paint the way I know how to paint. I've been painting this way for 10, 15 years.' But we didn't. We've had Hans come in and give classes and lectures with these guys, and they *got* it—and it shows on the screen."

Right: **Hans Bacher's ideas about production design were a critical guide when it came time for the Layout Department to actually stage and compose each scene. Tonal layout art by Arden Chan.**

Opposite: **Visual development by Hans Bacher.**

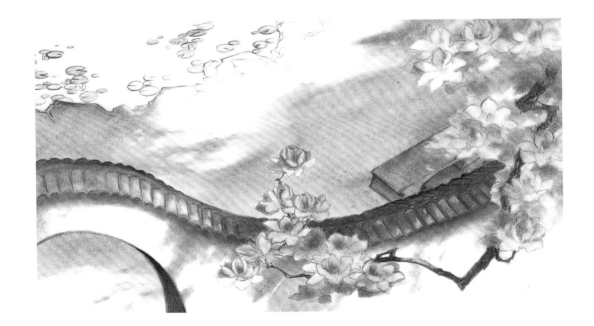

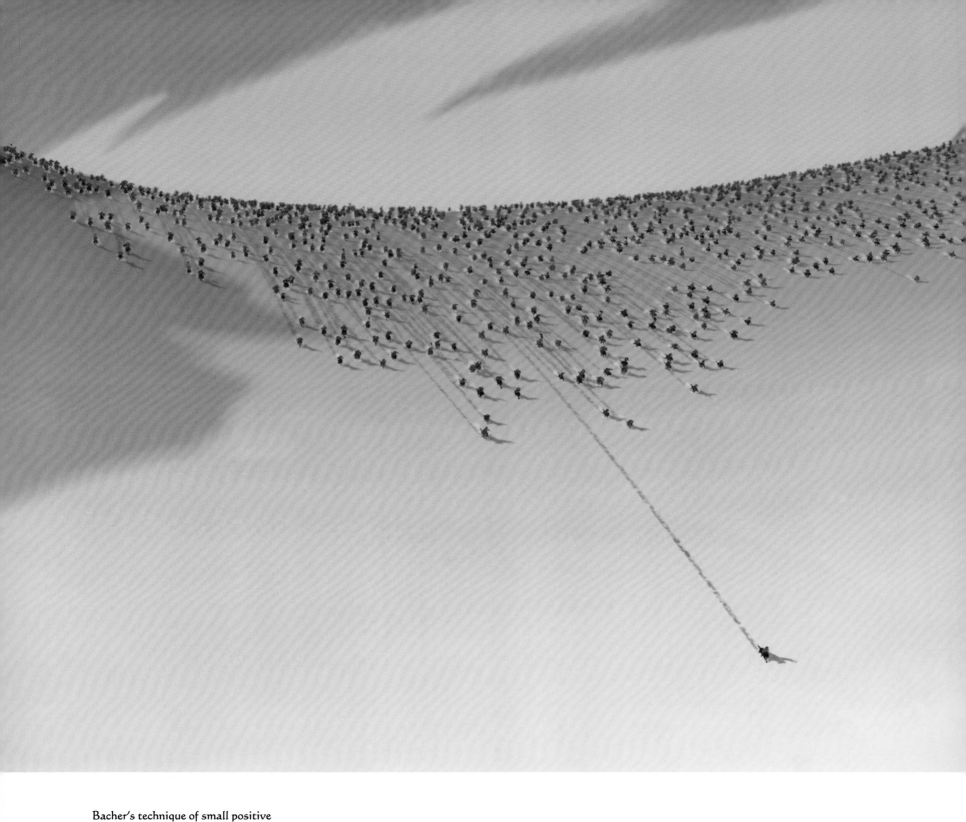

Bacher's technique of small positive detail contrasting with large negative shape is well illustrated in this scene from the Hun attack sequence. The sequence was ultimately made possible by the use of computer-generated imagery (CGI) to animate each of the many independent figures. CGI by Chadd Ferron, Tony Plett, and Heather Pritchett. Production still.

It also helped that many of the artists were fresh to the medium, and excited to be at work on their first Disney feature. Bancroft explains, "They were hungry to improve themselves and grow as artists."

Art Director Ric Sluiter notes that "Hans' graphic sensibilities set the stage for the simplified approach we would take with this film. It was a real struggle for most of the artists to come around to the strong graphic look Hans was pushing to establish. He should get a lot of credit for leading the design of the film in that direction."

Robert Stanton remembers there being some apprehension. "Hans showed us these sketches and all of us said, 'Oh, my God, this is way too

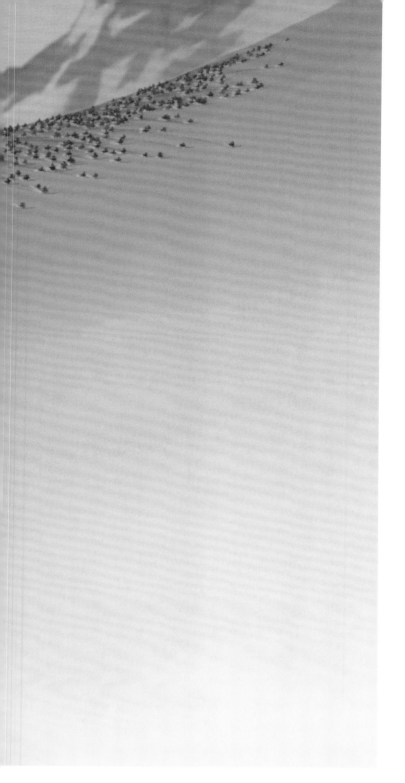

Right: Bacher's directions for the styling of the Hun attack sequence were very specific. Shadow reference art by Hans Bacher.

Below: Production still. CGI by Patricia Hannaway and Marty Altman.

simple,' because we had all been nurtured into this illustrative, tight style of painting. We were getting more realistic yet losing the *life* in the work.

"But within our vision was to *find* the life and lose extraneous details that just got in the way. So it became more basic, 'Keep It Simple, Stupid,'— the old K.I.S.S. technique. That's what Hans brought in. And he also brought in the idea of simple shapes. Small positive detail and the big negative shape. Just having a big shape with simplicity, but having a small positive detail."

This design consensus was the beginning of a heady feeling of collaboration and an overriding sense of balance that would pervade the making of *Mulan*.

For the benefit of his colleagues, Production Designer Hans Bacher created a style guide which summarized his approach to the design of *Mulan* and included everything from an explanation of yin and yang to directions on staging, composition, and lighting. He also included a list of more than 35 film directors whose work he recommended studying—films ranging from silent era German Expressionism, to British and Hollywood epics of the 1950s and '60s, to the Italian-made "Spaghetti Westerns" of the 1960s and '70s.

COMPOSITION

Composition is the harmonious combination of forms and space.

Try to create the right selection of *order, rhythm,* and *intelligent balance* in your first approach to the composition.

An important consideration is the right balance between *space*—the *negative area* that is all around your objects and defines their shape—and the *objects,* or the *positive form.*

The design of the layout should lead the eye to the area where the action takes place—to the *stage.* Never overload the picture with too much unnecessary detail where you will become trapped and won't be able to follow the character action.

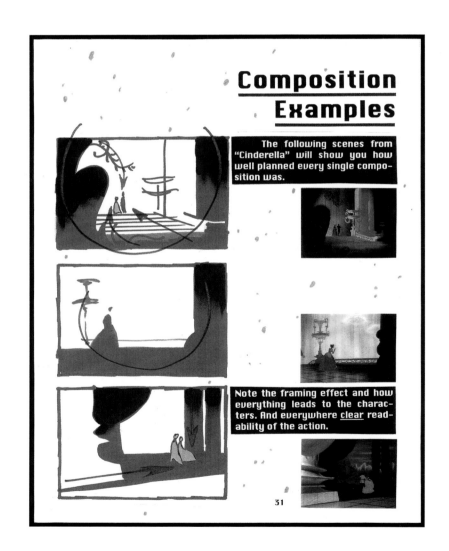

Composition Examples

The following scenes from "Cinderella" will show you how well planned every single composition was.

Note the framing effect and how everything leads to the characters. And everywhere clear readability of the action.

31

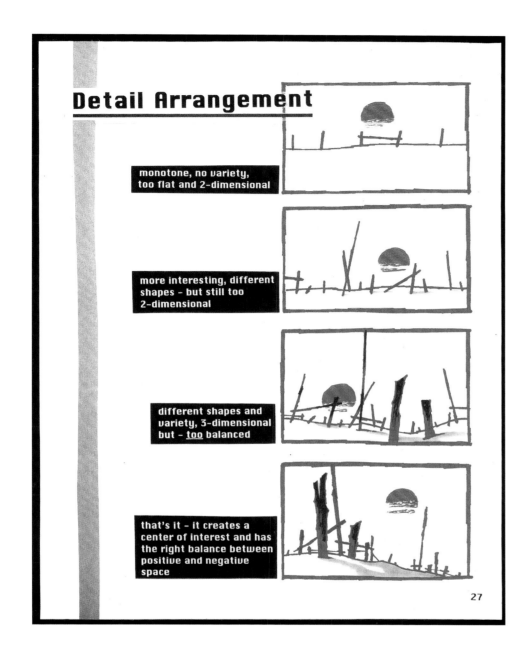

Detail Arrangement

monotone, no variety, too flat and 2-dimensional

more interesting, different shapes – but still too 2-dimensional

different shapes and variety, 3-dimensional but – __too__ balanced

that's it – it creates a center of interest and has the right balance between positive and negative space

27

LAYOUT

Always create a stage for the animation.

The best way is to plan the key poses first and then build your background around them. Working that way you keep the character acting area free from too many disturbing background details.

Of course, elements like perspective and the camera angle should be planned first in thumbnails, as well as the contrast—dark in front of light and light in front of dark.

These pages: **Pages** from

Hans Bacher's Style Guide

and excerpts from his notes

on composition and layout.

Rhythm of Composition

Usually you have to decide in your composition how you fill your picture depending on the story and the action you have to stage, to design it symmetric or not, keep the camera low or high, use shadows in a certain direction and choose the right camera lens for a wide or closer shot. It all depends on what kind of emotion you have to create following the story and if your scene works in connection with the preceeding and following shots.

33

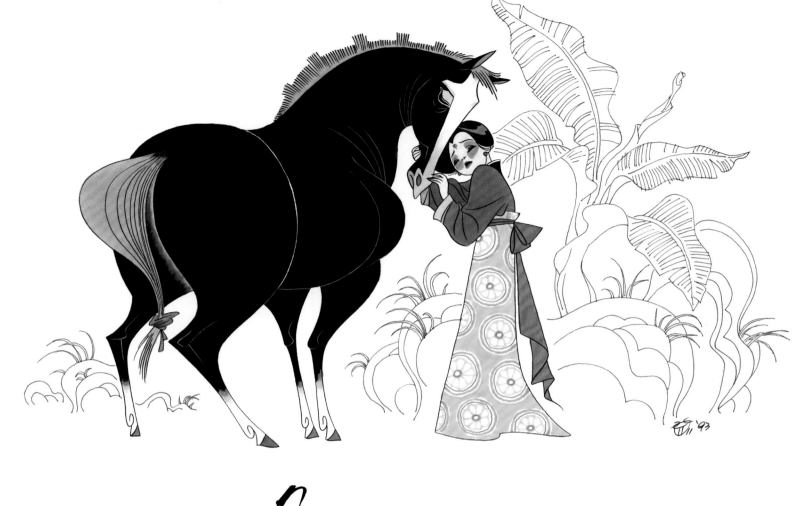

These pages: Visual development by Chen-Yi Chang. Mulan with Khan (above) and in front of an ancestral *bei* (opposite).

Obviously, creating cohesive, integrated and well-designed settings begs the question, "But what of the actors?" Bacher's design philosophy was specific in its intent to create 'space' for the actors, to establish settings that enhanced the characters, rather than detracted from them. Chen-Yi Chang provided the character design philosophy that created a cohesion between settings and characters that would establish a fully integrated and fully realized visual world for *Mulan.*

Supervising Animator Aaron Blaise recalls the impact of Chang's design concept. "He's one of the best artists on this picture. He's just amazing. All of us drew and drew and drew and drew, and by this time we had our own individual characters, and we kind of had the personalities, and we all did tons of designs of them—but none of the designs matched as one. There wasn't a harmonious design theme through them. Then Chen-Yi came in and just unified everything. It was just that simple, getting Chen-Yi and saying 'Take care of it,' and he did. Then we kind of learned how to draw like Chen-Yi. The entire staff."

"He just blew me away," Barry Cook states. "Chen-Yi's artwork is very moving emotionally when you look at it. It could be a simple design drawing, or a funny character drawing. But his stuff has so much depth of *feeling* in it. So, right away, we knew we had to get this guy on the show—whatever he was going to do. I think that when he came in, suddenly we *knew* that the

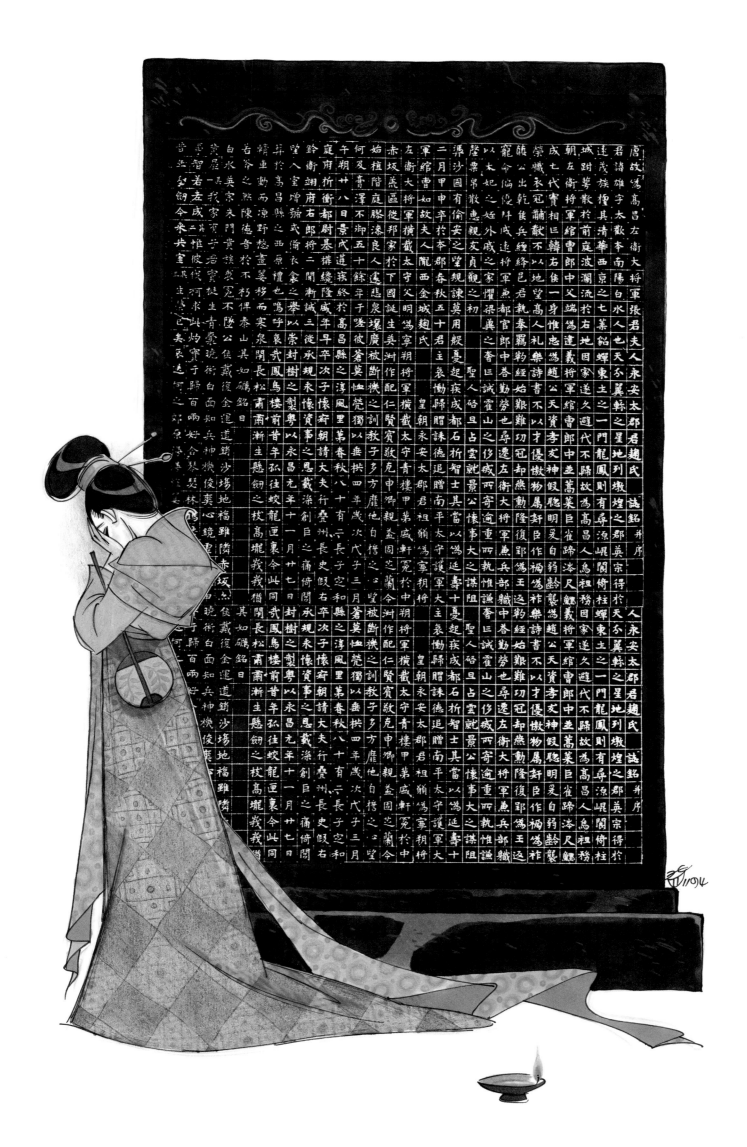

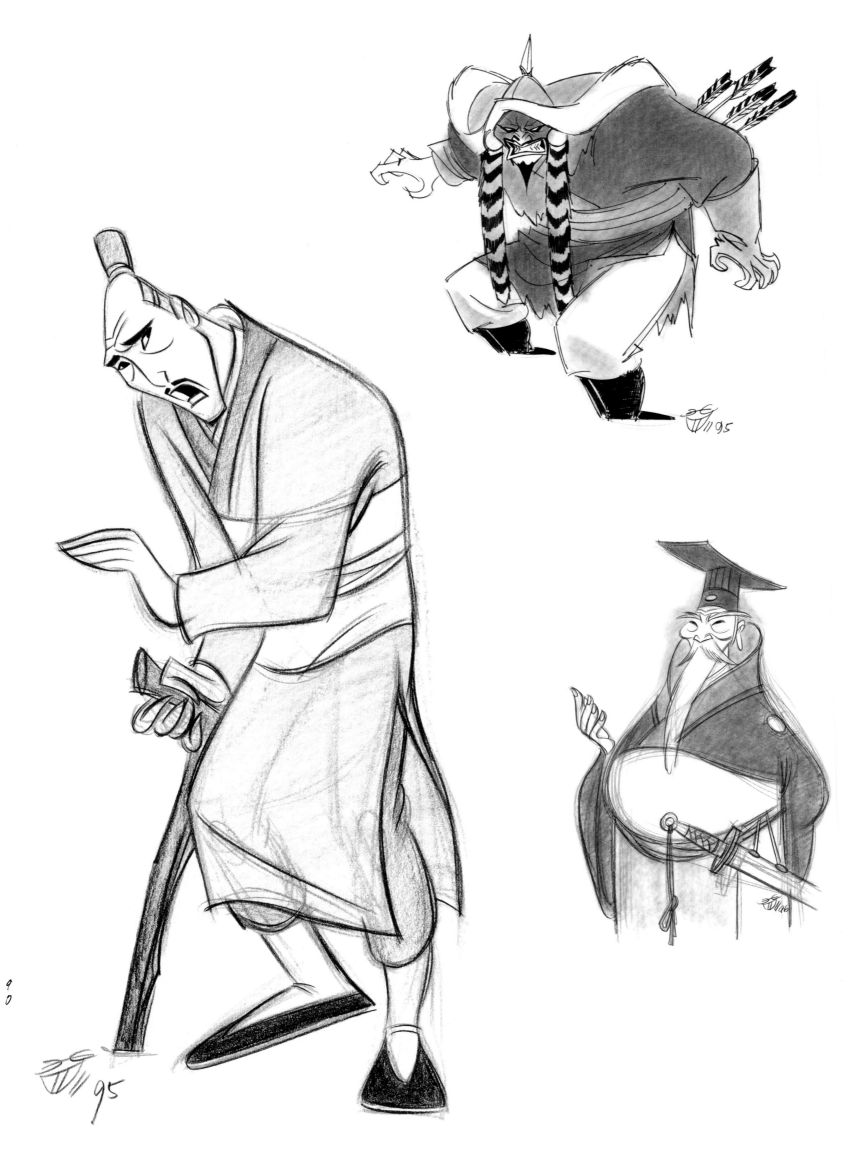

character design was not going to be a problem. Hans' early development art on *Mulan* was so simple, so pure. Chen-Yi's work is the same way. So, we've all found a way to work together to produce the best results."

Chang was working at another studio when the offer to work on *Mulan* came. "I was thinking, 'Gosh, I've got to join this project, because if I don't do it, I'll be missing the chance of a lifetime. I know Disney is not going to make another Chinese story, so it felt like my destiny, I've got to do it, I've got to participate in it.'

"I didn't know how much a role I would play in the show, I just wanted to participate in the production, so I feel really grateful. I really appreciate the directors and the producer giving me the opportunity. Otherwise I wouldn't have done what I think is my best work so far."

These pages (from left to right):

Visual development of Fa Zhou,

Shan-Yu, the Emperor, Shang,

and Mulan by Chen-Yi Chang.

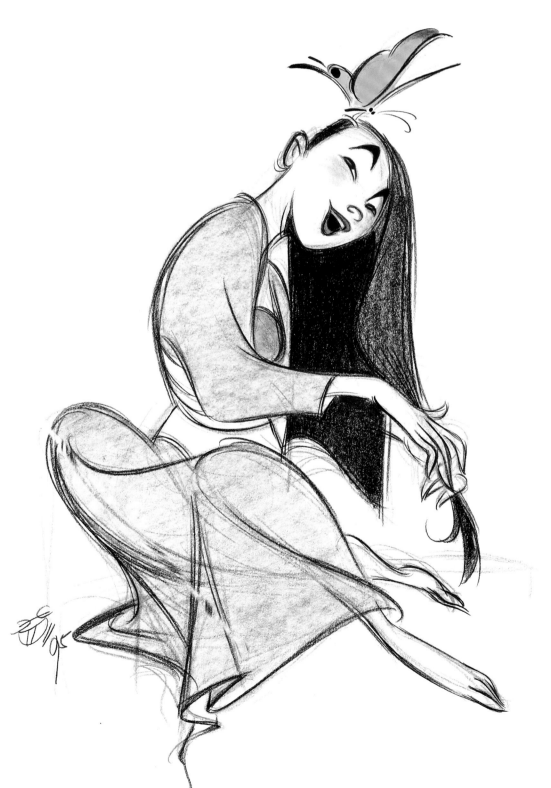

Chang's design approach and visual philosophy merged seamlessly with that of his colleagues, Hans Bacher and Ric Sluiter. Chang explains, "Overall, I think that the design approach is to *imply* instead of to *show*. If you know how to do it right, you don't have to draw every branch and every single leaf on a tree. You just need to show part of it to imply that there's a tree there. That's the approach in a lot of Chinese art.

"There's one thing I noticed a lot, is the S-curve quality in ancient Chinese art," Chang continues. "That's the one quality I pulled out from the Chinese art that I think should be emphasized. And I put it onto the surface. And by that we lost the solid quality of form. So our characters tend to look a bit flat. And also, I approached the costumes to make them look like they're all made of silk, so they have a very flowing quality to them. And by that, we achieved a quality of rhythm, but at the same time we kind of sacrificed the sense of volume and solid drawing. And I think I did the right thing, because that's what you see in Chinese art—the rhythm, the flowing quality, the elegance of the drawing."

"It's like drawing a circle," Chang continues. "You don't have to draw a full circle to communicate to the audience, 'This is a circle.' You just need to draw an arc here and an arc there. If these two arcs work in the right way, then

Above: **Visual development by Chen-Yi Chang.**

Below: **Production still.**

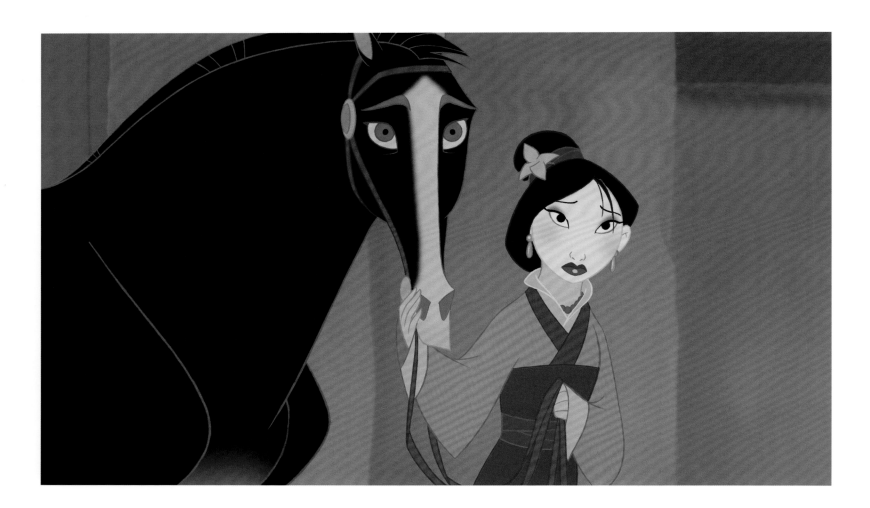

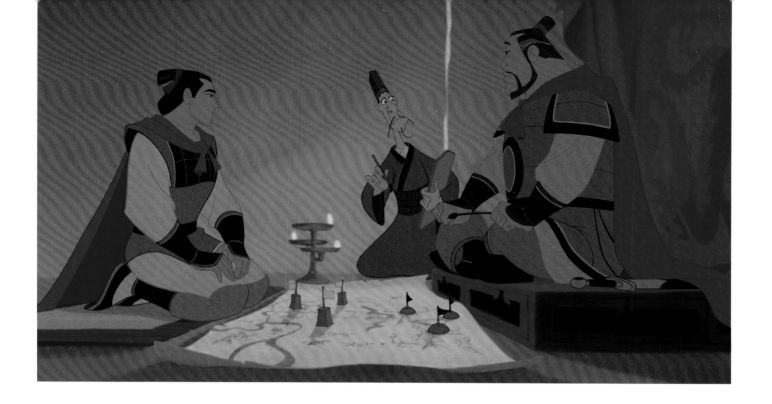

Chi Fu looks on as Shang and
General Li discuss strategy
for stopping Shan-Yu. Though
the costumes often *appear* to
be ornately detailed, they are
actually composed of simple
shapes that, taken together,
imply the detail. Production still.

they read as a circle. But if they are done *wrong,* then people don't get a circle.
When a character is in action, you don't really pay attention to the details. The
details give a flavor to the character, but as long as you've got the point, you
don't need that extra stuff, so I did my best to simplify or get rid of the detail.
That's why we get rid of the unnecessary wrinkles, folds, things like that, and
bring them in only when the animator needs it for a specific expression or
gesture. When a character is boiled down to its essence, then everything has to
be drawn perfectly. If it's done wrong, then you can see it right away, because
you don't have details to distract from it. You don't have all the other stuff to
hide it. That's why I really rely on good artists to make it right."

Supervising Animator Ruben Aquino sees Chang's style as "very
graphic, almost flat, a very simple style. Simple styles are good for animation.
It's easy to draw simple shapes, simple designs, and to move them around. It's
not a traditional Disney 3-D design. Although our films are based on two-
dimensional drawings, the challenge is to make them work in the simulated
three-dimensional world that we create. But, because the design is flat, it's a
little harder to turn around. It was a challenge for us animators to take the
designs that Chen-Yi helped us develop and to make them work in 3-D. It's
been interesting. It looks good, though. It's one of the best-looking pictures
that I've worked on."

While the various supervising animators were inspired by Chang's
designs and incorporated his ideas into their own work, it was the Cleanup
Department, headed by Ruben Procopio, that was ultimately responsible for
safeguarding the consistent application of Chang's style while maintaining
the animators' intentions. Procopio likens his department's work to "taking a
diamond in the rough and meticulously shaping the facets and polishing it to
its brightest shine."

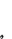

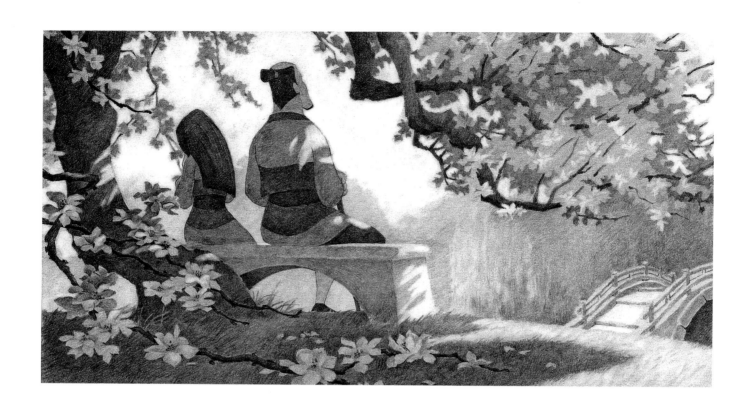

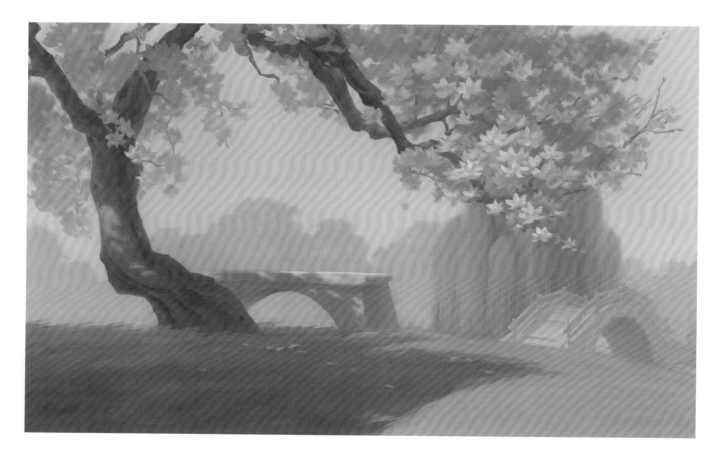

*C*hen-Yi Chang, Hans Bacher, and Ric Sluiter created a style of art and a creative environment that the artists could not only see, but feel. "In art there is labor," Chang states, "and there is artistry. In order not to be overwhelmed by the labor part of drawing the design, you must begin to feel the design—to touch upon something you can see, but don't quite understand."

Robert Stanton explains, "It was like we were reteaching ourselves how to be *artists* again instead of just being thorough *renderers*."

"It's the same concept as Chinese paintings," says Los Angeles Head of Backgrounds Sunny Apinchapong. "The Chinese artists practice painting, say, painting the same blade of grass hundreds of times before they get it right, and then, when they actually do the artwork, it flows more smoothly. They don't have to struggle with the technique. It becomes second nature. I told all my painters to study the layout for a long time before they sit down to paint. I know they can paint—but I also want them to *feel* the painting that they're working on."

Sluiter agrees: "We are constantly sending paintings back and saying, 'No, it's got to be done in one brushstroke.' Look at *Bambi*. They put a couple of colors on their brush and hit it once. That's a Zen style of painting— practice, get it right, and then put it down."

Head of Cleanup Ruben Procopio says, "We're attempting to capture a Chinese *feeling* and it's unconventional for me to say to an artist, 'Even though you're following the model sheet, do what *feels* the best in this scene. If it goes off the model, so be it. If it *looks* and *feels* right, do it.' Each line is like a brushstroke and each line has meaning—just as in the simple beauty of Chinese painting. That's what we're trying to achieve."

Pam Coats recalls the growing tendency of the production staff to move forward based on *feeling*. "Let's take Head of Layout Bob Walker for example. Bob is a guy's guy. In our first layout meeting, I listened to Bob talk about camera movement and what Mulan felt. 'She's feeling this. I want the camera to be with her. She needs space; this is where the camera would back up.' We met for two hours, and all discussion centered around the emotions of the scene. Layouts were determined by what would enhance the story and spotlight the characters. As I watched, I was so overwhelmed by the focus and emotions coming out of these guys that I actually started to cry.

"You can't just say, 'I'm gonna make a show with a lot of heart.' It just seeps through and the show becomes heartfelt. *Mulan* started to gain, somewhere along the road, a life and a spirit. It developed into a living, breathing entity."

Opposite above: Layout study of the Fa family garden by Peter DeLuca.

Opposite below: Background art by Xiangyuan Jie.

THE SUPPORTING CAST

"**A**fter we finalized the main characters," Chang explains, "I told the directors that I would like to do the secondary characters, because I'm concerned that artists here—because of their educational environment—don't really have a good set of graphic icons to portray the individuality of Asians, and this would be my opportunity to do so. Even though they are secondary characters or background people whom the audience probably won't single out, I still tried to make them look like individuals, people you would see if you went to Asia."

These pages: Visual development by Chen-Yi Chang. Chang sketched most of the film's secondary characters, including the other girls who are sent to the Matchmaker (above), a variety of villagers (top), and members of Shan-Yu's Hun forces (right).

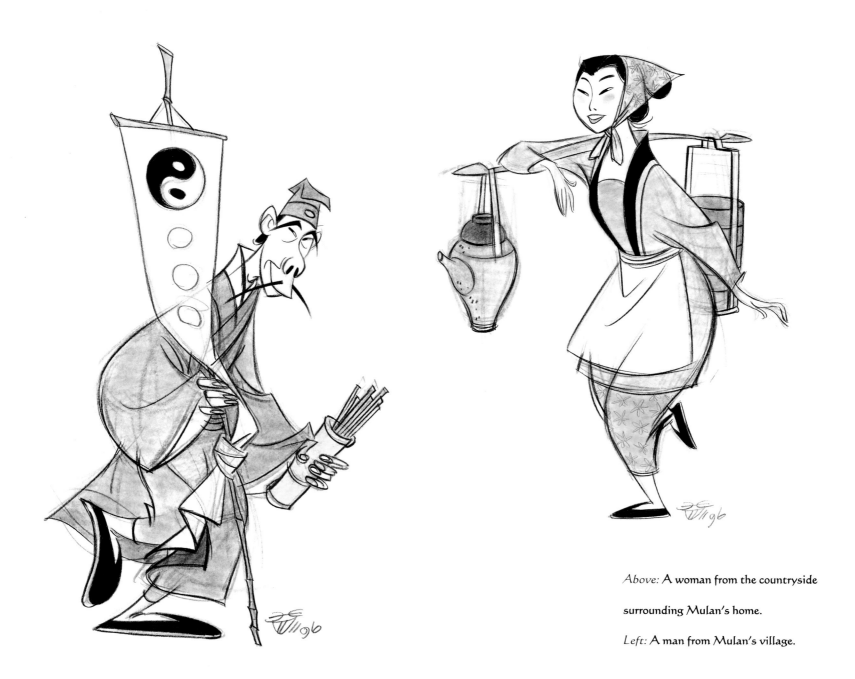

Above: A woman from the countryside surrounding Mulan's home.

Left: A man from Mulan's village.

Chen-Yi Chang was also concerned that the filmmakers maintain a high degree of veracity in character design. "I got a lot of confusion and headache at the beginning of the development. Because at that time I knew I was facing two hurdles. One was Westerners who had a stereotypical idea of how ancient Chinese should look. I mean, like, long mustaches and pigtails. Totally false. And so I was wondering, 'If I present the *real* look of ancient Chinese, they would get shocked, and they would probably think I didn't do any research at all.'

"The other audience group is Chinese, most of whom grew up, like I did, with low-budget TV and movies that used the Ming dynasty culture to represent all of the previous dynasties, which is totally wrong. If I go back to the time that Mulan is supposed to have lived, and create a more accurate representation of that era, the Chinese might be shocked, because not many of them know much about it. It will be educational for everybody."

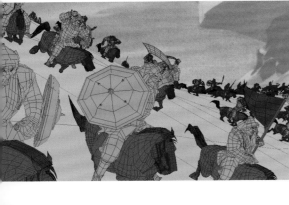

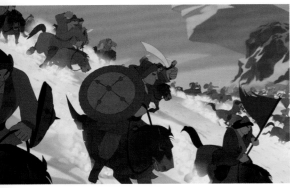

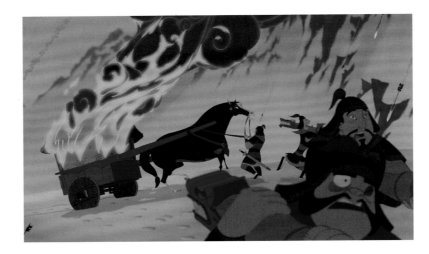

Above: **Digital Production's** wire-frame model (top) and the final production still (bottom) of the charging Hun forces. CGI by Sandra Maria Groenveld and Tony Plett.

Above right: Production stills. CGI of the munitions cart and flaming arrows by Darlene Hadrika and Mary Ann Pigora (top). CGI of the bamboo by Mary Ann Pigora (bottom).

DIGITAL PRODUCTION

The *Mulan* project presented new challenges for the Digital Production Department in creating a seamless integration with traditional hand-drawn animation and the graphic style established by Hans Bacher, Ric Sluiter, and Chen-Yi Chang. Merging the mediums to create realistic three-dimensional environments, effects, and objects was no small task. Digital Production collaborated with layout, effects, and character animation to create such varied environmental elements as the flags, the temple floor, bamboo, rain, snow, and the flaming arrows; objects including the munitions cart, Mushu's metamorphosis from incense burner to living creature, and Mushu's "snowboard" shield; and the impressive footage of the Hun charge and the final crowd scenes.

Adapting to the poetic style of *Mulan* has been a stimulating stretch of creative muscles for Digital Production's Supervising Animator Rob Bekuhrs and his team. "In essence, we're walking between two worlds. We generate two-dimensional work by following the tenets of hand-drawn animation, using three-dimensional tools. For me it's actually refreshing to hammer on tools that weren't made to do the things we're getting them to do. The challenge is to avoid becoming a 'sore thumb.' Getting a character, say a Hun riding a horse, to look dynamic from all angles can be tricky. If it's not done properly, it looks ridiculous—very inappropriate."

Head of Digital Production Eric Guaglione and his staff broke new ground in creating some of the most spectacular shots in *Mulan*, particularly the crowd scenes. "I had this brainstorm to adapt some early tests we had done that fused hand-drawn 'extras' with computer-generated polygons, creating a turbocharged rubber stamp of sorts. We put the process through the paces and threw 10,000 guys in a shot. When we saw it, we were stunned. I think this was the first time in the history of Disney animation that we have seen 10,000 hand-animated characters on-screen at once. They have full integrity and full movement, in sizes ranging from full frame to way out there in the atmosphere. Mix it in with some effects animation and some foreground characters and it fits the film perfectly—because it's traditional hand-drawn animation with a CGI execution."

Although justifiably proud of their high-tech innovations and "turbocharging" of the traditional animation process, Guaglione and Bekuhrs agree that the greatest accolade they can achieve is congruity. Guaglione upholds, "The best effect you can ever do is the one that people never notice."

CGI of the crowd by Jason W. Wolbert and Marty Altman.

*D*avid Tidgwell has been watching Disney effects animation since his childhood. He saw *Bambi* again and again, obsessed with the fire effects. "When I grew up, I found out there were special people who just did those kinds of drawings, and I was thrilled. It changed my life," Tidgwell recalls. As head of effects animation at *Walt Disney Feature Animation Florida*, Tidgwell has added to the tradition that influenced him on *Pocahontas, The Hunchback of Notre Dame,* and now *Mulan.*

There are very few scenes in *Mulan* that do not benefit from the expertise of the Effects Animation Department. Their work encompasses all lighting effects, shadows, and the film's living elements that create atmosphere, such as smoke, fire, snow, and water. "There's a lot of 'special effects' to draw from in Chinese art," explains Tidgwell, "so we're pretty

Below: **The avalanche.**

Production stills.

Bottom: **Avalanche-effects**

animation by Garrett Wren.

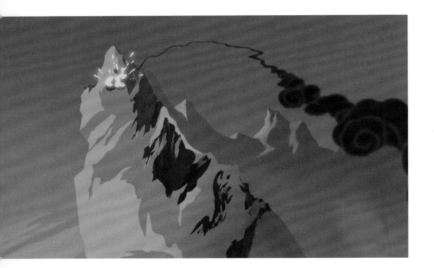 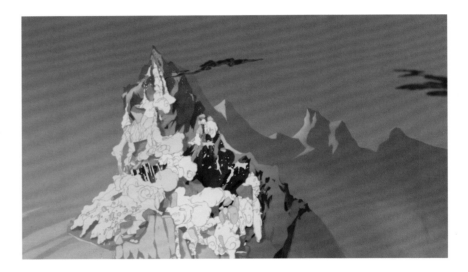

lucky there. One thing I was really surprised about was how the rendering of certain things hasn't changed over hundreds and hundreds of years of Chinese art. Smoke was always drawn the same, 5,000 years ago and 100 years ago. There's almost a symbol for smoke. But that also made it particularly easy to adapt to the movie.

"What made it hard to adapt to *Mulan* is that it's very two dimensional and we had to fit the two-dimensional designs into the three-dimensional world of the movie. Luckily the characters were designed fairly two-dimensionally as well, and the layouts were very simple and straightforward. We had a pretty easy time fitting the smoke and the fire effects into the style of *Mulan.* Water was a little more problematic because it moves faster and had to follow through more—and water follows really rigid rules about the way it moves. You know water drops have to fall in a certain direction, take on

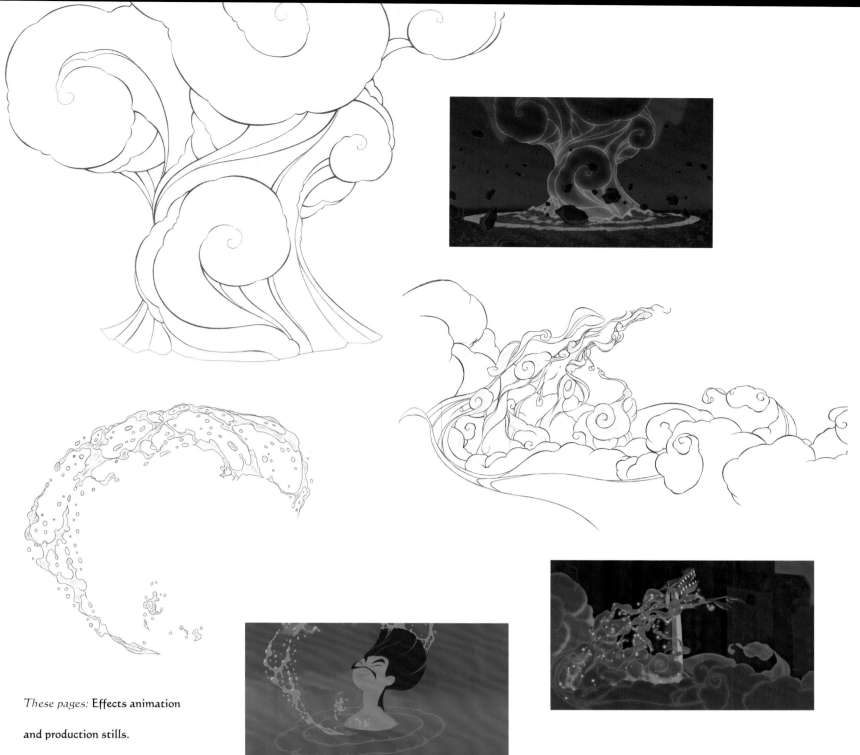

These pages: **Effects animation and production stills.**

Top: **A mishap during army training sends Chi Fu's tent up in smoke. Smoke-effects animation by David Tidgwell.**

Above right: **Mulan takes a swim. Water-effects animation by Bob Bennett.**

Above far right: **Mushu comes to life. Smoke-effects animation by Troy A. Gustafson.**

certain shapes as they fall. Smoke pretty much moves smoothly and continuously."

As with much of the rest of the production, the simple appearance of the art belied its complexity. "It's ridiculously precise," says Tidgwell. "People keep running into that, and everybody at one point says, 'You know, I never had a harder time getting drawings down on paper for the first time, it's ridiculous.'"

Like many others working on *Mulan* the effects artists found their way to the "poetic simplicity" of their art, not through draftsmanship as much as through feeling. Tidgwell explains, "While you're making the initial conscious decisions to make those designs, it's very difficult. By the fourth time you do a scene, it comes out very naturally. You develop a sensitivity to the original Chinese art as you go."

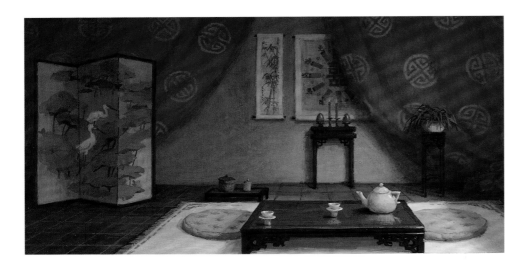

Above: Visual development

of the interior of the

Matchmaker's house

by Sai Ping Lok.

Below: Visual development

by Robert Stanton.

C
O
L
O
R

*T*he color styling for *Mulan* continues an overall visual approach that would extend to every component of the film's production, including story development, staging, and music. The idea, based upon the visual and story approaches that were emerging from and unifying the *Mulan* production, became known as "poetic simplicity."

"When we first started the film, we wanted to do all Chinese colors," Ric Sluiter explains. "We felt, 'We've got to be true to the Chinese culture.' But in China, red means life, while here it means evil. White means pure, there it means death. Colors have different meanings in China. So we

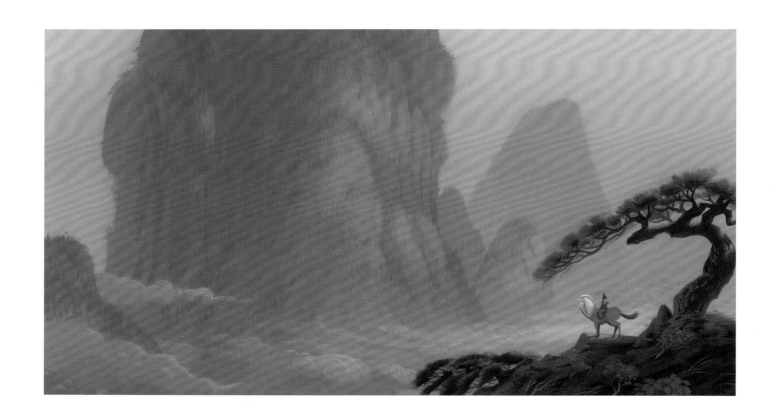

couldn't be quite so *literal* with our choices, because the Western audience wouldn't understand it, and it may look a little strange to us to have the villain dressed in white. So, we let the emotions of the story dictate the color."

"The initial color was inspired by Hans Bacher," Robert Stanton explains, "but then we started to refine it, and we had Sai Ping Lok do a lot of inspirational work for the film. Within his work there's a touch of realism, but also there's a beautiful sense of color. And so we were basing our color direction on color harmony, but without being too realistic. I think the design helps bring it away from that, you don't have a lot of detail. We don't want it to feel photo-realistic, that's not the style."

sea.—22 "Reunites with family and shang"

Cri-Kee, Mushu, and the rest of the Fa family guardians celebrate during the closing song, "True to Your Heart." Color key series by Robert Stanton.

Sunny Apinchapong feels, "It's beautiful. The look is tasteful, very simple and clean, which was difficult to achieve. When we painted scenes with nothing but flat snow, we were basically using just one color. It was a challenge to make them look good. But what resulted was a lot of beautiful scenery. This is like an epic for animation—it has that kind of feel to it."

Irma Cartaya, a nine-year Disney color stylist, responds to her work on *Mulan* more emotionally than technically and concludes, "I like the fact that the story is beautiful. And the artwork, when you're looking at it, it soothes your eyes. It's beautiful to watch. You can sit there not listening to what they're saying or what's going on and it's pleasing. You're really captured by what you're looking at. Just looking at a silent frame, you know exactly what's going on. It's simple, and it's beautiful, and yet it's incredibly detailed."

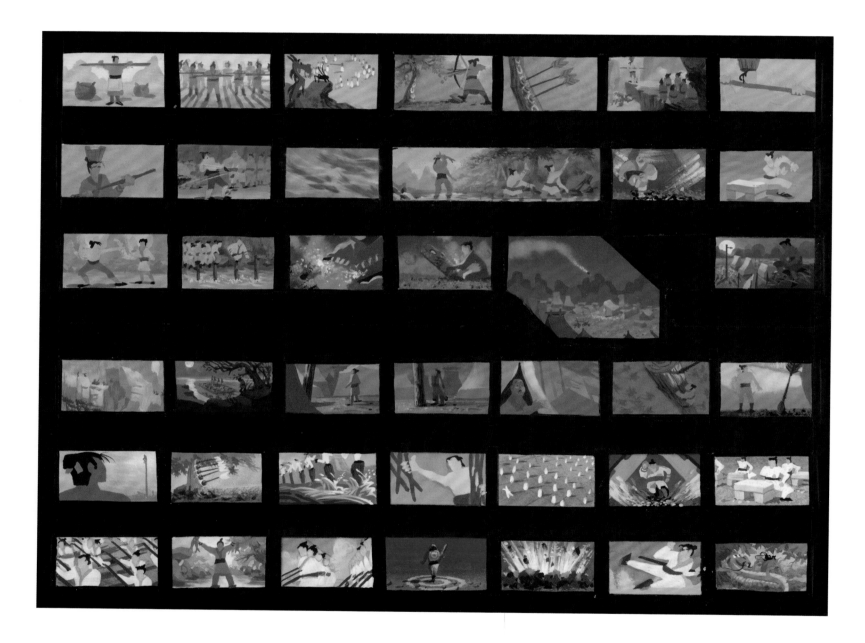

Above: This color key series shows the color evolution throughout the sequence "I'll Make a Man Out of You." Color key series by Robert Stanton.

Top and right: Production stills.

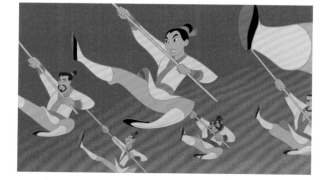

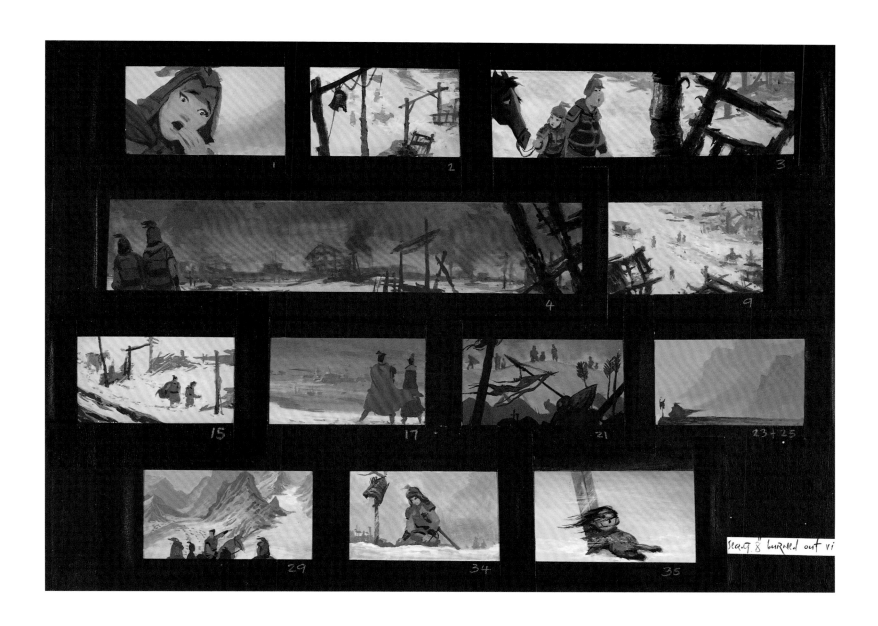

Above: The Imperial army finds a mountain village destroyed. Color key series by Sunny Apinchapong.

Right: Production still.

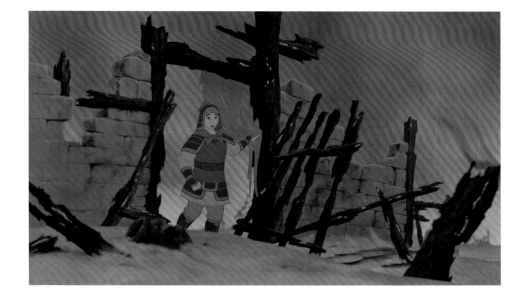

*R*obert Stanton explains that the color styling for the film is based not only on good design, but issues of story and, most of all, feeling. "In the beginning of the movie we present all three palettes. We present yellow, blue, red—the three primary colors in the movie, within the context of the movie. We're trying to use color intensities to reflect the intensity of the emotions. If the emotions are somber, the color's going to be less saturated, played down. At moments in which there are intense things going on, you'll see one of those colors intensify. The colors will be honest to whatever the character is feeling. But we don't want to go *beyond* their emotions, because then the background isn't supporting the story idea. We're not showboating."

There was also a conscious decision to avoid convention. The legacy of animation has provided a shorthand visual vernacular to the artist, a patois of visual cues that audiences immediately understand. For instance, in Sequence 17.5, Mulan finds herself solitary and dispirited in the snow. Ric Sluiter remembers, "We talked about that sequence having indications of the cold, the chattering teeth, and snow blowing, and falling. Predominant blues and white. Let all the elements give more texture to the environment, 'feeling' the cold.

"But that was just so *typical*. We decided on a quiet kind of solitude. If you've been *in* that cold, you understand…that motionless cold. I'm from

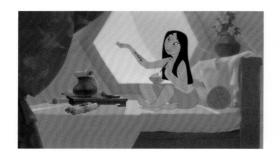
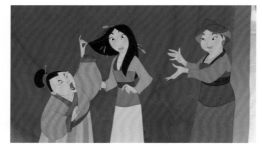

The three primary colors of
Mulan—yellow, blue, and red—
are all established early in the
film. Production stills.

Canada, I know that kind of feeling, where the cold carries an eerie silence. You hear more sounds than just the wind howling. By staying away from the conventions, we wind up communicating an isolation that's both physical and emotional."

Stanton elaborates: "In Sequence 17.5, we went away from the typical styling of a scene in the snow. Instead of blue, it's sort of a grey-green, and Cri-Kee's fanning this little tiny, tiny fire, adding just a little touch of red. The fire eventually goes out, but we were working complementary colors against each other. We were also translating the idea that's in the drawings into a philosophy of color, which hasn't always been easy. Some scenes are very monochromatic."

Left and bottom: The color styling of Sequence 17.5—in which Mulan is abandoned—is designed not only to look cold, but to *feel* cold. Color keys by Robert Stanton.

Below: Production still.

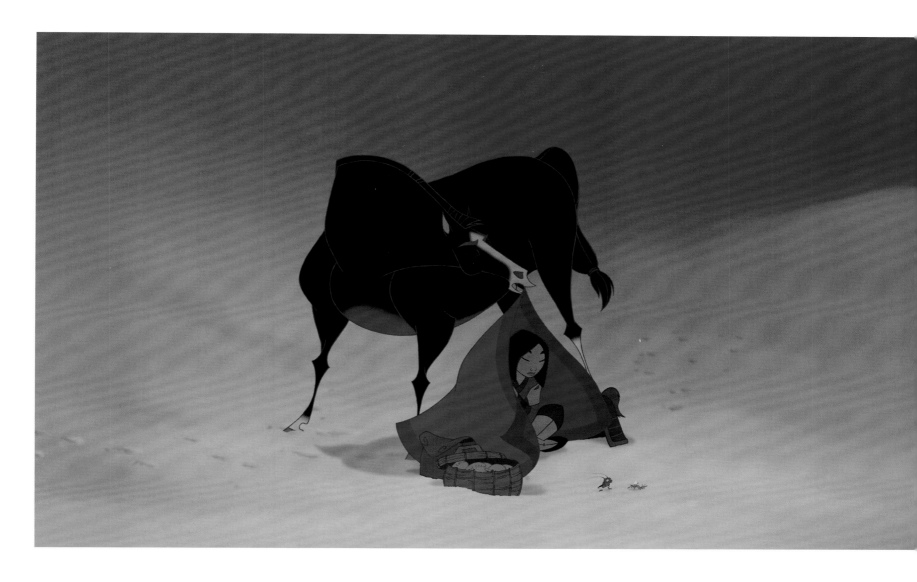

Far left: Cleanup of Fa Zhou by Cleanup Character Lead Monica Murdock, animation by Mark Henn.

Near left: Cleanup of Chi Fu by Cleanup Character Lead Scott Anderson, animation by Supervising Animator Jeffrey Varab.

Below: Production still.

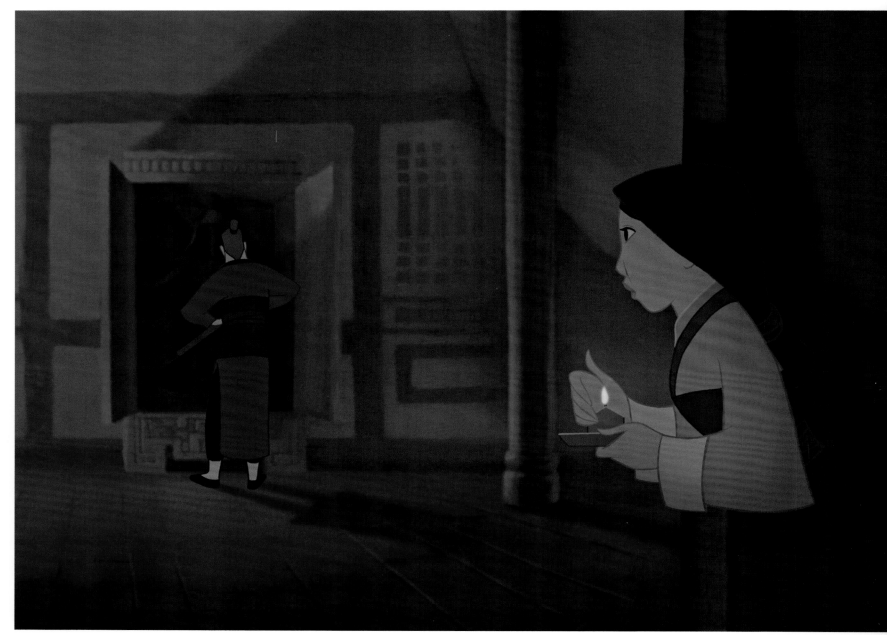

Below right: Fa Li, Grandmother Fa, and Mulan share each other's concern for Fa Zhou. Rough animation of Fa Li by Supervising Animator Ruben Aquino, of Grandmother Fa by Todd Waterman, and of Mulan by Mark Henn.

The *Mulan* artists carefully avoided abrasive shifts in the color styling that would detract from the story content. Again, the issues of subtlety and careful balance were addressed. Stanton says, "Something I think that has evolved through the process is an understanding of how to use subtle colors to get across the mood. Not only that, but to have the color flow into the next scene, not just logically, but emotionally. That's been the biggest task, trying to reflect the emotional content within the color, but also to 'flow' it through the film without it standing out.

"At the beginning of Sequence Five, Fa Zhou is in his room. He's gotten the conscription notice, and there's a reality that this man is leaving his family behind—and he's probably going to die. He goes to a cabinet that contains his armor, and we have a touch of red. When I was working on the scene, the whole time I was thinking, 'I want a subtle touch of red, without it overpowering everything.' So I had to do it three times. The first time I did it I went *way* too far.

"So we're not just looking at design, we're not just looking at color. We're thinking, 'Does this make me *feel* this way?' 'Does this color, does this image make me *feel* like that? If it doesn't, then let's try it again."

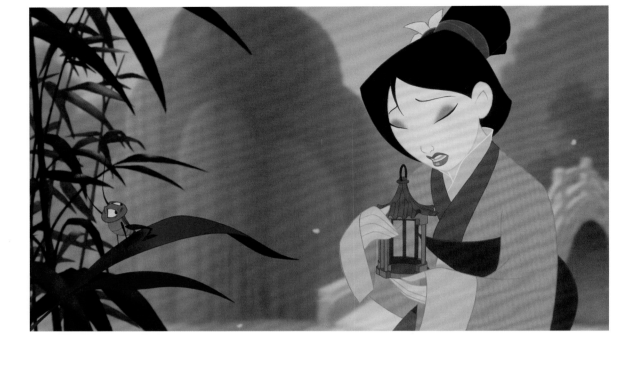

As the designers traversed the visual world of *Mulan*, so did the story team make an arduous journey through the story of the secret soldier.

"*Mulan* is a story that has had to travel through a minefield this entire time," Head of Story Chris Sanders says. "Keeping it on the right path has been a very delicate task. If you adjust the story one way or the other just a few degrees, *kaboom!*

"The first mine that continually threatened it, lay in the army story. Because that immediately suggested that Mulan would be an 'outcast tomboy,' so the war gives her an opportunity to go off and prove to her father that these boyish qualities she had all along were good qualities. That was a creepy version that was easy to fall into, because that was the construct that was the *easiest*. Immediately we started working *against* that, working to pry that one up and get rid of it—and it was difficult."

Sanders veritably shudders when he thinks of the direction the film might have taken. "The first time we screened Act One, it was abominable. It was a mess. The girl, who's a misfit tomboy, loved her father, was about to get married—she was betrothed to Shang and didn't like him—and, in the temple was a giant stone that had her future written on it. She was leaving home for four different reasons. Why did she leave? Did she leave because she was really a tomboy and the war was a convenience that would let her indulge that? Did she leave because she was escaping a bad marriage? Did she leave because she couldn't stand the idea that her destiny was written for her? Did she leave because she was trying to protect her father? Who *knows* why she left."

Above and opposite: **Mulan** sings "Reflection." Production still and storyboard art by Dean DeBlois.

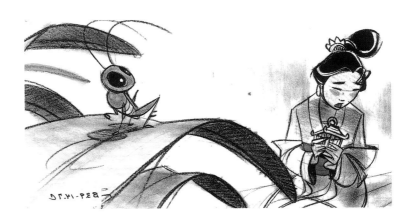

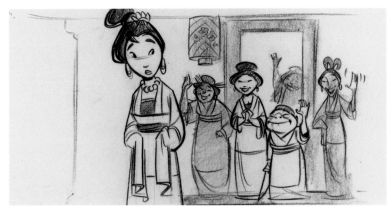

MULAN: Ancestors . . .

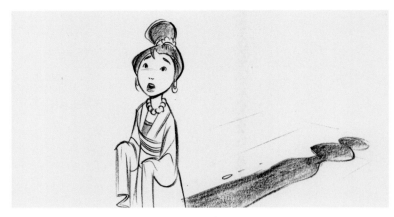

. . . hear my plea. Help me not to make a fool of me . . .

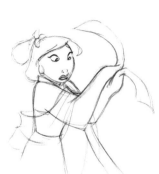

. . . and to not uproot . . .

Cri-Kee disrupts Mulan's meeting with the Match-maker. Rough animation by Mark Henn.

Pam Coats also remembers the story muddle. "For a while, we got really sidetracked and started to make a film that's been made before—by us—about a girl who's unhappy and leaves home because of that. Through that storyboarding process, we discovered that this was not a girl we liked. This is a willful girl who is leaving home because she is unhappy. That didn't make us care for her."

Dean DeBlois recalls Mulan's unattractive and self-seeking militancy. "There was a sequence in the beginning where Fa Zhou was carving Mulan's destiny on a big stone tablet in the family temple. It was Mulan's betrothal day, and she was going to be married to a predetermined person whom she hadn't even met. Her life was being mapped out for her. She wasn't going to stand for it. In a crucial moment, she decided, 'to hell with destiny,' shattered the stone, and said, 'I will write my own future.' There was even a song written for this sequence. Then Mulan rode off into the night—but to escape, to make her own life. Well, it wasn't very endearing. She was going to go off to prove to the world that no one was going to write her destiny—that she was going to do it herself. It was just so militant that it really isolated her, and turned her story into something nonempathic and very self-righteous. That was something we didn't like at all."

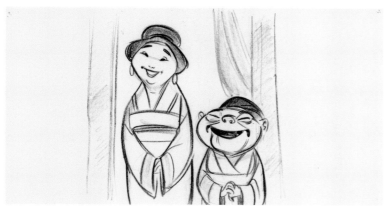

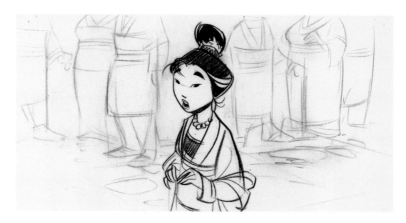

. . . my family tree.

Keep my father standing tall.

Sanders remembers another major misconception that contributed to the story mess. "*Mulan* was originally conceived as a romantic comedy, like *Tootsie*. The war as a backdrop for a romantic comedy? The story crew *never* liked that idea. We wanted to use war as the anvil to place this character against. The writers were dead set against focusing on the war, feeling it was too messy and dark. Eventually I said, 'I've had enough of this.'

"I threw a fit," Sanders recalls. "I was tired. I wanted to kill the romantic comedy off once and for all. I wanted to scrape the bad marriage off, I wanted to bury the tomboy thing. The rest of the story crew felt the same way. This was a turning point. I went to see Pam Coats, and I said, 'I've made a decision—Mulan leaves home because she loves her father, which is true to the original poem. Tomorrow, when we have our next story meeting, I'm going to attack any idea that gets in the way of this one thing.' Pam said, 'Go ahead.' Barry Cook was on my side with this, too. He had always felt that Mulan should leave for the love of her father."

"So, we got it back to the original intent of the legend," Coats concludes. "Talk to anyone in China about the legend, that's what they consistently articulate about it. This is a girl who did what she did for the love and honor of her family."

"So we had that meeting and I said, 'I'm going to put to rest any other story except the one: Mulan loves her father," states Sanders. "If any other story interferes or competes with that, it must die.' So all this stuff started leaving in favor of this one idea. That was the first time that her character got a big chance to live. She leaves home to save her father, so she has to leave home against her will. There was our answer: How does Mulan *feel* about life? She wants to fit in, she wants to stay home. Her militancy went away, and it was such a wonderful breath of fresh air, to have this character who wanted nothing more than to be a good daughter. We get one little glimpse of her turmoil inside during the 'Reflection' song and then we put it away. We let it remain unseen for most of the film, and then at the end of Act Two, she opens up one more time and questions her own motivations. There's a different sort of appeal and universality to a character who doesn't have a larger plan for her life. This makes her different from, say, Ariel and Belle."

Coats is quick to give credit for putting the *Mulan* story on track. "Chris Sanders established her character—we wouldn't have Mulan without him. He's got talent and an imagination that is unbelievable. Mulan is who she is because of Chris and what he put into her character. And Mulan's character started the *heart* in the project. He pushed us and pushed us, until we all started thinking about her alike."

Mulan returns from the Matchmaker, too ashamed to face her father. Storyboard art by Chris Sanders.

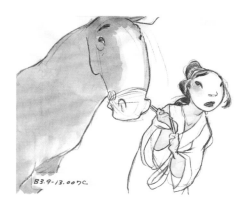
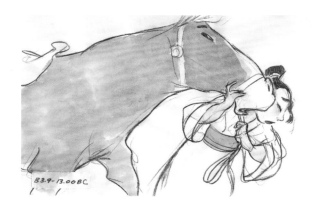

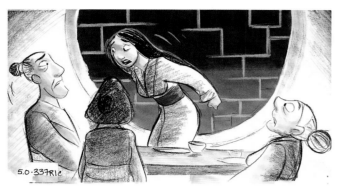

MULAN: You shouldn't have to go.

Mulan challenges her
father. Storyboard art
by John Sanford.

FA ZHOU: It is an honor to protect
my country and my family.

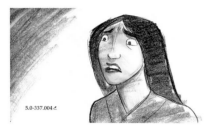

MULAN: So, you'll die for honor?

FA ZHOU: I will die doing what's right!

"If I say something in first person," Sanders is just as swift to explain, "I speak for the *whole* story crew. I'm so proud of these guys, they did such a good job. I always went back to them and told them every problem I had. I never held anything back. It was truly a story *team*, we were always of a like mind. I think that maybe divine intervention brought all the story crew together. I don't remember ever arguing amongst the story people about what kind of character we wanted on the screen. I think everybody knew who she was before we even started building her.

"We finally got our selfless character, who just wanted to be part of the crowd, and she was doing this all for her father, which was a nice, fresh thing to work for.

"We also wanted her to be imperfect—to be clumsy, to say things that were inappropriate. It always charms me when Mulan is awkward—when she acts like an idiot in front of Shang because she's nervous. If she always knew exactly what to do, no one would identify with her.

"I can't count how many times people said, 'She's acting so clumsy,' and I'd say, 'Yep. Good!' They'd say, 'But, but, she's acting clumsy. We can't have that.' And I'd reply, 'Why not?' They could never answer me."

"What I like about her is that while she's strong, she also has insecurities, moments of self-doubt," Screenwriter Rita Hsiao feels. "She's not perfect, and that's what makes her so likable and interesting. Her moments of doubt, or moments of sheer determination—when she stands up to her father at dinner, or when she's sitting in the rain and makes the decision to go—those are moments that I feel really capture her essence. She can be insecure and feel terrible, but she has an inner drive and a spirit that comes out and makes her take action."

Sanders agrees, "We had moments where we looked at it and said, 'That's it, that's her, there she is, she showed herself, she surfaced, right there! Hold on to her!' It was weird and wonderful that everybody saw her the same way. Everybody saw the very selfless, sweet, imperfect, funny Mulan, and we just started looking for moments to emphasize that.

"It was quite a while before we were satisfied with her first sequence, where she's waking up in the morning. It looks deceptively simple, but the story crew has taken pains to keep her personality clearly defined. Mulan is late, still in bed, in her underwear, her hair is pulled this way and that, and she's writing on her arm—which was Dean DeBlois' idea. Hopefully the audience will think, 'That's *me*! I'm late, I'm messy in the morning.'

"I think that's more and more what communicates throughout the film, her insecurities, her clumsiness, her imperfections are so communicative. People in the audience recognize it. Mulan is more *interesting* because she's

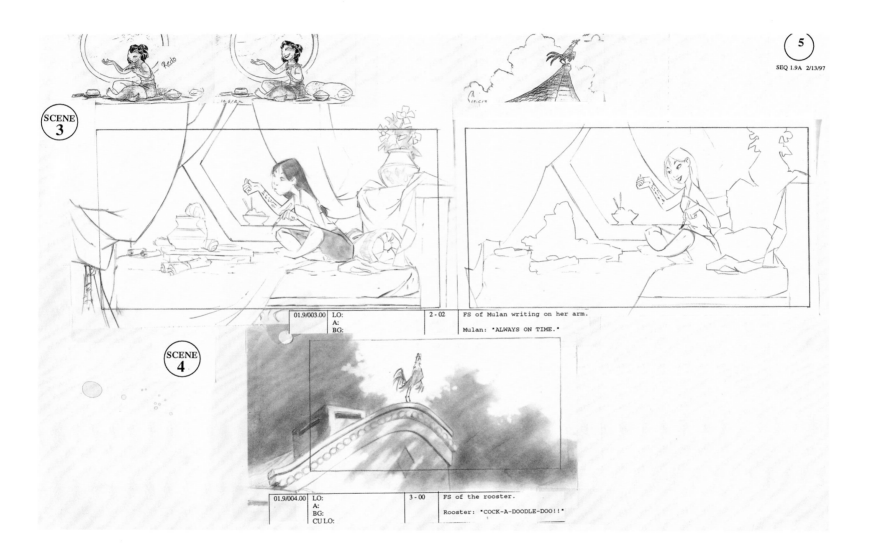

Mulan prepares for her meeting with the Matchmaker by writing notes on her arm in case she forgets something. Workbook page by Craig Grasso.

fallible. There's nothing in the film that was accidental or easy. Every single bit of imperfection was purposely placed there and fought over and defended and watched after and protected, because those were so important, to keep her character endearing."

Composer Matthew Wilder joined the effort to shape Mulan's character. "For David Zippel and myself, giving voice to Mulan's character centered less on an external desire than on her inner struggle to understand what she feels." Lyricist David Zippel explains, "Mulan is trying to find a way to be true to herself, yet still meet the expectations of the world she lives

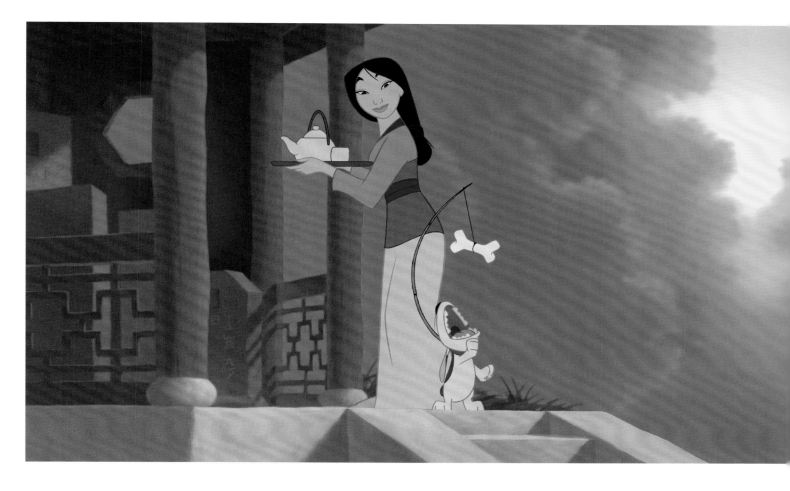

Top and above: **Mulan and Little Brother**, her playful companion at home, who is always eager to help out with the household chores given a little incentive. Production stills.

in." Wilder says, "That ultimately became our springboard to understanding Mulan's quest to find herself. Mulan's song 'Reflection' became a representation of her inner struggle." Zippel concludes, "Her world view becomes both personal and universal. Everyone understands the desire to 'fit in.'"

Rita Hsiao takes this idea one step further. "She gets made up like a bride to impress the Matchmaker. That doesn't work. Then she gets dressed up as a man to fit into the army. That doesn't work. It's not until she takes off all these disguises that she's able to finally win respect, defeat the villain, do everything she's wanted to do—but as herself."

Establishing a credible and appealing central character was key to the story department, but the task remained to identify the pivotal relationships within the story, and bring the same level of credibility and appeal. Initially, the character motivation that the story team had fought so hard to make

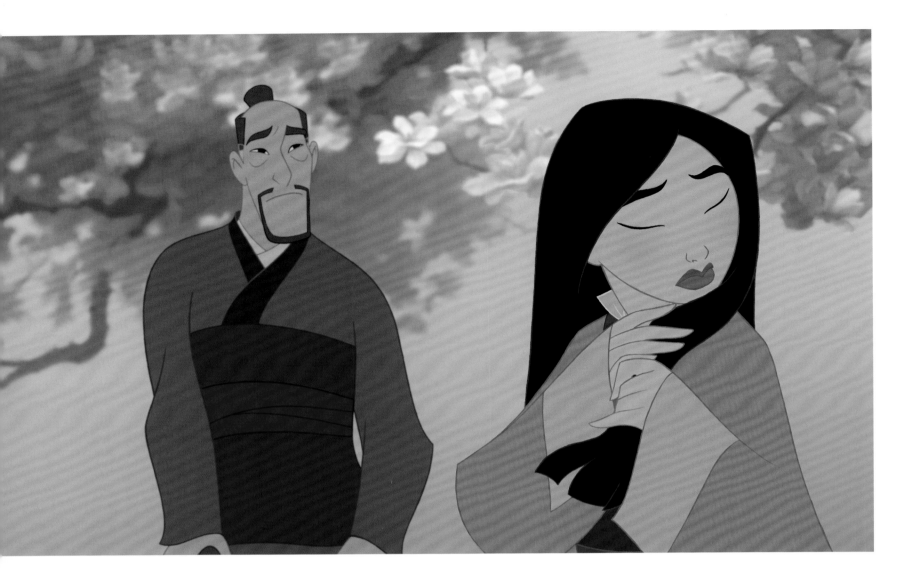

Fa Zhou approaches

Mulan in the garden.

Production still.

primary became something of a burden. Dean DeBlois explains, "I think it evolved out of the notion that we were dealing with a 'foreign' ideal, doing something purely out of honor, a duty that you're born to uphold and therefore do without question. Honor is a pretty universal concept, but to *label* it as honor and not give a specific example of *why* a person would want to live up to that—we found ourselves tripping over it."

The story team realized that they were being encumbered by the weight of their own theme. They decided that rather than presenting some ponderous evocation of their thematic foundation, it was better to simply let the characters behave in accordance with it—revealing it in the process. DeBlois says, "We needed to make it a very 'gettable,' universal, emotional story. Establishing that as our focus, we decided that we had to really get audience empathy. We had to lock the audience into the *characters.*"

The primary relationship that motivates the story is that of Mulan and her father, Fa Zhou. Cultural codes of family honor aside, creating a credible father-daughter relationship was vital if the audience was to believe that Mulan would do what she does. DeBlois says, "I think the initial problem that we had was to get past the idea that a father would *let* his daughter take his place. There are different versions of the Mulan legend, but in one of them,

she *convinces* her father that she can pass as a boy by showing up at his doorstep disguised as a man. He doesn't recognize her, and so he *lets* her go fight." The solution was simple: Mulan would leave without the knowledge of her family.

DeBlois continues, "So *then* our biggest challenge became Fa Zhou and Mulan's relationship. We had to set up a bond that was so endearing that it wouldn't even be questionable why she would risk her life for him.

"We've fought hard along the way to maintain a father and daughter dynamic that reaches beyond the traditional and the cliché. The relationship shared by Mulan and her father moves into something that's simply heartfelt and emotional."

Sanders recalls one of those relationship-defining scenes. "One of the things I'm personally the most proud of is 'the blossom moment.' That moment came from an early version of the story where Mulan got in trouble in town, and Dad defended her in front of some of the townspeople, and on their walk back home—Mulan was really embarrassed—the dialogue note was, 'Dad says something nice to her.' I tried to play the scene in my head. I pictured flowering trees all around, to create an atmosphere of calm. I was having trouble making Dad sound nice as he discussed her failure, until I thought, 'Maybe he tries to change the subject, to ease her humiliation.' That idea set the tone for a conversation between them that began to play itself out in my head. I just wrote it down."

This strong relationship helped define *Mulan* for Score Composer Jerry Goldsmith. "My chief goal was to get acquainted with the characters.

Fa Zhou tries to comfort and reassure Mulan after her disappointing meeting with the Matchmaker. Storyboard art by Chris Sanders.

FA ZHOU: My, my what beautiful blossoms we have this year.

But look, this one's late.

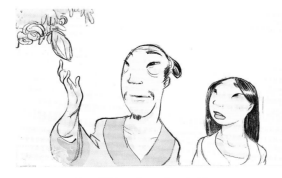

But I'll bet that when it blooms . . .

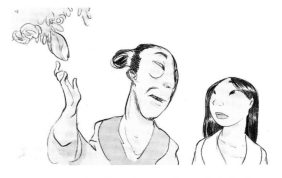

. . . it will be the most beautiful of all.

Mulan's relationship to her father became a very important element in the music. That was what I concentrated on in the first piece I wrote. Their relationship is vital—it sparks the whole thing."

With key story and character motivations locked in place, the story team, much as had happened with the visual development team, felt *Mulan* emerge as an entity. Sanders feels that "the film has taken on a life of its own. If you try to tack something on that isn't needed or isn't in character with the film, it will reject it. We're at a point where we've established our characters and their world well enough that if you just walk outside of its parameters by a *bit*, it becomes very obvious.

"At one point, for instance, we really pushed the romance between Shang and Mulan, and it—like pins popping out of a storyboard—was rejected. A film will tell you what is right for it if you are listening."

Sanders says, "I'm generally a fairly timid individual. I won't make a fuss if someone scratches my car at the car wash. But I found myself being able to defend Mulan, and I really grew in that sense. I still wouldn't lose it over a scratch on my car, but I can fight for Mulan endlessly, because I believe in her so much.

"For every story moment in *Mulan*, I can argue and defend that point like a lawyer. Most avenues that she travels down are because all the other avenues were explored and boarded shut. Her character does not travel randomly."

After reaching the village where Shang's father, General Li, should have been awaiting their arrival, Mulan and her comrades find only ruins. Over a nearby ridge they then discover that the general and his troops are dead. Storyboard art by Chris Williams.

SHANG: I don't understand. My father should have been here.

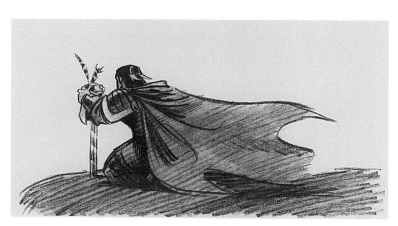

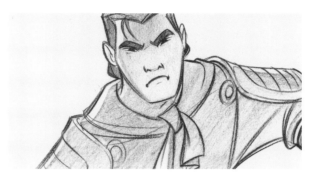

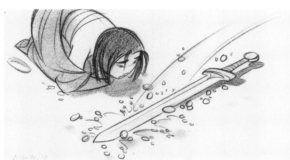

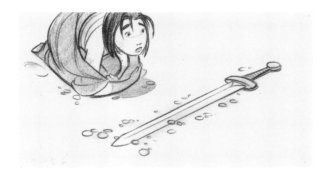

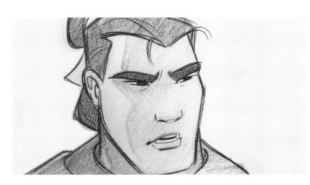

This page: Though a romance is suggested at the film's conclusion, the emotional tension between Mulan and Shang reaches its high point when he refuses to execute her after her deception is revealed. Production still. Background art by Peter Moehrle. Layout by Ray Chen, cleanup layout by Kevin Proctor. Storyboard art by Dean DeBlois.

SHANG: A life for a life. My debt is repaid.

Throughout two years of pre-production, as the story team worked on the evolving story, artists refined—and sometimes totally redefined—the appearance of characters, to meet the needs of the story, or to attain a more satisfying balance between design and personality. The final stage of character design occurs when the animators are assigned to their individual characters. It is often said that the animator is an "actor with a pencil." They bring consistency, personality, and spirit to the character through the skill of their drawing. Mark Henn explains, "I've always felt very strongly there's two sides to being an animator. There's the draftsmanship, and then there's the actor. I like both, which makes being an animator a perfect job for me."

These pages: **Rough animation of Mulan and Mushu by Mark Henn and of Shang by Craig Maras.**

Opposite top: **Production still.**

123

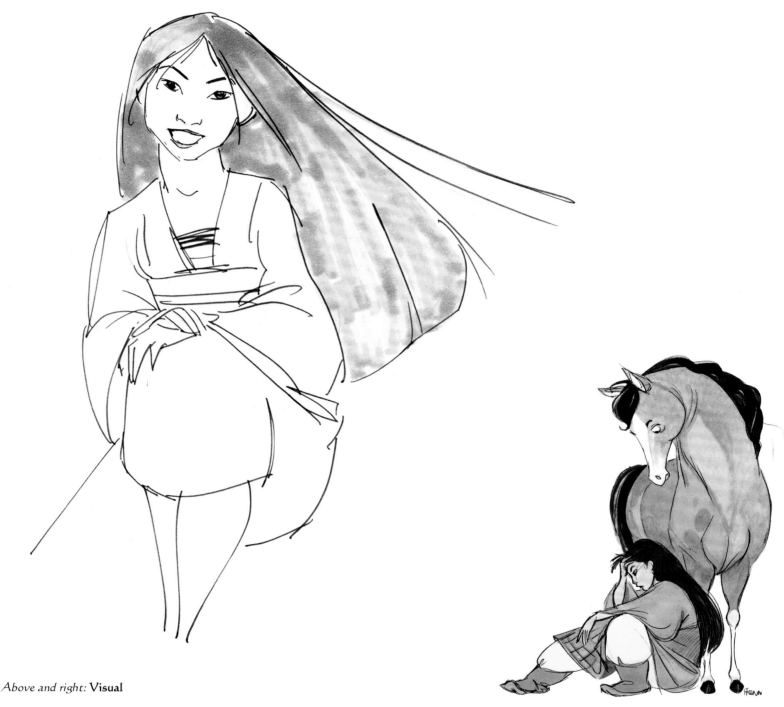

Above and right: **Visual development of Mulan by Mark Henn.**

Opposite: **Production still. Animation of Mulan by Elliot Bour, cleanup by Rachel Bibb.**

M
U
L
A
N

*C*hen-Yi Chang had specific ideals in mind in designing Mulan's appearance—ideas based on Chinese culture. "My concern as a Chinese artist was that Mulan's look be classical in Chinese terms, but also have a modern quality. Mulan presents an ideal of what Chinese think is beautiful. For example, the egg-shaped face, the willow-leaf eyebrows, and the almond-shaped eyes—actually, we call them 'Phoenix Eyes.' Then the cherry-blossom lips, that's the ideal of the Chinese woman. Her features pretty much reflect the idealized Chinese beauty. We chose green as a basic color for her, because she's a girl of nature, she likes to play outdoors—even though she's supposed to stay at home."

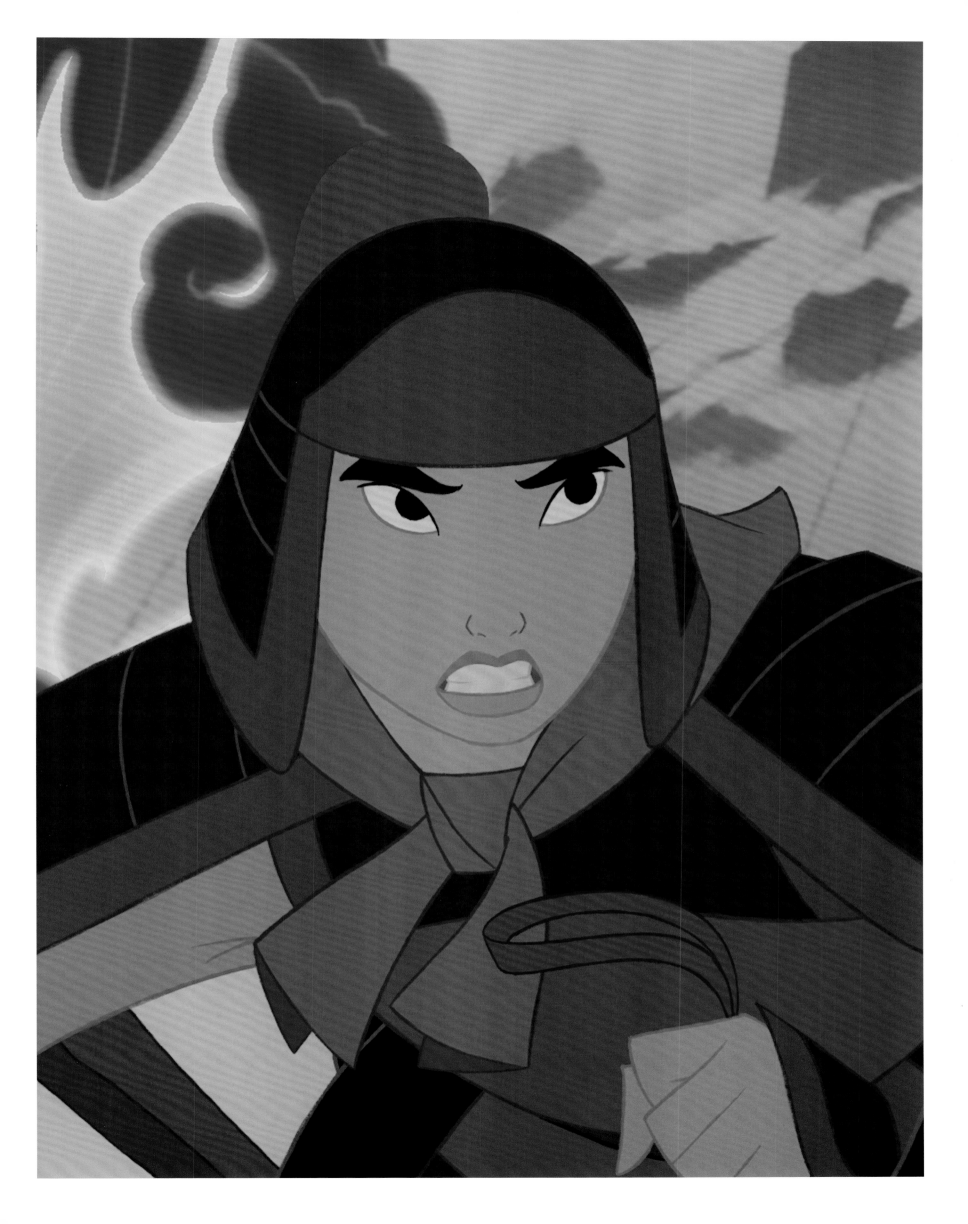

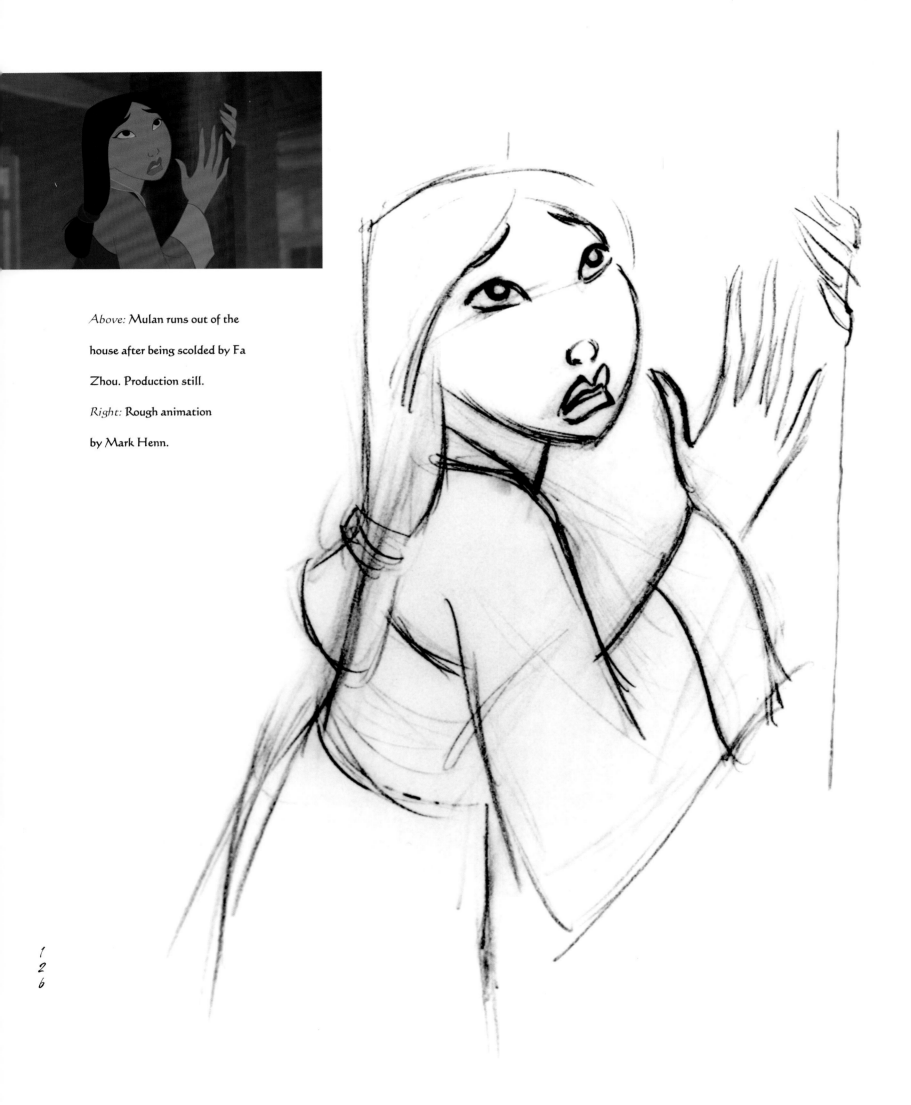

Above: Mulan runs out of the house after being scolded by Fa Zhou. Production still.

Right: Rough animation by Mark Henn.

Mark Henn says, "The beauty of being an animator is, I'm a guy, and here I am performing as a woman on the screen. But I've also been dogs and cats and mice. I can be anything that I can draw. But with the succession of female characters that I've done, I've often had to reassure myself, 'Well, at least I know I have the flexibility to be a lion cub on the next picture,' which I did. On several occasions, I felt like, 'What am I gonna do now? I just finished doing Belle on *Beauty and the Beast*, and now I've gotta do Jasmine for *Aladdin*, and I've got to find what it is about Jasmine that's *different* than Belle, besides outward appearance.

"Granted, there are many similarities from one Disney heroine to the other. Most of these women are a little discontented with their life situation, but how each of them approaches it, and what each one does, is very different. Jasmine wasn't necessarily unhappy being a princess, but she was unhappy that being a princess kept her cooped up. She was the poor little rich girl. Belle was a country girl looking for bigger and better things. Pocahontas had a degree of longing for 'the road less traveled'; but it wasn't as pronounced as, say, Ariel.

"Mulan's motivation is a lot about honor and self-sacrifice, which is kind of a new angle. New for us, but age-old in China, and that's interesting. I will always remember *Mulan* as one of those pictures where the emotional core of the story was always *there* and always remained intact no matter what angle we tried to tell the story from. Finally, it just dictated its own direction. The picture kept saying, 'This is really a story about a father and a daughter and honor—not girl meets boy and they live happily ever after.'"

Storyboard art by

Chris Sanders.

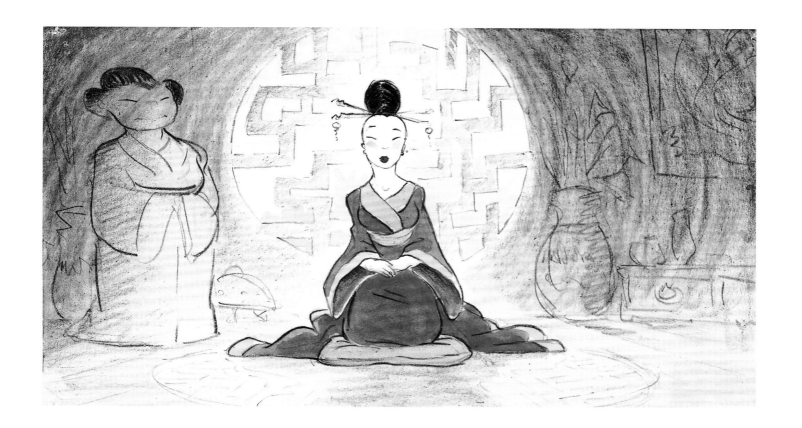

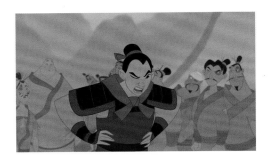

CHI FU: I didn't know Fa Zhou had a son.
MULAN: (umm)mmm . . . He doesn't talk about me much.

Above: In an effort to pass herself off as a man, Mulan resorts to the masculine art of spitting. Rough animation by Mark Henn.

Top: Production stills.

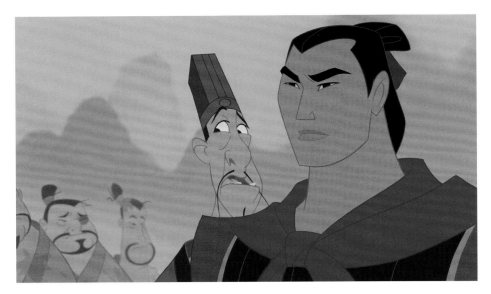

CHI FU: I can see why—the boy's an absolute lunatic.

Chris Sanders remembers, "There was definitely a moment where we gained our first real firm foothold on what Mulan would go on to be, and how the story crew and, I think, everybody has treated Mulan. We began treating the story as a potential cinematic experience. The biggest mistake you can ever make, making a Disney movie, is to be aware that you're making a *Disney* movie as you make it. Everyone treated *Mulan* as a *film.* The last time I saw this happen so completely was on *Beauty and the Beast.*

"Mulan has always been thought of as a real person in real situations. No story person has ever done anything with her that wasn't believable in her world. I think the best story people are aware of their medium only in the freedoms it can occasionally afford them. Otherwise it does not figure into their story work. Every film has its own set of rules that it must adhere to, and animation is no exception to this. I've seen several writers and artists come here and immediately abandon their senses, thinking that flowers and animals always sing and talk in our movies."

For *Mulan,* most of the supervising animators were called upon to perform for more than one character. "In some cases splitting an animator's focus isn't the best thing to do," Pam Coats explains. "But with *Mulan* it added to the emotional dynamics. We cast Mark Henn as both Mulan and her dad, and the scenes between them are remarkable, because Mark is doing them both."

Left: At the conclusion of the song "I'll Make a Man Out of You," Mulan meets Shang's challenge to climb the pole. Cleanup by Daniel Gracey, animation by Anthony Michaels.

Top: Production still.

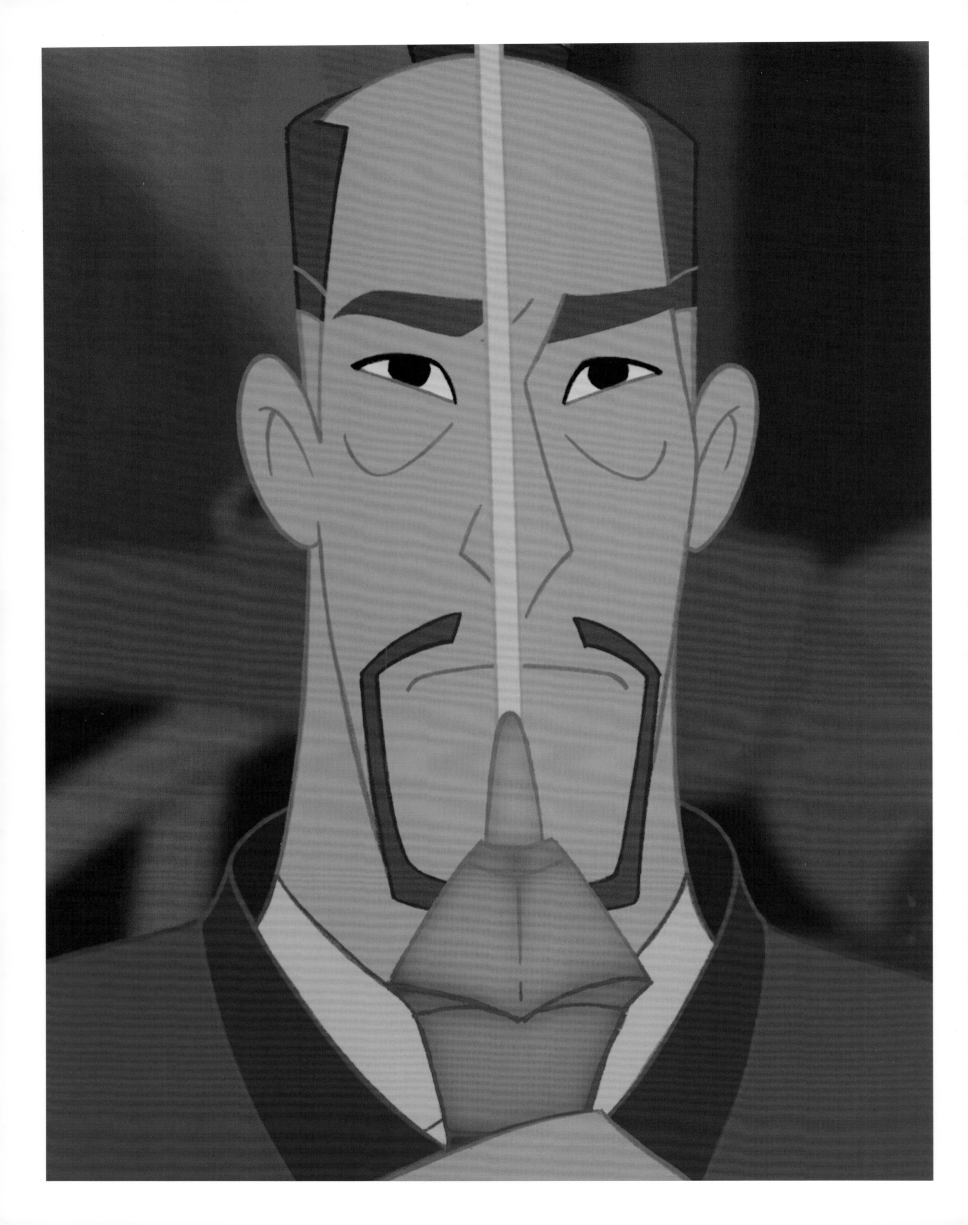

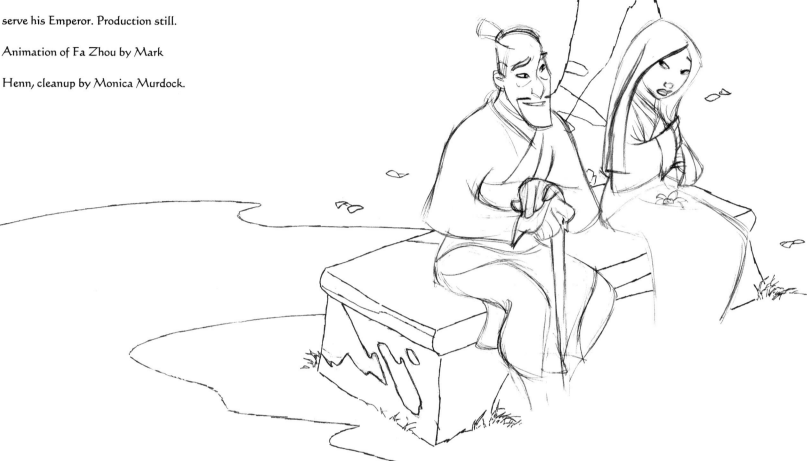

F
A

Z
H
O
U

"As the story evolved, it became clear that the father/daughter relationship is the foundation of the film," Mark Henn relates. "Because of that, they asked me to animate Fa Zhou as well. They knew that the sequences in which Mulan and her dad are together are the building block for what happens in the rest of the story. Hopefully, based on my acting abilities, they felt that I'd be able to pull it off and make it believable—this must be a very *real* relationship. I think it works. One of my assistants, every time she sees these scenes, wants to run home, pick up the phone, and call her father to say, 'Dad, I love you.'

"As I said, it's a very real, very believable relationship. No matter which kind of characters I do, that's always the *most* important thing; whether it's Mulan and her father, or Simba, or Belle, or Jasmine, or anybody. That's what I've grown up with in animation, and was taught to believe when I got to Disney by Eric Larson, Frank Thomas, and Ollie Johnston. It's the believability in the characters that has to work."

uben Aquino was assigned as supervising animator of Li Shang, the disguised Mulan's commanding officer and, ultimately, friend. A 16-year Disney veteran, Aquino began his Disney career as an inbetweener on *Mickey's Christmas Carol.* He became a supervising animator on *Oliver & Company,* and has served in that capacity since, on *The Little Mermaid, The Rescuers Down Under, Beauty and the Beast, The Lion King,* and *Pocahontas.*

"Toward the end of *The Lion King,* I was approached to work on the *Mulan* project in Florida. I was in California at the time. I was intrigued because of my Asian heritage, and since Disney's never done an animated film set in the Far East, I thought this would be a great opportunity for me to work on something unlike we've ever done before and which had great artistic potential."

Regarding Shang's appearance Aquino says, "We were pretty happy with the early test version of Shang that we came up with, but I knew that Chen-Yi wasn't. He came up with a design, based on what I had done, but it was a lot simpler. And then Tom Schumacher said, 'I like it, but his chin's too much like Buzz Lightyear.' He had this big chin. So I went over the Chen-Yi design and reduced the chin. Everybody liked it. And that's the final version that we have now."

Chen-Yi Chang sees Shang as "a bit conventional. He has the shape of typical superhero. That's a formula, but it still works for us. But he can be warm as a military commander. He honors his father, cares about his men, and

Above: **Visual development of Shang by Ruben Aquino.**

Below: **Rough animation of Mulan by Mark Henn and of Shang by Ruben Aquino.**

Opposite: **Production still. Animation of Shang by Philip Morris, cleanup by Cleanup Character Lead Bryan Sommer.**

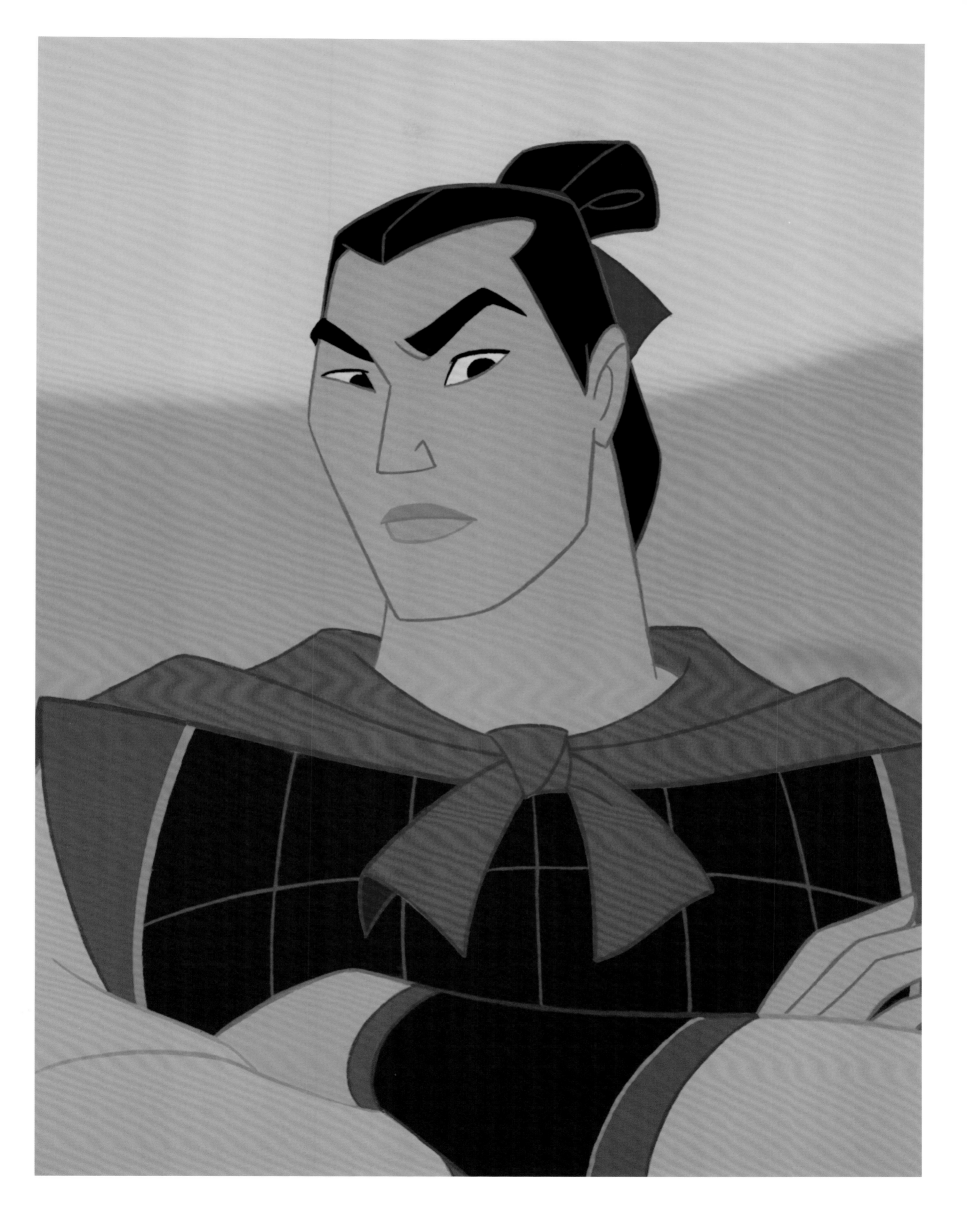

has a sense of humor, all of which work against his physical archetype. Still, in terms of story, we played it in degrees, so he wouldn't overwhelm Mulan, because Mulan is the focus of the story."

In an earlier version of the story, Shang was Mulan's betrothed, and the couple met briefly before Mulan disguised herself and joined the army. In another earlier version they *didn't* know each other, and the pair joined the army together but Shang was not her commanding officer. They were military peers. There was another character who was an army captain, an older officer. Finally, the character of that commanding officer and the betrothed Shang were combined into one.

Although a certain romantic tension was retained between Mulan and Shang, the structure of the story demanded that it be one-sided. "There is a love interest in Shang, which we only kind of hint at," Aquino says. "It's present, but it's low-key. We did that intentionally because we didn't want to complicate the story too much. But you still get the feeling at the end of the film that they might get together because Shang does come back to find Mulan."

Right: **Rough animation by Ruben Aquino.**

Top: **Production still.**

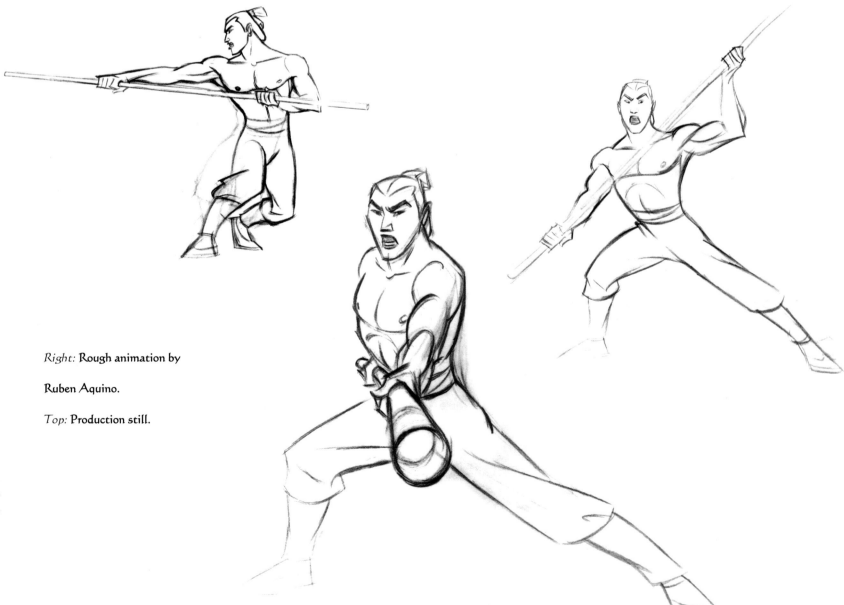

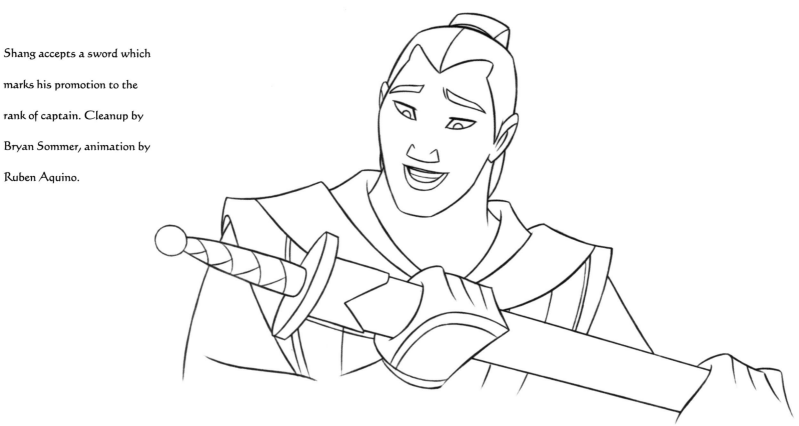

Shang accepts a sword which marks his promotion to the rank of captain. Cleanup by Bryan Sommer, animation by Ruben Aquino.

"As I picture Shang," Aquino goes on to say, "he's the latest in a long line of military officers. His father is the general. His father's father was a general, and probably back for generations. He went to the ancient Chinese equivalent of *West Point*. He had all the proper training, read all the right books on the art of war. He is proficient in martial arts, and can fight with a lot of different weapons—swords, lances, and sticks. He knows military theory, but he has never actually commanded troops or seen battle. He really wants to do well by his father and when he is promoted to the rank of captain, it is his big opportunity to show what he can do—that he's got the right stuff.

"When I started thinking about what actors or personalities Shang would be similar to, Barry Cook said maybe Clint Eastwood combined with Bruce Lee. Lee for the physicality, the athleticism, martial arts skills, but with Eastwood's understated macho. That's who I think of when I think of Shang—very cool, very definitely in control, and very by the book.

"A moment of the story that shows another side of Shang is the burned-out village sequence," Aquino continues. "It is the emotional low point for Shang. He's just found out his father has died, but he has to get back up and command his troops because China is in danger. The Huns are on the march and they've just defeated his father's army. He has to protect the Emperor. We see the strength of his character there. At the moment of his greatest grief and personal loss, he gathers his own inner strength to inspire his troops and rally them to go on."

Right: Visual development of

Yao by Chen-Yi Chang.

Below: Visual development

by Aaron Blaise.

Opposite: Production still.

Animation of Chien-Po, Yao,

and Ling by Tony Stanley,

cleanup of Yao by Cleanup

Character Lead Phil Boyd

and of Chien-Po and Ling by

Cleanup Character Lead

Tom Fish.

Y
A
O
,

C
H
I
E
N
-
P
O
,

A
N
D

L
I
N
G

After Mulan joins the army, assuming the identity of the boy soldier "Ping," fate throws her in with a disparate trio of fellow soldiers. Yao, Chien-Po, and Ling become an extended family to the solitary Mulan. The animation of the three was split between two supervising animators, Aaron Blaise and Broose Johnson. One of the graduates of the animation intern program at Walt Disney Feature Animation California, Blaise has lent his talents to *The Rescuers Down Under, Beauty and the Beast, Aladdin, The Lion King,* and *Pocahontas;* and the Roger Rabbit shorts *Trail Mix-Up* and *Roller Coaster Rabbit.* Blaise was assigned to the role of Yao.

Blaise admits that his source for Yao was close by. "There's something of a cliché about an actor, or animator, trying to put a little bit of himself in all his characters, but it's true. I tend to have a pretty hot temper sometimes, and so I tried to find that part of me and make that *all* Yao. He's this guy that just has no fuse—let alone a short fuse. If he was in a fight, he'd be way over his head. He'd get his butt kicked every time, but he'd be in there punching to the last minute."

Like his colleagues, Blaise found his design of Yao was influenced by the distinctive character stylings of Chen-Yi Chang. "If you look at his character design, everything flows. You've got to draw like Chen-Yi, and you're trying and trying. And now at home, when I'm drawing something for myself, I find myself drawing like Chen-Yi. His design principles and drawing principles have kind of rubbed off on everybody. And I think they'll probably influence us from now on. It just goes on and on—each picture has a little of the last in it.

"In the case of *Mulan* and Yao, it's smooth curves and a simplicity in line. The artwork attempts to get as *much* information across as possible with as *little* information as possible. By doing that, the artwork naturally comes across looking Asian. Even if you don't intend to create Asian looking work, by following the principles we followed, the artwork will end up with an Eastern feel."

Broose Johnson came to Disney as a cleanup artist on *Oliver & Company* and *The Little Mermaid*. He became an animating assistant on *The Rescuers Down Under*, then animator on *Beauty and the Beast, Aladdin, The Lion King,* and *Pocahontas. Mulan* characters Ling and Chien-Po mark the beginning of Johnson's work as a supervising animator.

"Chien-Po quickly established himself as the gentle giant and a peacemaker among the group, a perfect contrast to Yao's short fuse. Then we thought of Ling. Where does he fit in? Well, for a while we thought he could be a con man—sort of a gambler type—but that didn't feel quite right or fill the needed gap. Ling grew over time and ultimately became part ladies man, part instigator, and a lot Goofy," explains Johnson. "I've always liked how loose and elastic Goofy's body is, perfect for broad physical comedy. Pratfalls and head bonks aren't that funny with Chien-Po and Yao, but they're hilarious with Ling. We decided if one of the three is gonna get smacked in the face, or lose some teeth, it's gonna be Ling."

Above: Visual development of

Chien-Po by Caroline Hu.

Top: Rough animation of Yao by

Aaron Blaise.

Right: Cleanup of Yao by Phil

Boyd, animation by Aaron Blaise.

Cleanup of Chien-Po by Tom

Fish, animation by Supervising

Animator Broose Johnson.

LING: SNAKE . . . AHH!

Above: Cleanup of Ling by Tom Fish, animation by Supervising Animator Broose Johnson. Cleanup of Mulan by James Parris, animation by Mark Henn. Water-effects animation by Kevin O'Neil.

Top right: Production still.

Below: Visual development of Ling by Broose Johnson.

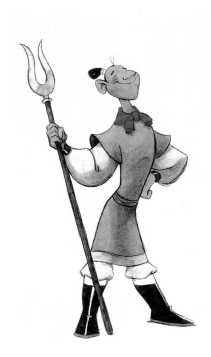

The interaction of Chien-Po, Yao, and Ling echoes classic 1930s cartoon shorts like *Alpine Climbers* (1936), *Clock Cleaners* (1937), *Lonesome Ghosts* (1937), and *Boat Builders* (1938), where charm and humor derive from Mickey Mouse, Donald Duck, and Goofy each being confronted with similar situations, and reacting in their own distinctive ways.

Johnson continues, "I worked poor Ling like crazy. I'd throw him around or smash his head, and yet, all the while, there's sweet Chien-Po, quietly being 'Mr. Peaceful' over in the corner and people would always say, 'I love that big guy. I want a plush toy of him!' Poor Ling—no respect.

"Since Chien-Po doesn't say a lot in the movie, people might see him as a big, dumb guy, which he's absolutely *not*. In fact, he is quite possibly the smartest guy in the whole army, but he only talks when he has something to say. There are often times when we approach a scene and say, 'Okay, Yao will do this, Ling will do that, but what should Chien-Po do?' Well, he'd just sit and observe. That's what he does. It's as if the other characters need to *do* something to be doing something. But for Chien-Po, 'stillness' is what he does. He holds the center. As soon as he *needs* to do something, believe me, he will."

In designing Yao, Chien-Po, and Ling, Chen-Yi Chang sought an efficient way of quickly communicating character traits to the audience. "There's three basic shapes which will probably be obvious to the audience. Yao is square, Chien-Po is round, Ling is a triangle, actually, two triangles put together, a diamond.

"So the shapes also represent their personalities, too. Yao is like . . . well, a brute. So he's got a hammerhead, squarish, just like a hammer. He likes to fight.

"Chien-Po is big, huge, but nice; so he's like a big Buddha. Even though he's got humongous power, he is gentle; he's like a whale; a gentle giant. So everything in his body, especially in his face, is created by circles."

"I actually see Chien-Po as being very similar to Jackie Gleason," Broose Johnson says. "Gleason was more of a big guy than a fat guy. He wasn't blubbery. He was compact and tight and graceful. So with that in mind, we tried very hard not to make Chien-Po come off like a *fat* guy. He doesn't budge. He's just plain big."

Below: **Rough animation of Ling, Chien-Po, and Yao by Broose Johnson.**

Right: **The dream sequence from the song "A Girl Worth Fighting For." Storyboard art by Tim Hodge.**

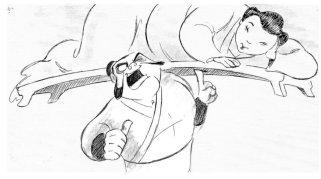

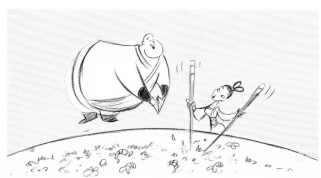

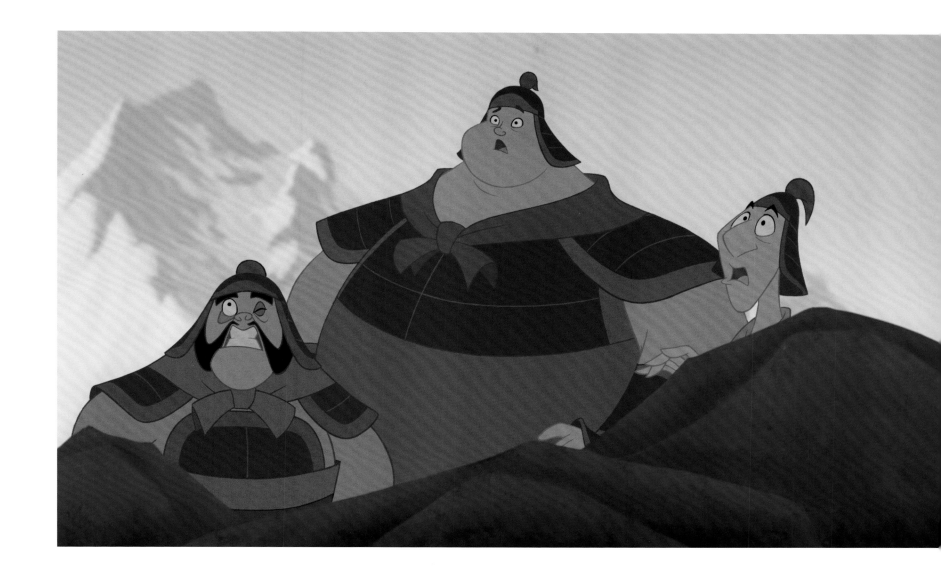

Above: Yao, Chien-Po, and Ling react upon seeing the oncoming avalanche. Production still.
Below: Color model of Yao, Ling, and Chien-Po in drag.

Chang continues, "Ling's head is triangular, and overall he has an aerodynamic shape. In China, when we refer to a person as someone 'with a pointed head and sharp face,' we mean he's someone who likes to make trouble for others but not get himself involved. And that's what Ling is. On the other hand, Yao's tough demeanor is conveyed through his square shape. And Chien-Po, round and smooth, is sweet and gentle.

"Each shape contributes meaning to the character. But, of course, I don't expect the audience to be consciously aware of the physical construction. What I hope is that they can at least intuitively identify the characters' personalities through their design."

Character traits also figured into color styling. Head of Color Models Irma Cartaya explains, "Yao, Chien-Po, and Ling—their colors match their personalities. Red for Yao—he's like a thermometer ready to burst. Blue for Chien-Po because he is calm and peaceful. And yellow for Ling because of his silliness."

MUSHU: Don't talk with your mouth full.
Now, let's see your war face . . .
Oooh, I think my bunny slippers just ran for cover.

M
U
S
H
U

Above and opposite: **Mushu tries to get Mulan to put on her "war face" for her first day of training. Production stills. Animation of Mushu by Charlie Bonifacio, cleanup by Cleanup Character Lead David Nethery (opposite).**

Top right: **Rough animation by Supervising Animator Tom Bancroft.**

Tom Bancroft came to Disney as an assistant animator on *The Rescuers Down Under.* He then became an animator on *Beauty and the Beast, Aladdin, The Lion King,* and *Pocahontas. Mulan* is the first time Bancroft has supervised the animation of his own character. And yes, *Mulan* director Tony Bancroft is Tom's brother. Not only that, his *identical twin* brother.

"I was really excited when I saw Chen-Yi's drawings because I love his style," Bancroft says. "Sort of the other side of Hans. Hans was slightly more realistic, very graphic. Chen-Yi had a cartoony graphic style, more comic-bookish, but a lot of fun. His character designs—even incidental characters—are *fun.*

"Chen-Yi had a very strong opinion about every character in the film. But as I worked with him on my designs for Mushu, I realized he didn't have a strong opinion about this particular character.

"So for Mushu it was difficult, the burden really kind of fell on me, and me being a first-time supervisor, it was fairly intimidating because I really wanted this character to be different than any other of the past cartoony characters that Disney has done, but I also wanted him to fit into the lineup, when you saw the characters together. I didn't want Mushu to look like he didn't have the Chen-Yi style that all the rest of them had or the Chinese influence."

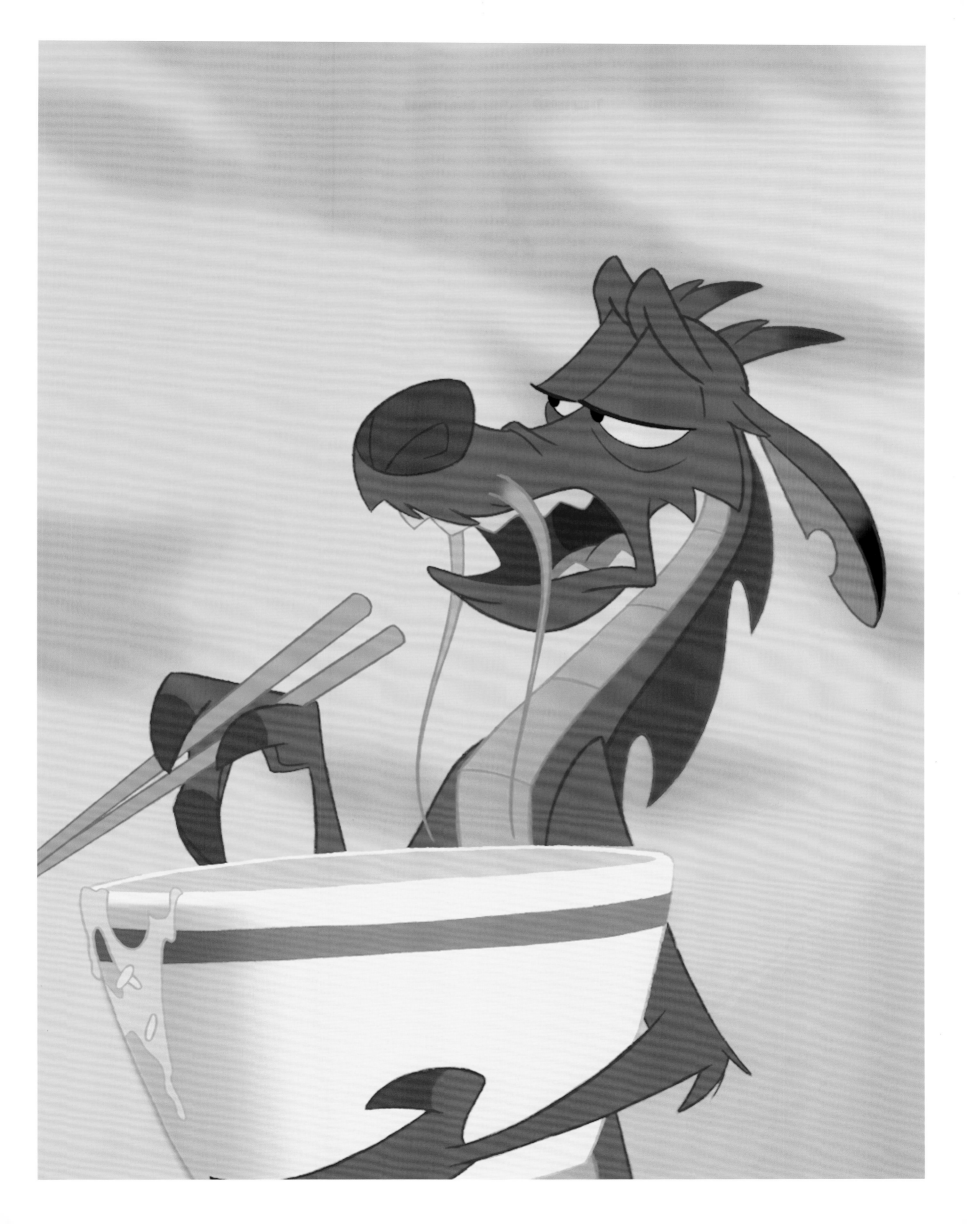

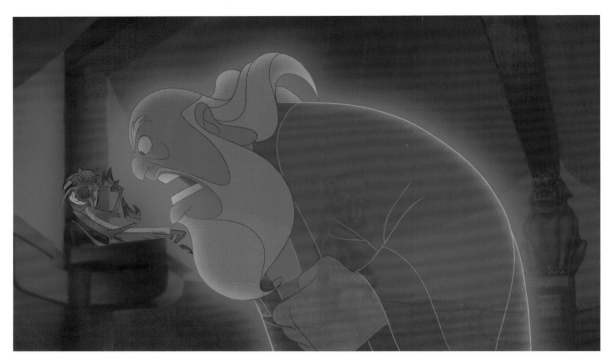

FIRST ANCESTOR: The point is we will be sending
a real dragon to retrieve Mulan.

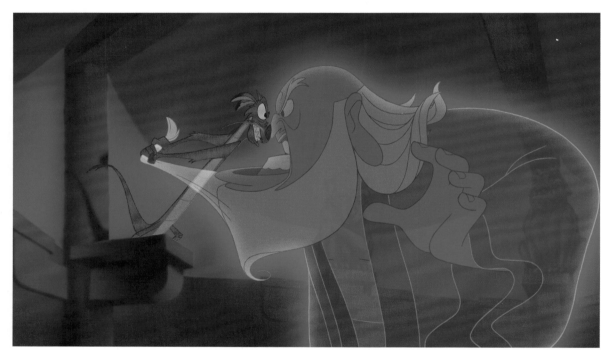

MUSHU: What . . . what? I'm a real dragon!

Left: Mushu reacts to an insult
from the First Ancestor as they
argue over who will be sent to
recover Mulan. Production stills.
Below left: Visual development
by Peter deSève.

The design of Mushu owes its look to a true Chinese-style dragon, more graceful and serpentine than the usual Western idea of the behemoth lizard. "Visually, Mushu is the most obvious example of the big S-curve," says Chen-Yi Chang. "Our animators could have made Mushu more crocodilish, more of a standard cartoon dragon—thick, stocky, with a big belly. I've seen it in American animated films. But, thanks to Barry's insistence, we've created a unique look for Mushu that is true to the Chinese culture."

As is often the case with comedic characters, there was a tendency for the creative group to fall in love with Mushu—and as a result, throw more weight on the film's comedic side. What often happens in that case is that the story is thrown completely out of balance.

Tom Bancroft explains, "Because I'm the supervisor of the character, my number one concern is how he fits into this *movie*, certainly how he looks, but I'm also very concerned with how he plays through the story and what his personality is—if it's running through the whole film the way we think it should be. Obviously, the story team has that same strong feeling that I do, but they have to do that for *all* the characters. Me, I'm just concentrating on Mushu. One of the things we discovered about Mushu was that giving him funny lines or wisecracks was easy to do, but if it was overdone, it would lose its effectiveness.

Cleanup by David Nethery,

animation by Tom Bancroft.

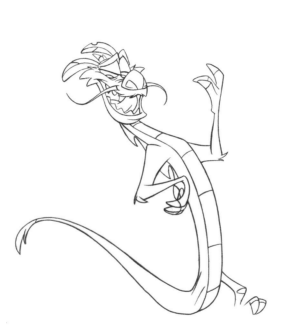

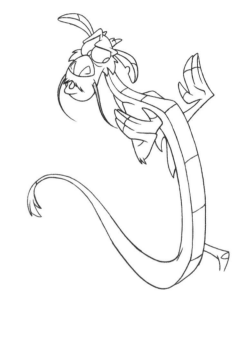

"So after the first pass, some of Mushu's business went to Cri-Kee. That gave him more of a use in the film, and a better balance as Mushu's partner. That really helped a lot. Cri-Kee carried more equal weight."

In addition, some of this humor went to Mulan. "She doesn't always have to be serious. We could split it up a little bit, and that became refreshing. It gave Mulan a whimsical side. She wasn't always just acting and reacting to things."

Again, as was the case in other areas of the production, the *Mulan* team wound up with a shared vision of the character. "It's not just me fighting for my version of Mushu, or Chris Sanders fighting for *his* version, or Barry or Tony saying, 'This is the way Mushu should be.' Through it all, somehow this has come together and has become *our* version of Mushu."

CRICKET (good Luck)

C
R
I
-
K
E
E

Mushu has a counterpart, and a counterpoint, in the character of Cri-Kee, the 'lucky' cricket. Veteran Disney animator Barry Temple was assigned as supervising animator. Temple began his Disney career as a cleanup artist on *The Fox and the Hound* in 1980, and has had a hand in nearly every Disney feature since then. His favorite experiences were animating the Sultan in *Aladdin*, Mrs. Potts, Lumiere, Cogsworth, and Chip in *Beauty and the Beast*, and as lead animator on Flounder in *The Little Mermaid*.

"The cricket was a character that some didn't want in the movie," Temple admits. "On the day it was assigned to me, the directors didn't want him in the movie, the story department didn't want him in the movie. The only people who truly wanted him in the movie were [Disney CEO and Chairman] Michael Eisner and [Disney story man] Joe Grant (who essentially created the character)—and myself, because I was assigned the character. I would sit in meetings and they'd say, 'Well, where's the cricket during all this?' Somebody else would say, 'Oh, to hell with the cricket.' They felt that Cri-Kee was a character who wasn't necessary to tell the story, which is true.

"In the same way, the mice and the cat weren't necessary to tell the story of *Cinderella*. Flit and Meeko weren't necessary to tell the story of *Pocahontas*. But I can't imagine now seeing *Pocahontas* without Flit and Meeko. These characters are able to reflect and support the circumstances and emotions of their companion heroines in a way that also provides an opportunity for entertainment.

Right: Cleanup by Kellie Lewis,

animation by Barry Temple.

Below: Cri-Kee gets the blame

for a little mishap with a cannon.

Production still.

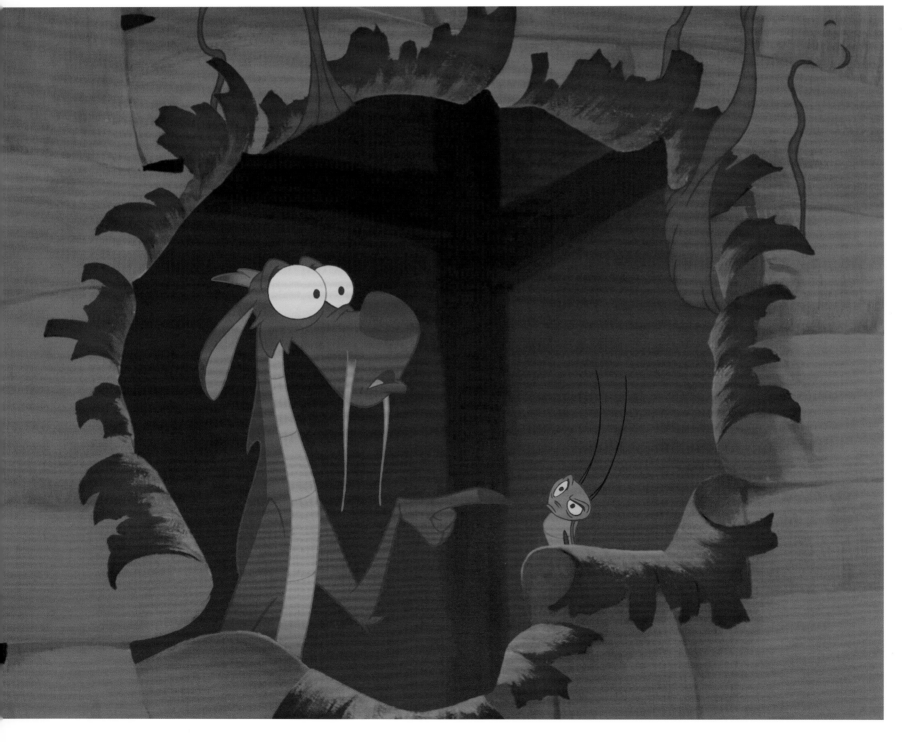

"They made the decision to make the cricket Mushu's companion, and what they came up with was really very good. Mushu translates for Cri-Kee. That's how they got it to work. Instead of having a cricket just hopping around, which could have been ineffective in realizing the character's potential, Cri-Kee becomes Mushu's steering mechanism. You'll see it two or three times in the movie, where Mushu wants to give up or he's being selfish, and the cricket sort of steers him back. And that provides Cri-Kee with more of a purpose. Instead of simply being there and chirping and going along with Mushu, he sometimes has to say, 'I'm going. You'd better come with me.' In contrast to Mushu's emotion-based reactionary nature, Cri-Kee is reason."

The three characters from her village, Mushu, Khan and Cri-Kee, become Mulan's inner circle. The three characters know the girl and her secret. Even when the soldiers abandon her in the snow, Mulan's hometown group is left.

Above: **Visual development by**

Burny Mattinson.

Above right: **Production still.**

In creating an animated performance for Cri-Kee, Temple faced a distinct challenge. "The script doesn't tell you much in terms of my character, because the character is pantomime. 'The cricket breaks out of his cage,' but it doesn't say what he's feeling, or doing, or what kind of mood he is in. It's both freeing and difficult. It's more difficult to have a pantomime character because a voice will give you timing and phrasing. With a pantomime character, you have to do it all. Even a lot of Cri-Kee's chirps and chortles and things are done later.

"It's such a difficult form of acting, and I don't know if I'd want to do it on a regular basis, but I am glad to have this opportunity because it's been done so well in some of our recent movies. The Magic Carpet and Abu the monkey in *Aladdin*. Flit, Meeko, and Percy in *Pocahontas*. Those were so well done, it's a challenge for me to try to live up to that standard."

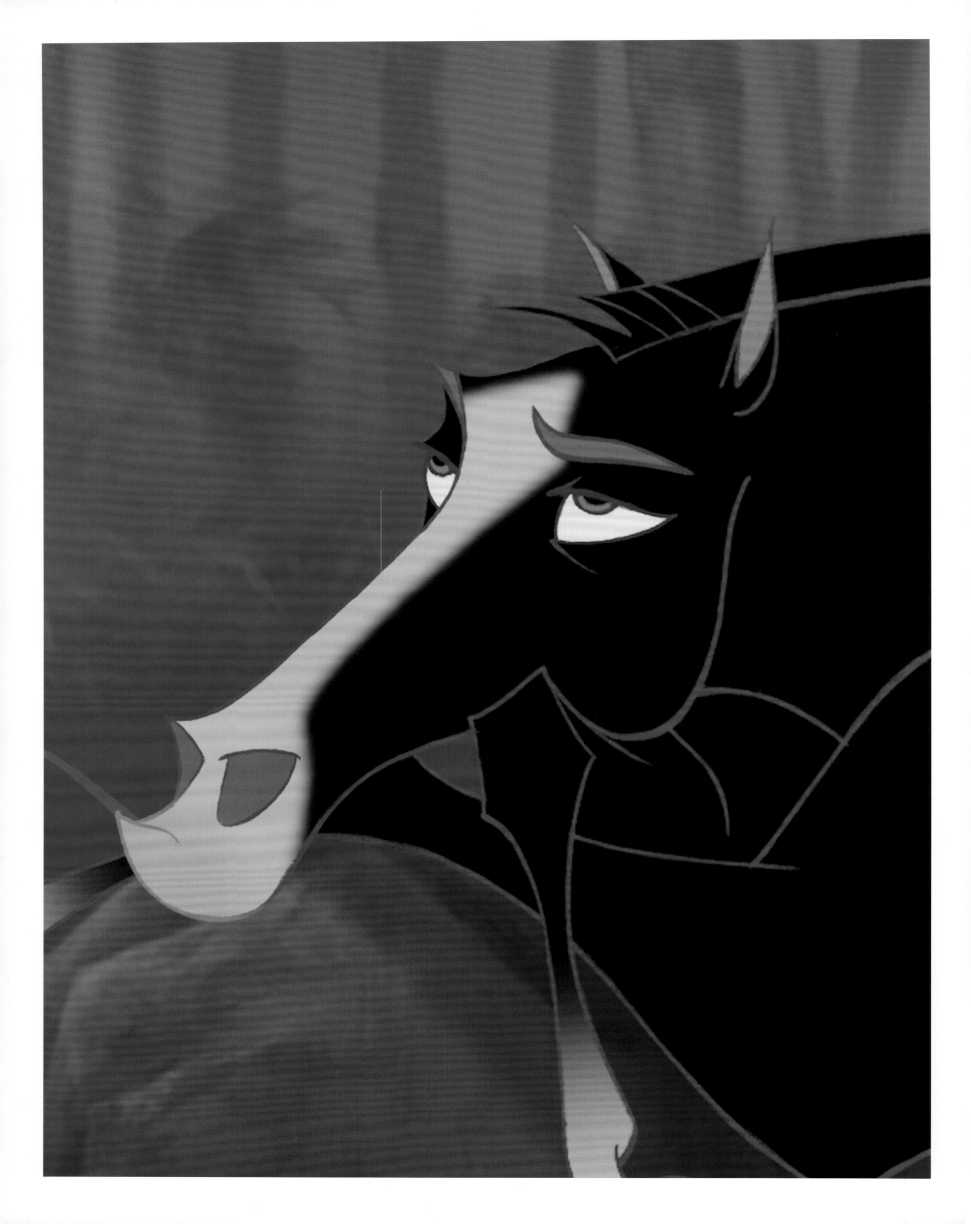

Left: Rough animation of Khan
by Supervising Animator Alex
Kupershmidt and of Mulan
by James Jackson.

Below: Visual development
by Alex Kupershmidt.

K
H
A
N

Opposite: Khan watches Mulan
practice her "guy" routine.
Production still. Animation of
Khan by Alex Kupershmidt,
cleanup by Cleanup Character
Lead Sam Ewing.

A 16-year Disney staffer, Alex Kupershmidt came to Walt Disney Feature Animation Florida out of the Walt Disney Imagineering theme park design group. His Feature Animation debut was as an animator on *The Rescuers Down Under,* after which he worked on *Beauty and the Beast, Aladdin,* and *The Lion King,* as well as the Roger Rabbit shorts *Trail Mix-Up* and *Roller Coaster Rabbit* and the experimental short *Off His Rockers. Mulan* is the first time Kupershmidt has supervised the animation of his own character: Mulan's loyal friend, the stallion, Khan.

Kupershmidt sees Khan as "kind of a unique character to the film. He's the only character who has no ulterior motives when it comes to Mulan. I assume Khan is about ten years old. She probably acquired him when she was six or seven, so they grew up together. They tune into each other, almost can read each other's minds. He's also true blue, a straight arrow. He would sacrifice himself for Mulan if she asked him to. He's the only character in the film who's black and white, so to speak. He also has certain qualities, particularly in his dealings with Mushu and Cri-Kee, a certain snobbishness. He's rather aristocratic, being a purebred.

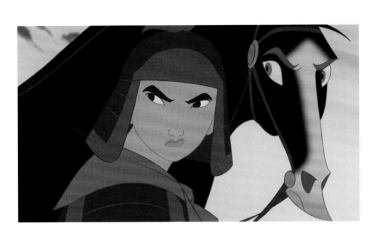

Above: Production still.

Right: Cleanup of Khan
by Sam Ewing, animation
by Alex Kupershmidt.

Below: Visual development
of a Tang dynasty-style
horse by Chen-Yi Chang.

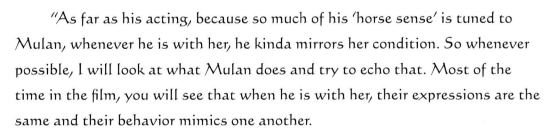

"As far as his acting, because so much of his 'horse sense' is tuned to Mulan, whenever he is with her, he kinda mirrors her condition. So whenever possible, I will look at what Mulan does and try to echo that. Most of the time in the film, you will see that when he is with her, their expressions are the same and their behavior mimics one another.

"He's rather large, so every time he's in a frame with somebody, he tends to draw the attention to himself like having a big black dot in the middle of the screen. So when he's acting with another character, the less he moves, the better it is. He can't be all over the screen really unless he's all by himself."

"We tried to use as much contrast of shapes as possible in Khan," says Chen-Yi Chang. "We do have the idea of an idealized Chinese horse—this huge bulky body with thin, sticklike legs. That's what you see in a lot of Chinese art. I think this design achieves the contrast and elegance we're looking for throughout the whole film. When I presented the character to Peter Schneider—he's a horse owner—he said, 'If I saw a horse with skinny ankles like that, I wouldn't buy it.'"

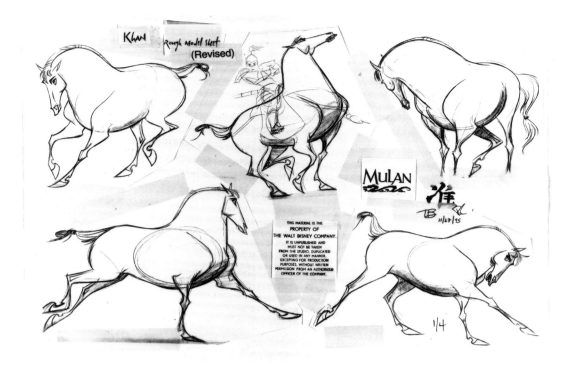

Left: Rough model sheet by

Alex Kupershmidt.

Below: Khan responds

to an order from Mushu.

Production still.

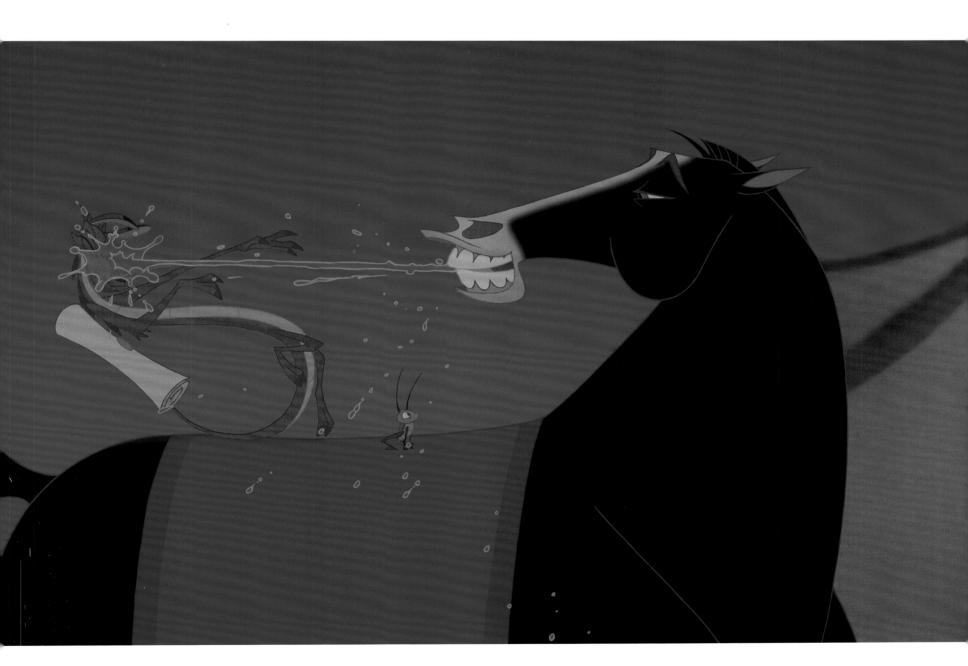

Below: Visual development

by Chen-Yi Chang.

Below right: Cleanup of

General Li by Cleanup

Character Lead Sam Ewing,

animation by Supervising

Animator Alex Kupershmidt.

Opposite: Production still.

Animation of General Li by

Alex Kupershmidt, cleanup

by Sam Ewing.

A lex Kupershmidt also performed another role, that of Shang's father, General Li.

"His personality is felt throughout the film by the way it motivates the character of Shang," Kupershmidt says. "Li is a professional soldier. He has spent all his life in the army. He's been successful with it, which is why he has acquired a status of general. He has the arrogant confidence of a man who is secure in the knowledge that his orders will be obeyed. He has the strength of someone who knows he has achieved the position that is suited to his abilities. Perhaps this arrogance does him in, because he didn't recognize just how sneaky and powerful the Huns would be. That's what I tried to give him.

"I think in Western culture, a man of power is almost always required to move a lot, creating threatening gestures. I think in Asian cultures, it is just the opposite. Whoever is on top has to do very little.

"I tried to make his movements and his expressions very subdued. But when he does say something, I tried to give him certain Mr. Spock-like gravity, if you will. Perhaps in that way, he and Khan are alike. They don't do all that much, in terms of physical movement. That's a tough thing to do for an animator. By nature, we want to do things that impress. But once in a while, you have to do what's proper. And at a certain point, the character will dictate what you do."

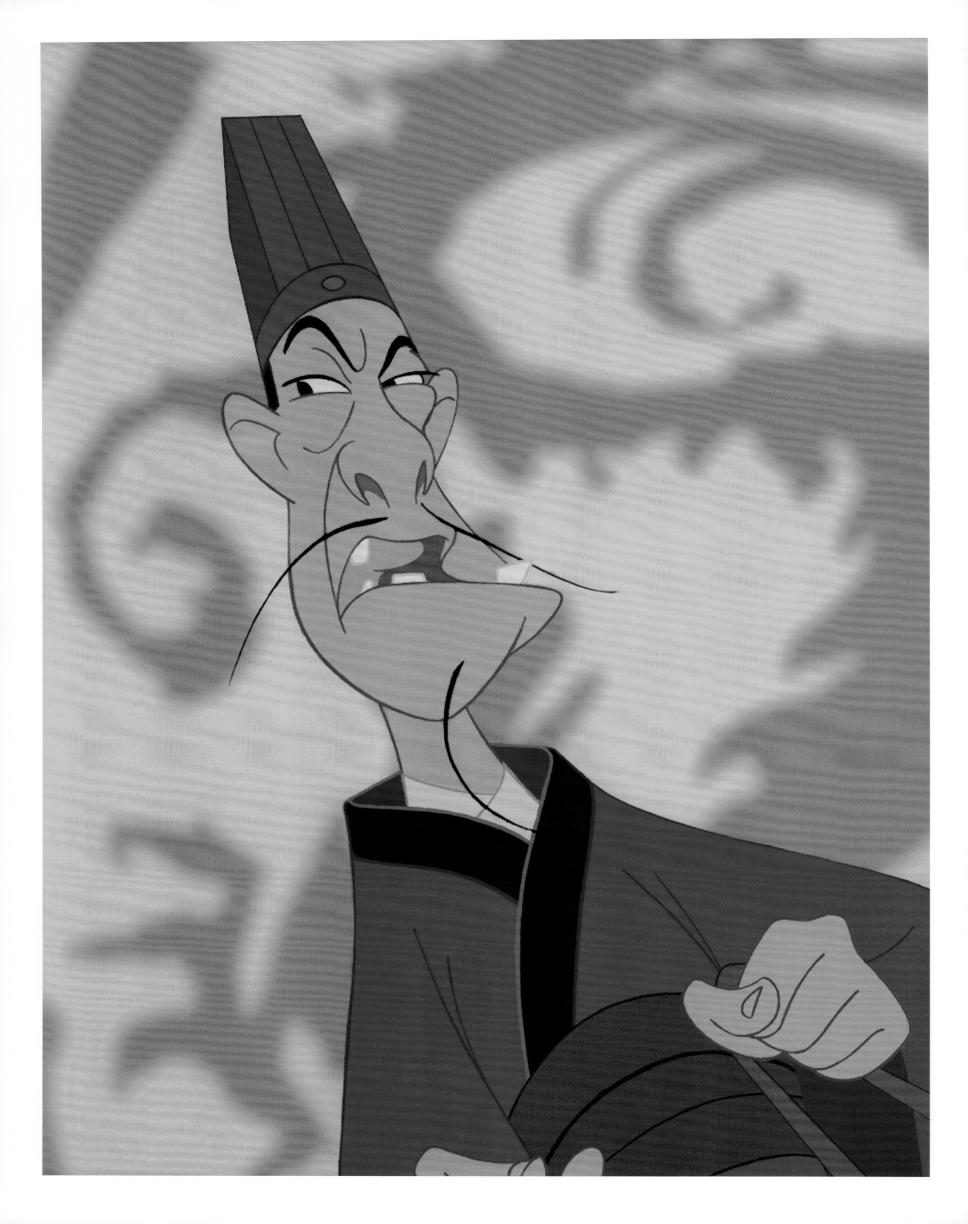

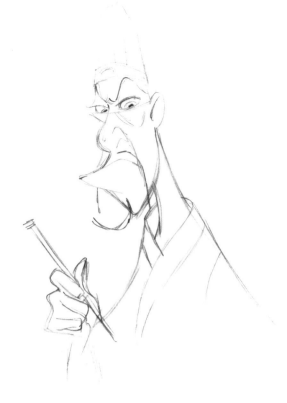

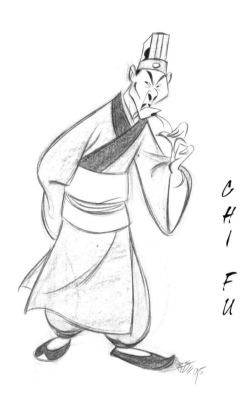

C
H
I

F
U

Above: Visual development

by Chen-Yi Chang.

Above right: Rough

animation by Jeffrey Varab.

Opposite: Production still.

Animation of Chi Fu by

Jeffrey Varab, cleanup by

Scott Anderson.

Jeffrey Varab began his career at Disney with the Christmas featurette *The Small One* (1978), after which he worked on *The Fox and the Hound* (1981) and did storyboards for *Tron* (1982). He left Disney, working as a supervising animator on several projects, including *All Dogs Go to Heaven* (1989), *FernGully…The Last Rainforest* (1992), *We're Back: A Dinosaur's Story* (1993), and *Balto* (1995). Varab has also applied his animation skills to the burgeoning computer animation field as one of the supervisors of the ghostly animated action in *Casper* (1996). Varab returned to Disney after a long absence to supervise the roles of the uninhibited Grandmother Fa and the reptilian imperial majordomo Chi Fu.

Again, a pervasive sense of balance and attention to the needs of the story dictated the behavior of the characters. In the case of Chi Fu, an inherent and effortless humor in the character came as a pleasant surprise.

"With Chi Fu's character," Varab explains, "the more unctuous we make him, the more funny he is—and you wouldn't think that. At the outset you wouldn't say that Chi Fu's brand of slime equates with humor, but the way he's playing, with the combination of his design, material, and timing, it's really working out."

Chi Fu's disagreeable traits are communicated through color, too. Color Stylist Irma Cartaya says, "Chi Fu is not a nice guy—he's basically a slimeball. His flesh tone is green—like he's seasick. And he's repugnant, just disgusting to look at."

Varab concludes, "*Mulan* was made for the character's point of view from the very beginning, and every concern was coming out of the characters. The drama is coming out of the characters. The conflict is coming out of the characters. The humor is coming out of the characters."

"Originally I was supposed to do Grandmother Fa only," Jeffrey Varab recalls. "She had a bigger role in the film. Eventually we had to reduce her role—we didn't want her to upstage Mulan. She was getting too cute, too slapsticky. But I've come to really bond with her in a way, because she just has so many nice bits throughout the whole movie.

"With Grandmother Fa it's been a constant toning down to let the comedy come out of her personality and how she approaches life, rather than just giving her a funny walk or funny dialogue to impart humor."

Above: Visual development by Supervising Animator Jeffrey Varab.

Right: Mulan and Grandmother Fa during the song "Honor to Us All." Production still. Animation of Mulan by Rune Brandt Bennicke, cleanup by Daniel Gracey. Animation of Grandmother Fa by Todd Waterman, cleanup by Cleanup Character Lead James Parris.

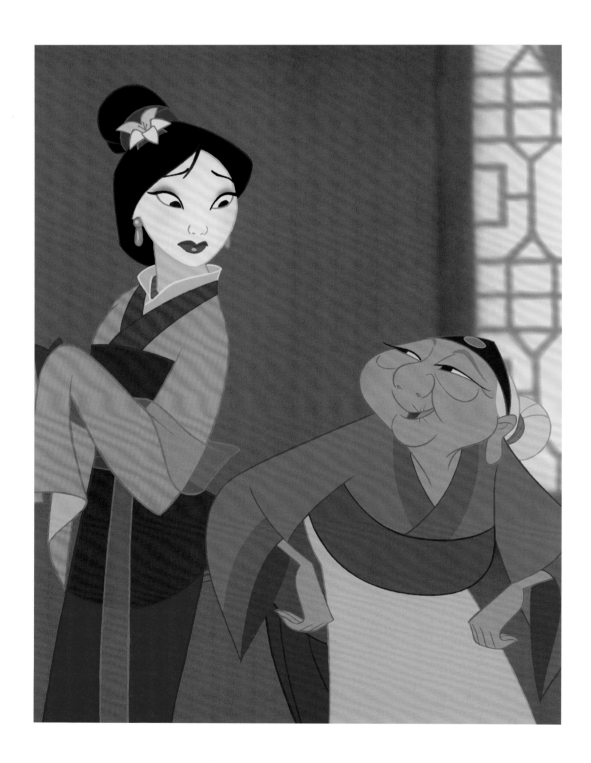

Left: Early visual development of Grandmother Fa by Chen-Yi Chang.

Below: Cleanup animation model sheet by Disney Studio Artist.

gRaNdMa
cleanup Model Sheet
(Revised)

shorter dress
and feet showing

160

Opposite: Visual development

by Chen-Yi Chang.

Right: Mulan is treated to a cold

bath. Production still. Water-

effects animation by James

DeValera Mansfield.

Below: Cleanup of Fa Li by

Cleanup Character Lead

Monica Murdock, animation

by Ruben Aquino.

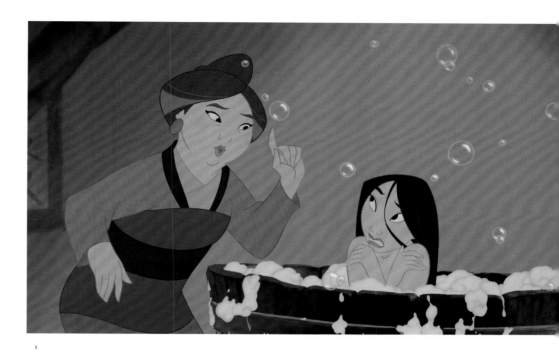

F
A
L
I

"**F**a Li represents the ideal Chinese woman, wife, and mother," says Supervising Animator Ruben Aquino. "Physically she resembles Mulan—just a bit older and more plump—but their personalities are very different. Instead, Mulan takes after Granny who is a bit unconventional and unpredictable."

While Fa Li's character may be traditional and predictable she does, however, represent a break with Disney convention. Along with Fa Zhou, she creates a two-parent family for Mulan which is unusual because the heroes of past Disney animated films were often orphaned or had only one parent. The explanation for this reveals something about the complexity behind creating a tight story line that eliminates everything that is unnecessary. With two parents, unless they support the hero in different ways, they essentially perform the same story function. However, assigning different story functions to each parent can suggest a disagreement between them that may distract from the story's focus. In addition, animation being extremely expensive, it doesn't make sense to have two characters who do the same thing.

On *Mulan*, it was decided that Fa Li's function be to show what Mulan is supposed to become—the dutiful wife who supports her husband. Without her mother to represent what was expected of her, Mulan's dilemma and its ultimate resolution would not have been quite so clear. Fa Li, by being who she is, helps define who Mulan is not. In the end, the filmmakers gave Fa Zhou and Fa Li separate, black-and-white roles and let Mulan keep throwing herself in the grey area.

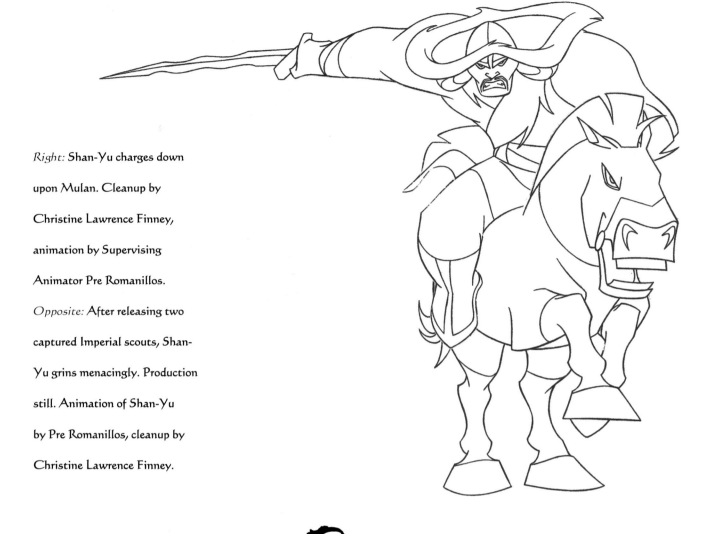

Right: Shan-Yu charges down upon Mulan. Cleanup by Christine Lawrence Finney, animation by Supervising Animator Pre Romanillos.

Opposite: After releasing two captured Imperial scouts, Shan-Yu grins menacingly. Production still. Animation of Shan-Yu by Pre Romanillos, cleanup by Christine Lawrence Finney.

SHAN-YU

P re Romanillos attended the School of Visual Arts in New York, and spent several years at UCLA studying acting and theater. He came to Disney in 1988 for *The Little Mermaid*, and has worked on *The Rescuers Down Under, Beauty and the Beast, Aladdin, Pocahontas,* and *The Hunchback of Notre Dame.* Shan-Yu is Romanillos' first assignment as a supervising animator.

"There is little difference between writing, acting, and animation," Romanillos says. "What I've learned about animation is that singing, dancing, writing, and playing a musical instrument are all the same thing. They are all part of the arts. The medium's different, but the approaches and objectives are the same. We gather information, become inspired, and try to communicate what we are seeing or feeling to someone else."

Romanillos has a clear-cut perception about the character he plays and that character's place in the story. "The film is really about Mulan's journey. And in order for her to make the journey she undergoes a change, a transformation from an innocent child to someone who saves China from impending doom. Shan-Yu is the impending doom. That's my character. The more real the threat is to China, the more powerful and heroic Mulan's actions become."

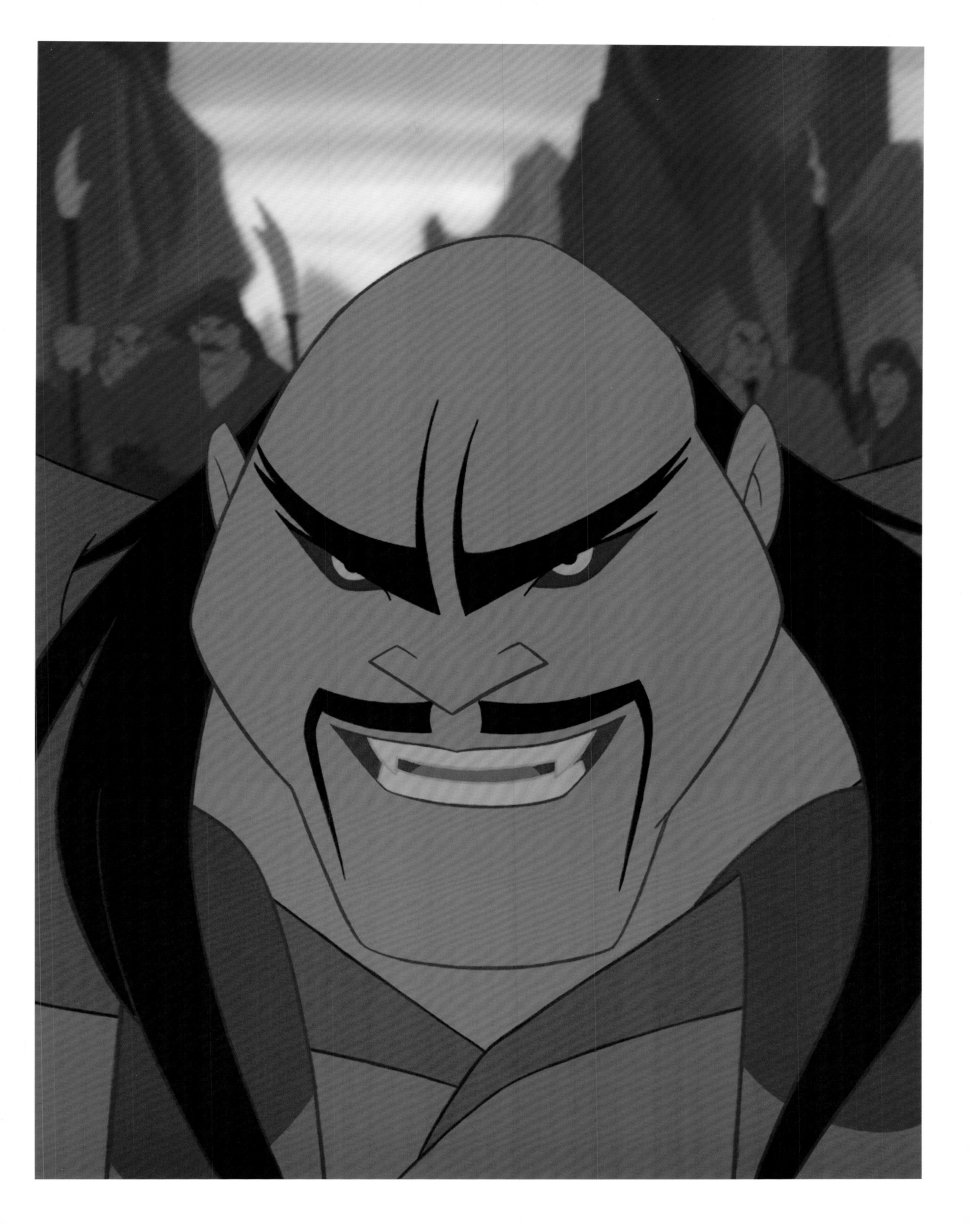

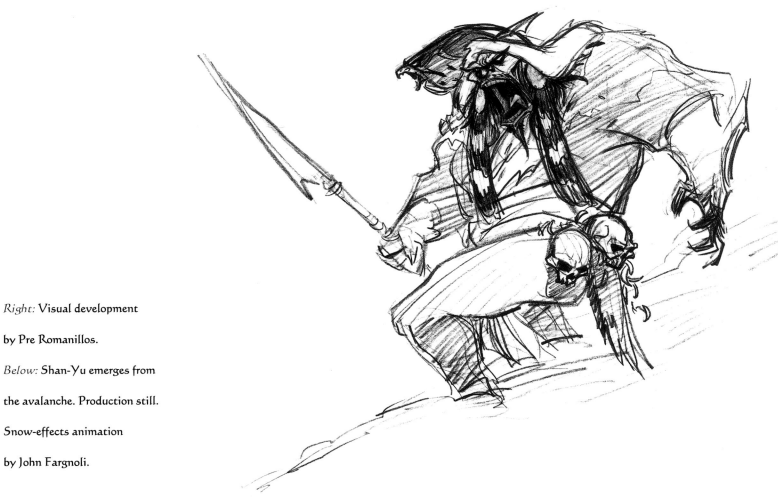

Right: Visual development
by Pre Romanillos.

Below: Shan-Yu emerges from
the avalanche. Production still.
Snow-effects animation
by John Fargnoli.

Below and opposite: Rough
animation by Pre Romanillos.

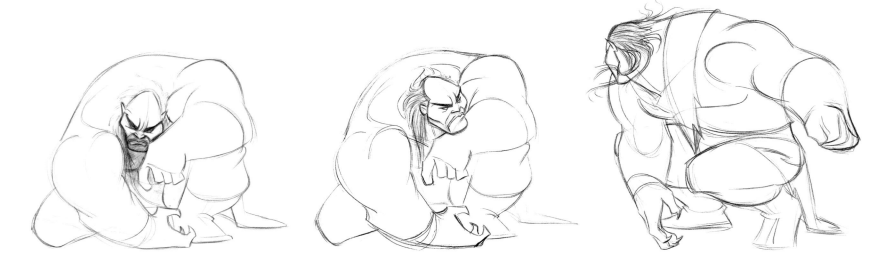

164

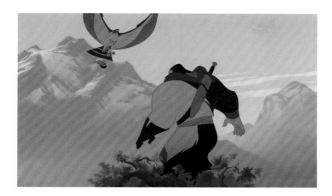

Above: Shan-Yu's falcon brings him a child's doll that provides clues to the location of the Imperial army. Production stills.

"For the longest time, I think my character's been the one that was kind of lagging behind in terms of development simply because they knew what they wanted, as far as this impending doom, this threat—yet they didn't quite know how to present it, without it overcomplicating this whole journey.

"I had read a book describing the Huns as ultimate warriors. Shan-Yu is that. He's been conditioned since he was little. He's invading China because, by building the Great Wall, the Emperor *invited* him. Shan-Yu has a superiority complex."

From his perspective as the film's barbarous villain, Romanillos makes an interesting observation. "It's strange—it's a war movie without a lot of war. I didn't think it could be done. But we've done it, and it works really well, because we focus on the relationships. The movie is really about relationships." (Much as *Gone With the Wind* is remembered as a Civil War epic, although there are no battle scenes in the film.)

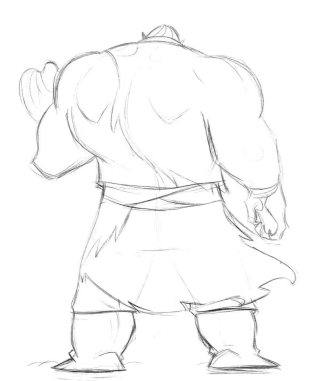
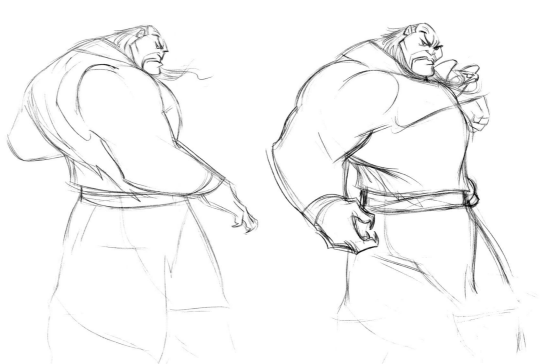

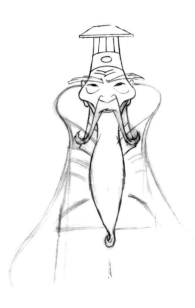

Above: Visual development

by Supervising Animator

T. Dan Hofstedt.

Above right: Visual development

of a rotund and jolly Emperor by

Chen-Yi Chang.

Below: Production still.

Animation of the Emperor by

T. Dan Hofstedt, cleanup by

Cleanup Character Lead

Rusty Stoll.

T. Dan Hofstedt began his Disney career with *Aladdin,* on which he animated several supporting characters. Since then, his animation has been seen in *The Lion King, Pocahontas, The Hunchback of Notre Dame,* and *Hercules.* For *Mulan,* Hofstedt supervised the animation of the Emperor.

Like many of his colleagues, Hofstedt was initially attracted by Chen-Yi Chang's character designs. "I took my cue," he recalls, "from the first sketch that Chen-Yi had done of the Emperor—very tall, very regal, very composed; you know, everything was wrapped up in that one sketch. He had confidence; he had kindness; he had wisdom; he had strength."

As his colleague Alex Kupershmidt discovered in animating General Li, Hofstedt noted that nobility and power could be communicated by minimal action. Hofstedt explains, "He didn't have to bounce around, he could just be very composed, and yet project a whole lot of feeling. . . . So I knew from the beginning that his personality had to be played in minimal movements, and that the movements he *did* make would have to have meaning.

"That presented a challenge—how to get the most out of each pose," Hofstedt continues. "So I challenged myself to try to tell the scene in as few drawings as possible, to keep the Emperor as composed and in control as possible, because I felt that that was a part of his personality that fit into the film."

Hofstedt was fortunate to be able to flex his acting muscles early in the production. "I animated the end of the movie first," he explains, "which really was the most critical part. The Emperor's most meaningful scenes were his confrontation with Mulan. It was a good opportunity to sort of run the gamut, because he was very severe, and he builds up in severity as he lists all of her infractions, and then finally he softens and says, 'You have saved us all,' and he smiles. Within that short space of seven or eight scenes I've got to go through a huge arc. It was good to work on that wide range in the beginning, so we could test the limits. In the scenes that followed, the character's acting boundaries were easier to determine."

THE ANCESTORS

In addition to performing the role of Yao, Aaron Blaise performed the supernatural role of the ancestors. "There are ten ancestors that actually speak, and they all have their own little distinct personalities. But the First Ancestor, I just played him all-powerful and very regal. The fun thing about them was to get a spirit-like feel. So I made them very wispy and floaty. And if you watch the First Ancestor, his sleeves and his hair never stop moving. He'll make a movement, and then it just kind of hangs there—very underwater-looking with lots of different timings and stuff like that. Cleanup hates me on those, but I'm really happy with how that turned out."

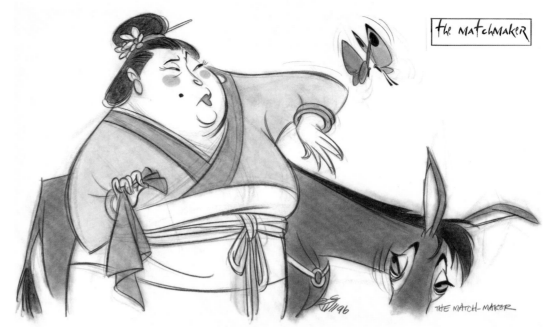

the MATCHMAKER

THE MATCH-MAKER

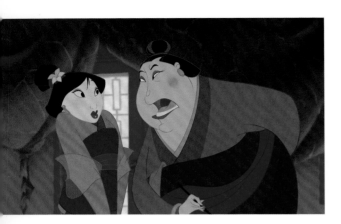

Above: Production still.
Cleanup animation of the
Matchmaker by Cleanup
Character Lead Kathy Bailey.

Right: Visual development
by Chen-Yi Chang.

Above: Cleanup by Cleanup
Character Lead Kellie Lewis,
animation by Byron Howard.

Right: Storyboard art by
Chris Sanders.

In addition to the cast of main characters in *Mulan* there were a number of secondary roles created that were in many ways no less important to the story. One of the most memorable is the Matchmaker, who, while she appears in only one sequence, leaves a lasting impression. Led by Brian Ferguson, whose previous credits include work as an animator on *Aladdin, The Lion King, Pocahontas,* and as a Lead Animator on *Hercules,* the Matchmaker represents the strictest interpretation of what is expected of Mulan by her culture. While Mulan's mother Fa Li is used as a subtle example of the traditional role of a woman in Chinese society, it is the Matchmaker who states it in no uncertain terms. After their disastrous meeting literally goes up in flames, she informs Mulan that she has failed. "You are a disgrace! You may look like a bride but you will never bring your family honor!"

Although Little Brother's appearances in the film are also few, Lead Animator Sean Keller and Animator Byron Howard perform the role to full,

1.9-629R

comic potential. In his first scene, "the smartest doggie in the whole world" literally has to be picked up and turned around to face the right direction when called by Mulan. Although the original legend features an actual younger brother for Mulan, the story team instead conceived of Little Brother as her companion at home. Chris Sanders came up with the idea for the simple but lovable pet, who reflected not only Mulan's slightly awkward nature, but her deep sense of loyalty as well.

In much the same way that Mulan's personality is seen in her companions Little Brother and Khan, the villain Shan-Yu's threatening menace is reflected in the falcon. Like his master, the falcon is a natural predator who acts swiftly and mercilessly. He is also a cunning agent for Shan-Yu—acting as a decoy to allow the Huns to sneak up on the enemy and as an advance scout, warning of the locations of the Imperial army. Throughout the film, the falcon serves as a messenger of evil and doom always preceding Shan-Yu's appearances. He is like the shadow cast by evil before you see the evil itself. Because of the falcon's close association with Shan-Yu it was a natural decision to assign Supervising Animator Pre Romanillos to both roles.

Above: Cleanup by Kathy Bailey, animation by Lead Animator Brian Ferguson.

Right: Production still. Cleanup animation of the falcon by Cleanup Character Lead Christine Lawrence Finney.

Below: Rough animation by Trey Finney.

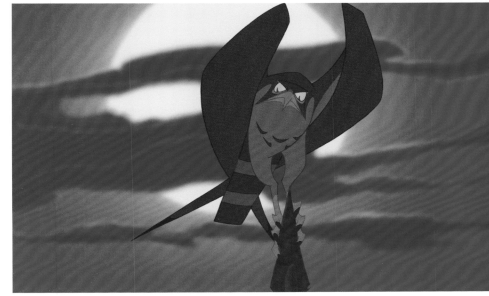

Creating an animated feature is a continually evolving process. It involves substantial experimentation and rethinking in order to achieve a desired result in character development, humor, or story action. Unlike live-action filmmaking, where the footage is shot from a finished script and then edited, in animation the script develops through a process of trial and error with various ideas and concepts. Some sequences are tightened and refined, others are augmented, while some are replaced or completely abandoned.

Throughout the journey of its development, *Mulan* evolved until it was a self-defining entity. Those in charge of creating *Mulan* learned to agree on its basic principles, thus showcasing another unusual and effective creative trait: the ability to let go. Over the course of production, when elements were not working in service to the story, they were altered or eliminated.

For instance, Chris Sanders recalls, "We had an overabundance of sidekicks; we had a dragon and a phoenix. Once we had two dragons, Yin and Yang. We immediately started trying to work on getting at least one of those cleared out of the story."

A number of songs were also considered and ultimately dropped. Composer Matthew Wilder remembers, "There's one piece that we wrote for Mushu that didn't make it into the film. It was a send-up of Ray Charles. Then another number that we tried for the same character that was a send-up of James Brown. You might expect Mushu to have a musical voice, but it just wasn't working, no matter how many different ways we tried it." "It was frustrating for us," adds Lyricist David Zippel. "Writing all these songs, and no matter what we wrote, it simply wasn't right for the story." "So, that moment fell by the wayside," Wilder concludes, "because the lack of *need* clearly defined itself."

An early version of the film's opening had Mulan riding Khan through the countryside. The sequence was eventually cut. Storyboard art by Thom Enriquez.

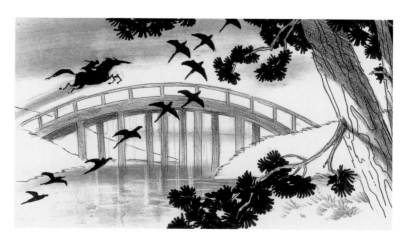

Below: At one point, the film opened with shadow puppets telling the story behind the building of the Great Wall. Although the idea was popular and the art distinctive, the sequence was abandoned. Storyboard art by Dean DeBlois.

Above: An abandoned character named Bao Gung. Visual development by Chen-Yi Chang.

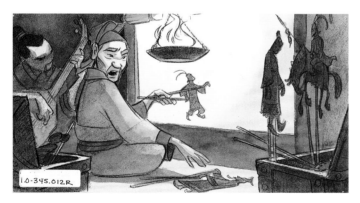

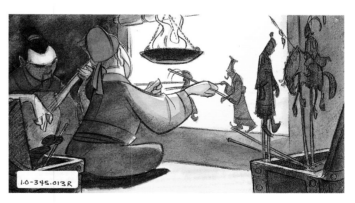

Right: Production still of the abandoned shadow puppet sequence. CGI of the shadow puppets by Sean Locke, Tony Plett, Chalermpon "Yo" Poungpeth, and Heather Pritchett.

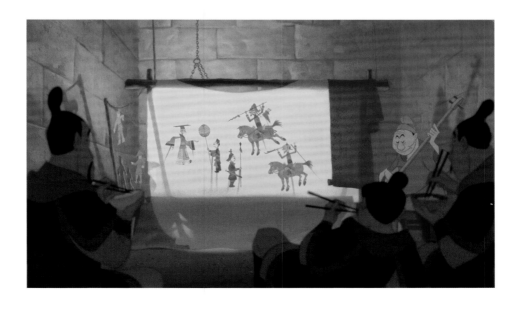

Near right: Visual development by Sean Sullivan.

Far right: Visual development by Sai Ping Lok.

Below: Production still. Smoke-effects animation by Jazno Francoeur.

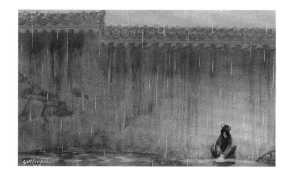

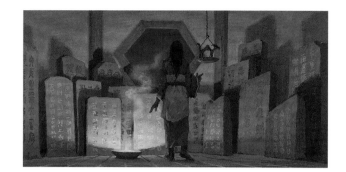

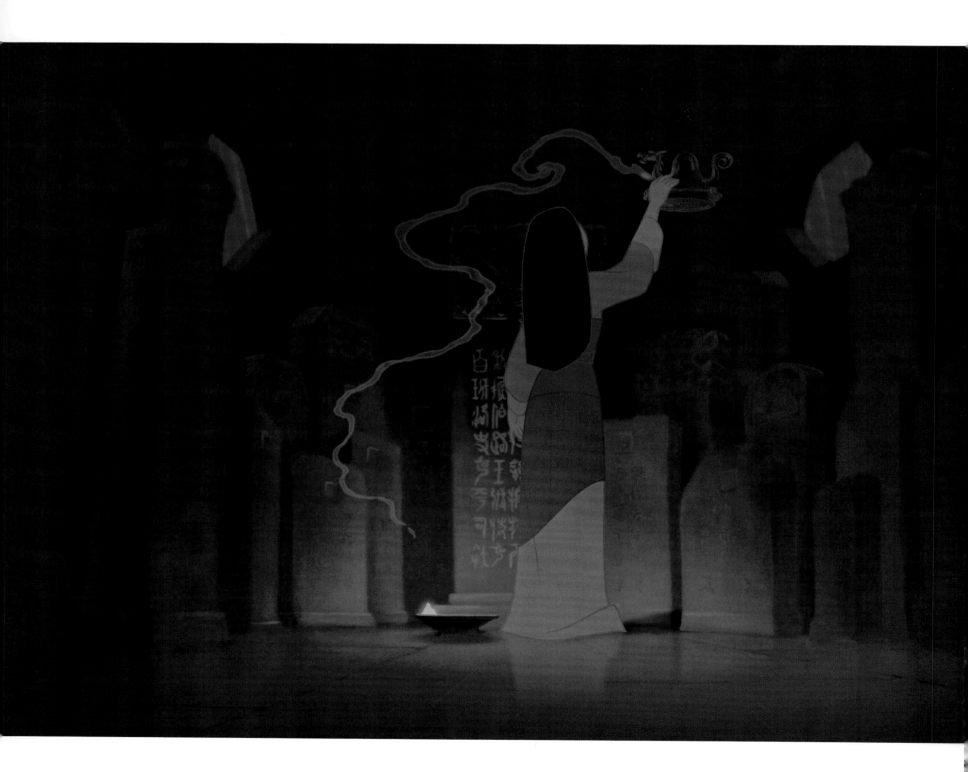

These pages: Afraid for her father's life, Mulan makes a desperate decision. She prays to her ancestors for guidance and protection, then takes the draft notice as her family sleeps.

Right: Production still.

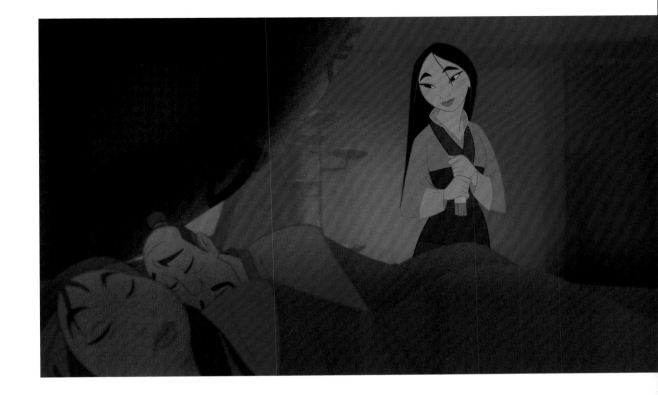

A DEFINING MOMENT: SEQUENCE SIX

*I*f there is an encompassing defining moment in *Mulan*, it is Sequence Six. As her family sleeps, Mulan makes a momentous decision. She takes her father's conscription order, cuts her long hair, and dons her father's armor— prepared to risk everything that matters to her, in order to *save* everything that matters to her. Mulan has made a choice that takes her past a point of no return. Not only is this a pivotal moment in the story, it also represents a point in the making of the film that can best be described as a complete and utter creative convergence.

Chris Sanders remembers, "When Dean DeBlois finished Sequence Six, there was definitely a feeling that *Mulan* had found itself. It had established its identity."

"Sequence Six started as a song," Barry Cook explains. "I had listened to the song and I had done thumbnails of images that stuck in my mind, of reflections, swords, just little ideas. When I listened to the song it had a lot of momentum to it. I gave the few ideas I had to Barry Johnson, who storyboarded the first version. We cut his boards to the song. It showed Mulan dressing in her armor. And then Chen-Yi Chang took it. I wanted the sequence to have his 'look.' So Chen-Yi redrew it, and put in a few of his own ideas that had meaning to him."

With Sanders' insistence that the one and only story of *Mulan* is "Mulan leaves home for the love of her father," the song was ultimately deemed inappropriate to the developing story. Cook continues, "So the song went away. We had this really strong story moment that launched off this song, but we no longer had the song."

"Dean asked to re-board Sequence Six," Sanders recalls. "He said, 'I know what I want to do, let me just do it. I know what I want to portray." DeBlois says, "The sequence was written in the script as a simple paragraph: 'Frustrated by what she sees and knowing what's coming, Mulan decides to take her father's draft notice as he sleeps; she steals his armor, cuts her hair, and rides off on Khan into the night. The family wakes up and realizes she's gone.' The only admonition I got before I began re-boarding the sequence was, 'We would like to try to play it with minimal dialogue.'"

6-41

6-42

These pages: Mulan cuts her hair with her father's sword and takes his armor. Transformed, she goes to the stable to get Khan.

Above: Storyboard art by Dean DeBlois.

Right: Production still.

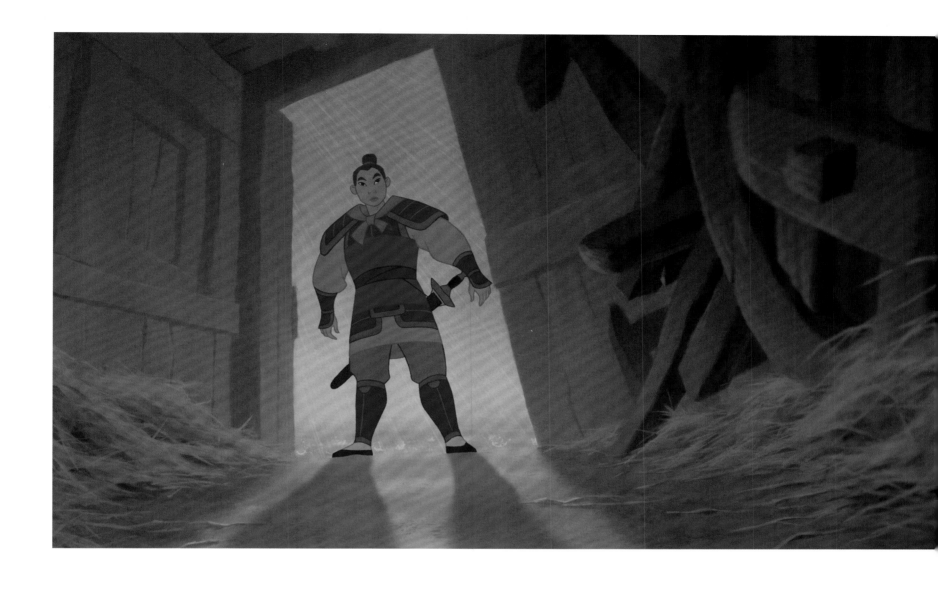

Above: Production still.

Below: Rough animation of

Mulan by Mark Henn and of

Khan by Alex Kupershmidt.

"We began to discover that silence works best for this film," Tony Bancroft recalls. "Whenever we got into a story session and we couldn't figure out what to do, we just said, 'How would it play if we were to do it silent, without any dialogue, just let the acting of the characters play the scene out?' Nine times out of ten, we discovered that that's the best way to do it."

Since DeBlois' directive had been to avoid dialogue, his whole approach became visual. "There's a respect, for instance, that goes along with the armor and the sword, and the way it's treated and handled. I felt there should be some ceremony and structure to how she did it, especially since she's just seen her father handling the same stuff that she's about to put on.

"As the sequence begins, all of the imagery is very flat, boxed-in, and structured. She is trapped within a structure that she is fighting against. Back and forth, seeing her mother upset with her father, her father blowing out a candle. We tried poetic imagery to symbolize what's going on. From the moment that she sees her parents, and the candle blowing out, we go tight on her resolved, determined face, and she snaps into action. From then on, the

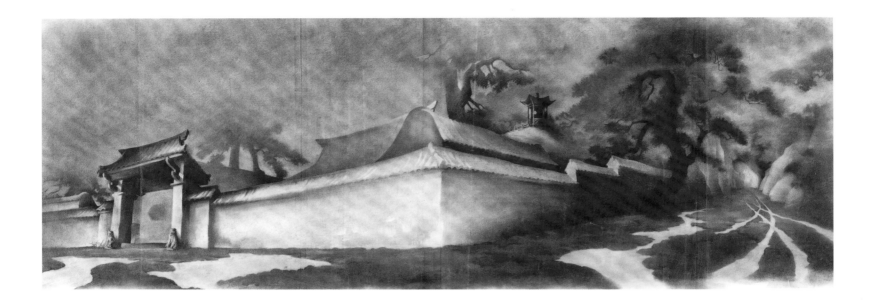

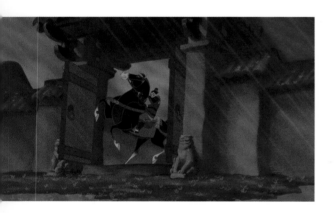

These pages: After Mulan and Khan burst through the front gate and ride away, a clap of thunder awakens the household and Fa Zhou finds Mulan's haircomb in place of the draft notice and his armor gone. Fearing for his daughter's life, Fa Zhou realizes that he cannot reveal what she has done or she will certainly be killed.

Above: Production still.

Top: Tonal layout art by Peter DeLuca.

cutting becomes more active and dynamic, with lots of camera moves. We tried to stage it so that from the moment she steals the draft notice, through to her cutting her hair and getting dressed, her face is hidden, until she's revealed as a soldier."

In approaching the layout of the scene, Robert Walker continued the staging conception that DeBlois had begun. "Sequence Six was all about Mulan making the transition from a woman into a soldier, and leaving the house. So the way that we staged the sequence was to assign a value to Mulan that transitioned through the sequence into something else, until she finally left. The value was the type of space she worked in. She started off in really flat space, and as the sequence progressed, we moved it into deeper and deeper space. Then once she left, we never went back to the flat space we had seen earlier. We tried to structure the staging to complement the story."

This staging extended to color design. The green tones assigned to Mulan, the comfortable tones of home, give way as the sequence progresses to more intense colors, and the increasing use of the symbolic "warrior red."

To add to the scene, Sanders found an existing musical selection from another film score, but one that matched the mood of what was being created. With this temporary score attached, the story reel was screened for Peter Schneider and Thomas Schumacher. Cook remembers, "Everybody just said, 'Wow!' That told me that we were on the right track. And the animators loved being able to tell the story visually."

DeBlois says, "Sequence Six was the first sequence that got put into production, and it helped to establish our 'silent' approach."

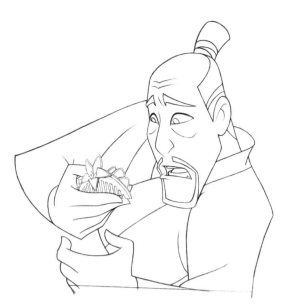

Above: Cleanup of Fa Zhou by
Monica Murdock, animation
by Joe Haidar.

Above right: Production still.

Below: Workbook page by Head
of Layout Robert Walker.

Bottom right: Production still.

Schneider says, "Animation is a visual medium, as opposed to a spoken medium. Sequence Six is the first thing we actually saw that *worked*. Sometimes in movies, you are confronted with a collection of components—story, dialogue, visual images—and it seems they'll never come together. Then all of a sudden for a short moment, things click into place, and they define themselves.

"For *The Lion King*, it was the opening sequence, 'The Circle of Life.' It put the whole picture into perspective. It was Sequence Six that put *Mulan* into perspective. We knew we could do it with greater simplicity—relying on visuals, and limiting dialogue—yet have it speak with a more universal eloquence."

Sanders feels, "Dean did Sequence Six wordlessly, eloquently, and it represented what *Mulan* would go on to be. Sequence Six became the standard that everything had to measure up to. It just hit, it was right, it was powerful, and everything we did afterward was compared to it."

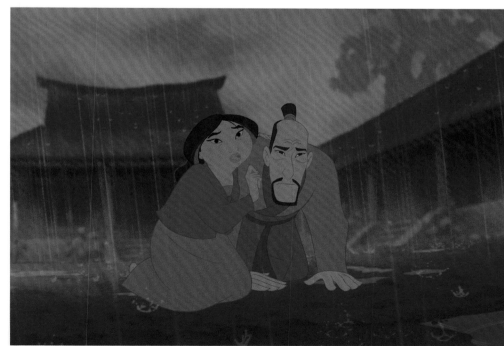

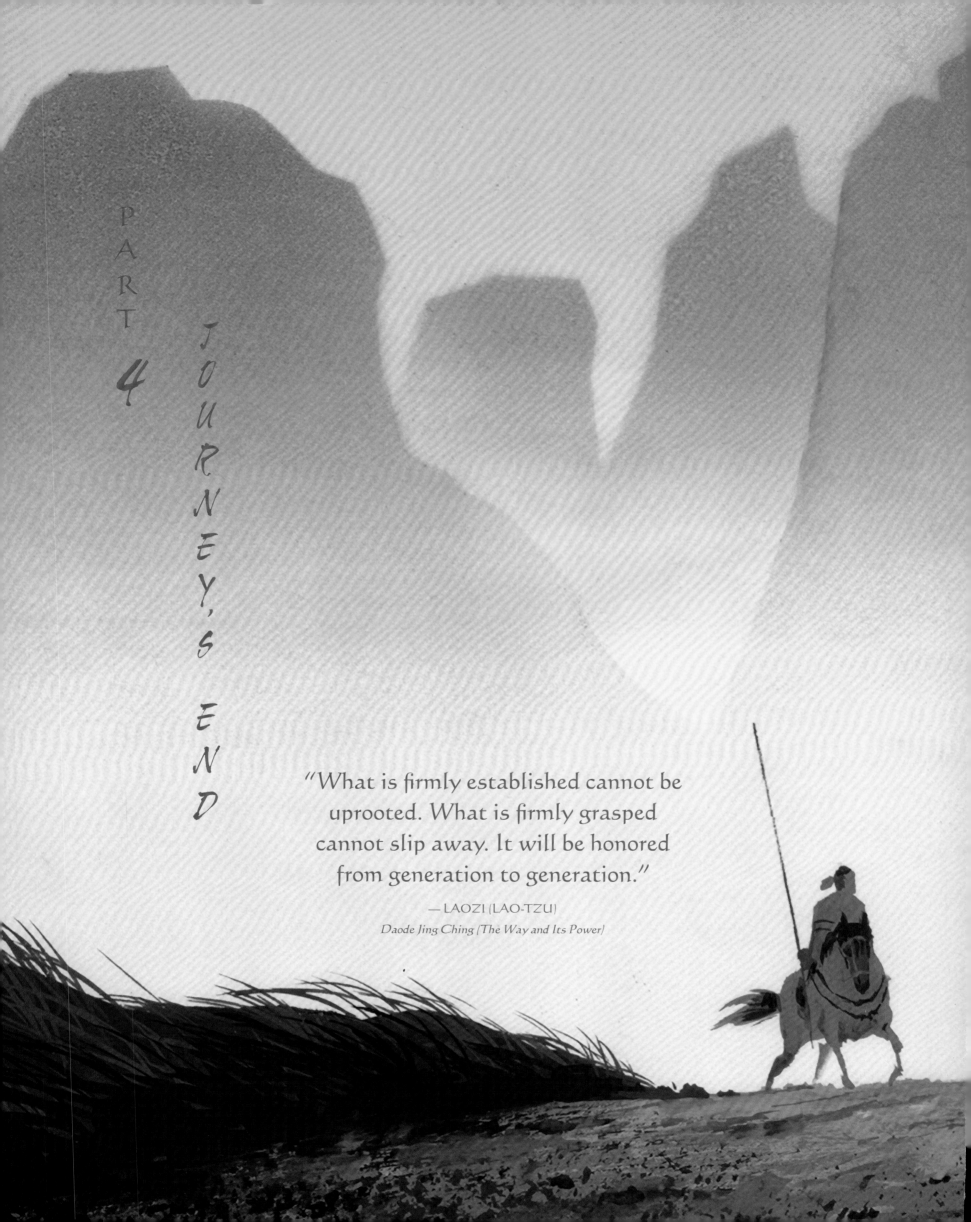

PART 4

JOURNEY'S END

"What is firmly established cannot be uprooted. What is firmly grasped cannot slip away. It will be honored from generation to generation."

—LAOZI (LAO-TZU)
Daode Jing Ching (The Way and Its Power)

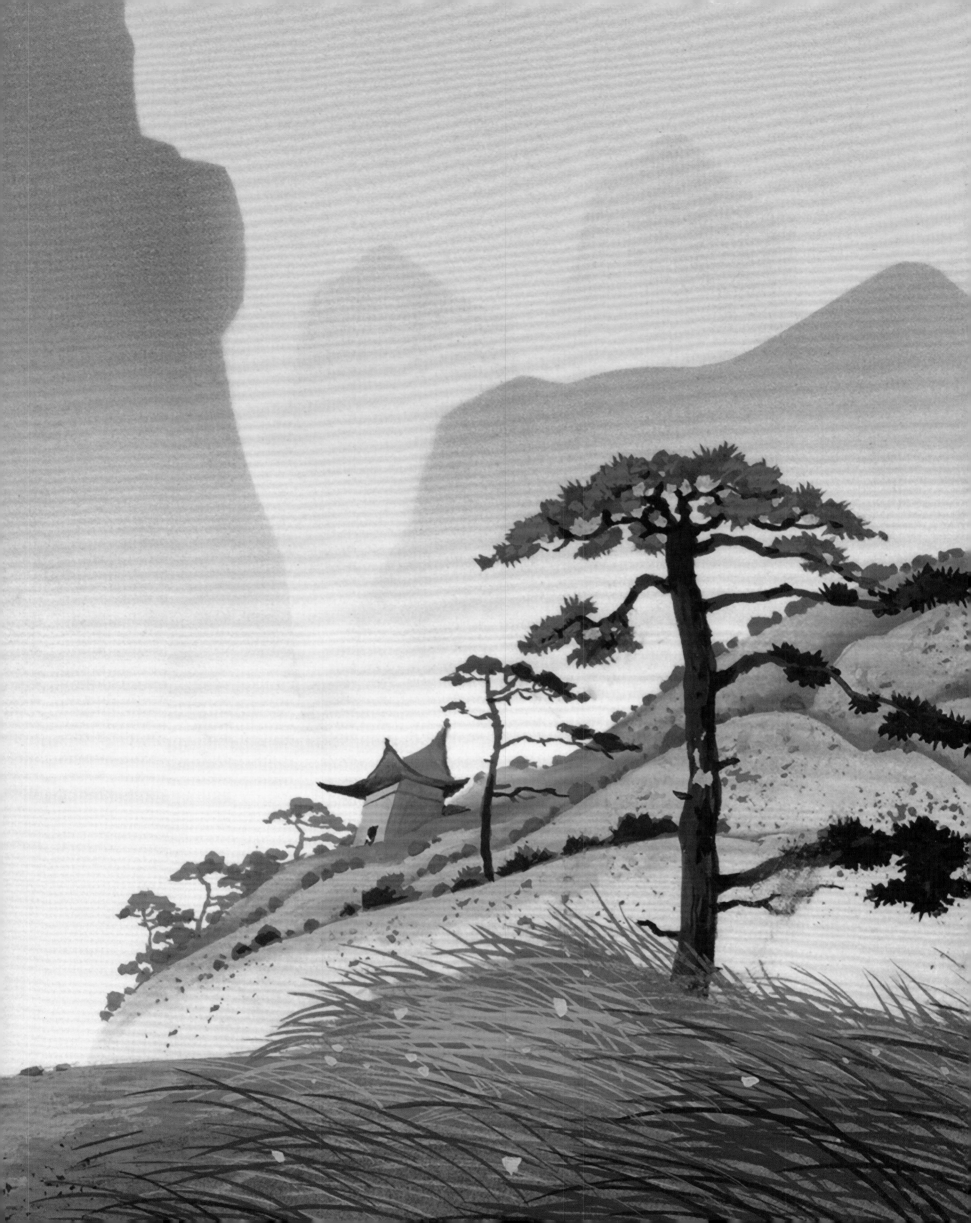

Preceding pages: Visual

development by Hans Bacher.

Above: The First Ancestor

emerges from the *bei*. Production

stills. Effects animation by

David Tidgwell.

*A*rguably, the greatest influence on the making of *Mulan* is its status as the first feature-length production that is primarily the property of Walt Disney Feature Animation Florida.

"They're a most remarkably talented group of people," Thomas Schumacher beams. "They're brilliant. Their commitment and readiness for this film is unparalleled. It's their first feature. They're very intimate down there—they want to prove themselves as a team, and they're doing so."

Pam Coats feels that their small scale and intimacy as a group "creates a 'small and naughty' environment. While there is certainly a downside to being away from our 'mother ship,' it does provide a freedom to just go off and do."

Broose Johnson continues, "Many of us are first-time supervisors, first-time leads, first-time cleanup people, first-time heads of departments. We're all doing so much for the *first* time, that for us, it's *our* journey as well."

Tom Bancroft agrees, "There's no doubt about it. When you talk about journeys, I think the big story of the journey of *Mulan* is the Florida studio. At first we were set up as a small studio and we were just going to do shorts. Within a year, we started helping out on features—*The Rescuers Down Under, Aladdin, Beauty and the Beast, The Lion King, Pocahontas, Hercules.* We've been contributing to features, but this is the first time we have the feeling of full ownership.

"We've finally gotten to the point where—as corny as it sounds—this is a labor of love for every single one of us. We've all done features before, and they were wonderful experiences. But this one's different. This means more." Bancroft concludes with comic menace, *"This time it's personal."*

Tony Bancroft agrees with his brother. "I think that this being Florida's first feature has helped us immensely. We have an eager group of artists here. They are willing to work their butts off and do all that they can. They don't know the meaning of the word 'impossible,' or the word 'no.' It's not just a nine-to-five job, this *means* something to them."

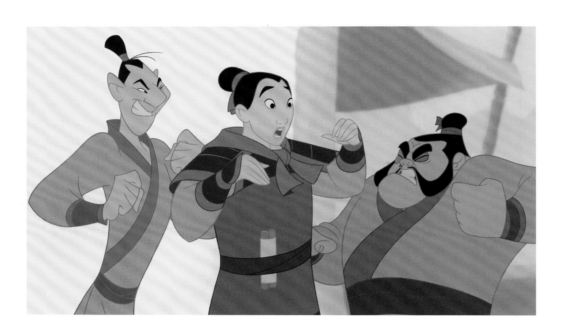

Above: Mulan gets off on the wrong foot with her new comrades. Production still.

Opposite: Shan-Yu surveys the lands he intends to conquer. Production still. Background art by Charles Vollmer. Layout by Andy Harkness, cleanup layout by Jeff Dickson.

Peter Schneider feels, "Florida is a very passionate, interesting group of people because they are somewhat isolated. Yet, at Florida Feature Animation there are some of the best artists in the world, who have found a home, a place, and a lifestyle in Florida that really suits them. They also have a tremendous sense of family and *esprit de corps,* and I think that has added tremendous strength to this movie."

Like the heroine of their tale, this seeming artistic isolation led the *Mulan* team to rely on one another. Rita Hsiao explains. "It's something like Mulan and her comrades in the army—they only had each other. They trusted and looked out for each other. And that's exactly what everyone in Florida did. The whole process was built on trust. And I think that's what made the film come alive."

And like their heroine, and because of the strong character they had actually created for her, it developed a collective consciousness among them.

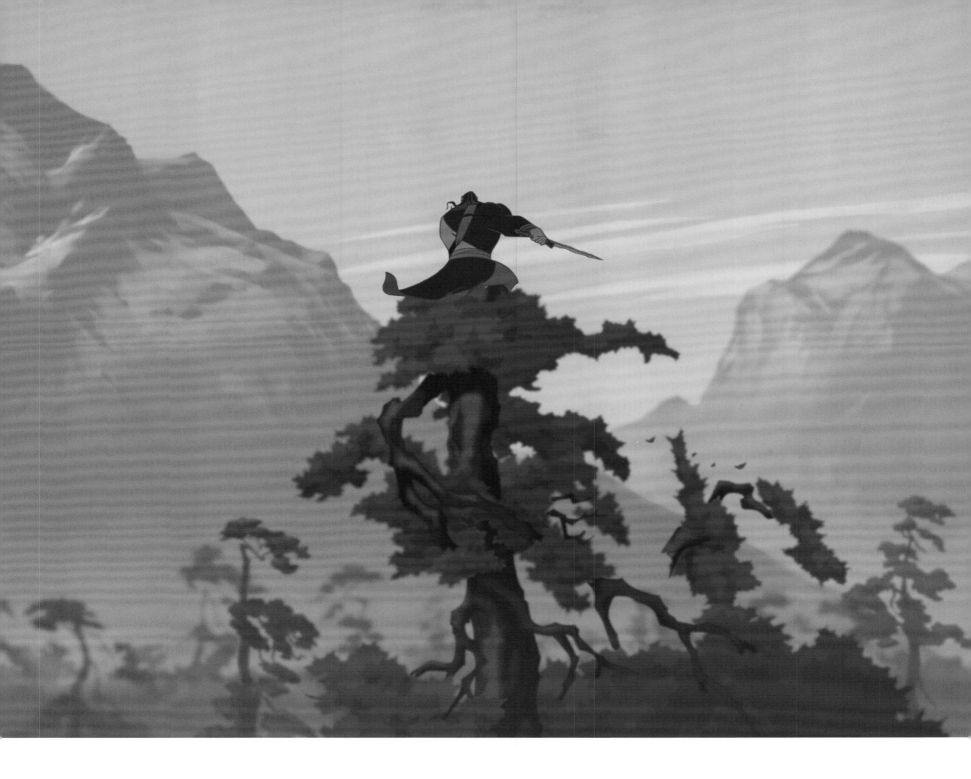

The *Mulan* team ethic developed organically. There was no deliberate training program or premeditated production morality provided in a handbook. The ethic developed from a desire to create excellence, a devotion to the validity of their pursuit, and a belief in their heroine.

Ruben Procopio feels that Mulan becoming a "real person" pushed her creators to excel. "I think something like *Mulan* takes on a life of its own. These things begin and we've got to give it a spirit, we've got to give it a life, that breath that we have. It starts to grow and progress, like a baby to a youngster, to a teenager, and to an adult. It's a lifetime within a few years here."

Color Stylist Irma Cartaya explains that "with *Mulan*, we're putting our lives on hold more than normal. You always have to put your life on hold to work on a film, but we *want* to do this. We're devoted to this film, and we'll do everything for it."

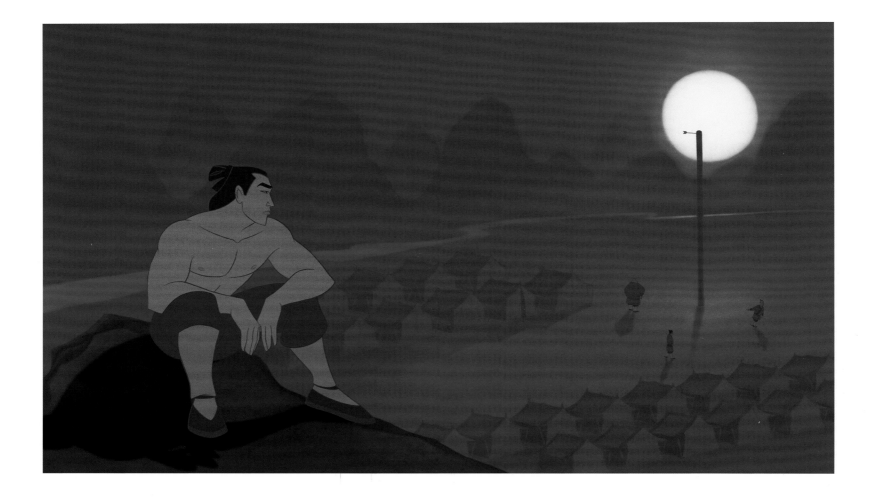

Above: Shang worries that his troops will never be prepared. Production still.

M
E
A
N
I
N
G

I
N

M
U
L
A
N

"Mulan will mean different things to different people," Pam Coats concludes. "A woman from France came up to me crying and she said, 'I know exactly how it feels to try and try and try to please your father. This movie means so much to me.'"

With this anecdote Coats draws near to the essential truths discovered by the creators of *Mulan*. On its simplest level, the end of *Mulan*'s journey is the retelling of a beloved folk tale and its transformation into a Disney animated feature. Observed on a larger scale, this transformation actually shares something of the quality of an epic quest myth. Without belaboring the point too much with references to the golden fleece, the Holy Grail, and enchanted cities; suffice it to say that the *Mulan* company set out to accomplish something, and happily arrived home with a much more bountiful treasure than they had intended.

For instance, there is a greater cultural legacy at the heart of *Mulan* than its individual successes and accomplishments. Although significant in and of itself on many levels, *Mulan* is also a component of a much larger body of work within the Disney canon. Peter Schneider explains, "The reason that I work here, and not at one of the competitors, is because I think there's

something very unique about Disney in itself. It's bigger than making a movie. Disney will always be the standard everything is held to. The passion that people have for the movies we've made—many great, some not so great—is one of the reasons that people become so enamored of Disney."

From his perspective as President of Feature Animation, Schneider sees *Mulan* not as a self-contained achievement, but a beginning of a new journey. "When you talk about Florida, and the significance of this project and how passionate they are, and hard they work, you're absolutely right. But from my point of view, it's not *one* movie that defines who you are. It's a body of movies, a series of movies. The culture of Disney is an enormous and complex mosaic.

"I can't wait to look at it ten years from now, when there won't be just one movie from Florida. It is this one, the next one, the next one. This is a brilliant first step. But life doesn't end when this comes out. It'll be fabulous...but then there's Monday morning—and it'll be time to go back to work."

Below: Production still.

Bottom: Mulan finally succeeds in climbing the pole and retrieving the arrow. Production still.

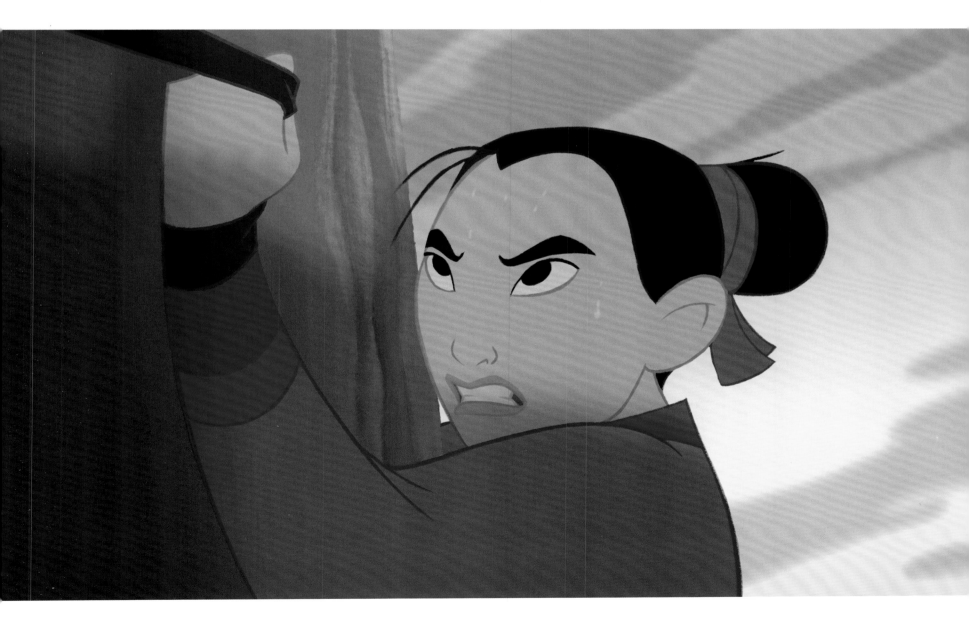

Above: The Huns ambush the Imperial army from above. Production still. Flaming-arrow–effects animation by John David Thornton.

*C*reating a work that will occupy a space in the canon of Disney was, however, not a fundamental goal of the people who created *Mulan*. It will, hopefully, be a secondary or tertiary result of their other efforts. Pam Coats says, "Every person here set out to do their absolute best, but I don't believe we ever set out to create what we've created. We discovered the story and characters throughout the course of our journey. Four years ago, I don't think any of us envisioned the completed film."

Barry Cook's criteria for *Mulan* are fairly simple. "Is *Mulan* a good story? Does it touch your heart? Do you care? Do you love the characters? These are the important things. That will be the true measure of our success."

Although it has a rich historic setting, a sophisticated visual design, and a compelling and accessible story, to the creative group, all of these elements seem subsidiary. "Clearly it's a movie set in China and clearly it's a movie set in the historic period," Thomas Schumacher says. "Neither of those things affect me most personally about the movie. They establish a certain context, they establish a palette of both color and emotion. But for me, what is powerful about the film is the notion of sacrifice, the notion of commitment, the notion of dedication, the notion of truth-telling, and the notion of doing the right thing—and achieving greatness. Those elements of the movie appeal to me most."

Cook says, "Looking back on it, the critical balance that I wanted to find was that equipoise between comedy and pathos. I'm a big fan of Charles Chaplin, and he continually proved that playing pathos and comedy close

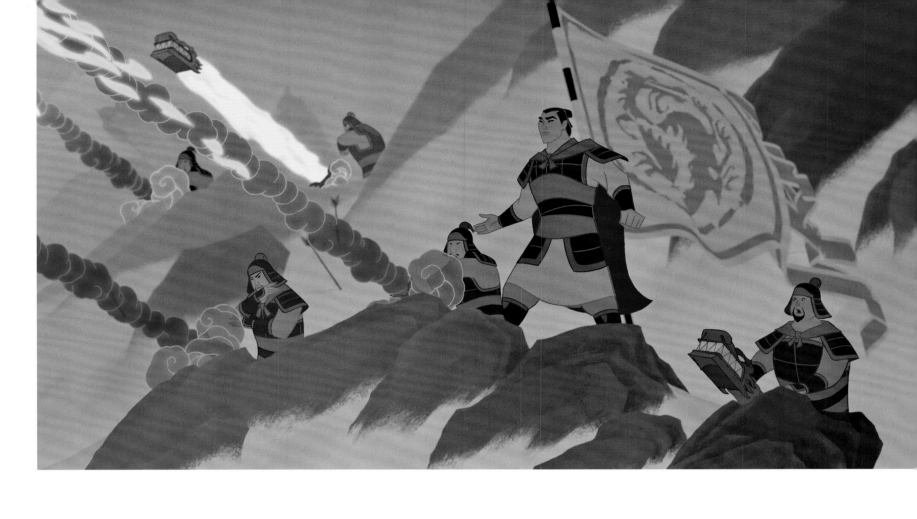

Above: Mulan fires off a cannon. Production still.

Top: Shang and his troops counterattack. Production still. Cannon-effects animation by Tony West. CGI of the flag by Darlene Hadrika.

together makes both of them much greater. I think that's one reason the film works so well as entertainment.

"That balance, though, requires sincerity, which is kind of a rare commodity in our current culture. Nobody here was afraid to be sincere. A lot of times you can try to put something over on an audience that is *meant* to be sincere, but it just comes across as calculated and smarmy. When you really do hit *truth*, people can react and respond to it."

Sincerity cannot be faked. The slightest hint of intent reveals itself. None of the *Mulan* team *designed* the sincerity into the story or its execution on-screen. Every element reflexively, honestly, seamlessly folded into the devising of the screen story and its visual design.

Where did they find this sincerity and balance? In essence, the story spoke to them, and they were sensible enough to listen. *Mulan* is not simply a time-honored tale specific to the Chinese. Mythologically, it draws together many tales, ancient and contemporary. It has spoken to Asian cultures for centuries, and continues to do so today, on many levels, because of its solid foundation. The ancient story, in turn, spoke to a team of people whose *only* charge was to adapt it, to retell it, and to make it vital to *their* audience through their own unique medium and talents.

Matthew Wilder explains, "All the artists had to respond and be sensitive to the material they had in front of them. You can apply only so much formula and then you have to respond to the *essence* of what the piece dictates." "This film really found its focus over time," adds David Zippel. "And, just like its heroine, it made an enormous journey."

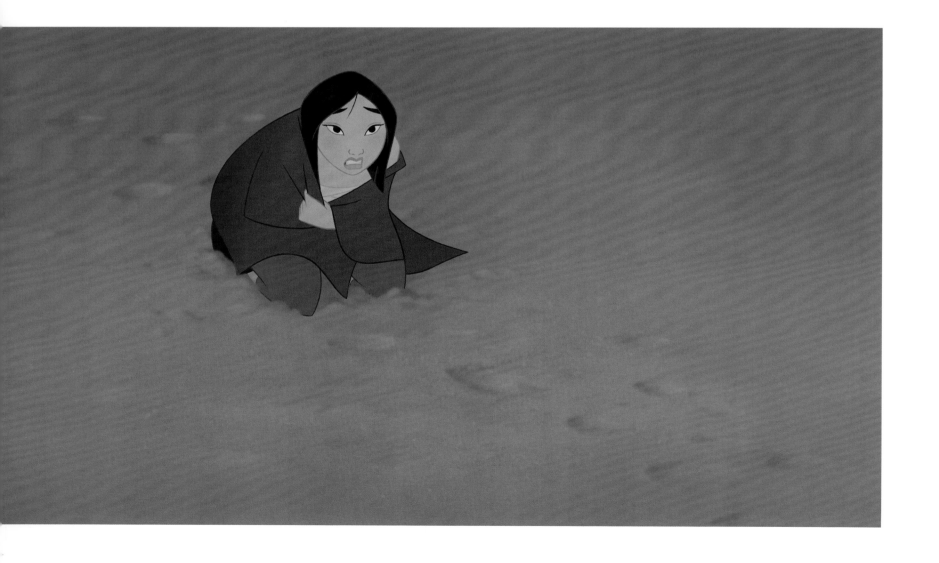

As production progressed, the character of Mulan became a stronger and stronger talisman of the efforts and goals of the production team. Her ethic of honor was so refreshing and appealing to her creators, that she *herself* began dictating the boundaries of their creation.

"Setting the goal to maintain Mulan's character delivered us from the many wrong roads we could have taken," Tony Bancroft says. "We could have made it a wacky comedy about a girl and her dragon. We could have made it so reverent that people would think they were watching a Chinese history lesson. We could have gone terribly *wrong*. But establishing and understanding who this young woman really *was* put us—and continues to put us—in touch with the truth and heart of the story."

Chris Sanders remembers the moment when Mulan began to inform the actions and art of the entire creative group. "I knew we had reached a turning point when the notes that the story crew received said, 'Mulan wouldn't do that.' When they were talking with *authority* about what she would or would not do, I was really happy—even if they were angry about something. Actually, when they got incensed that she was doing something she wouldn't do, I *knew* that we had really reached a milestone.

Mulan prepares to suffer the consequences of her actions—execution at the hands of the man whose life she has just saved. Production still.

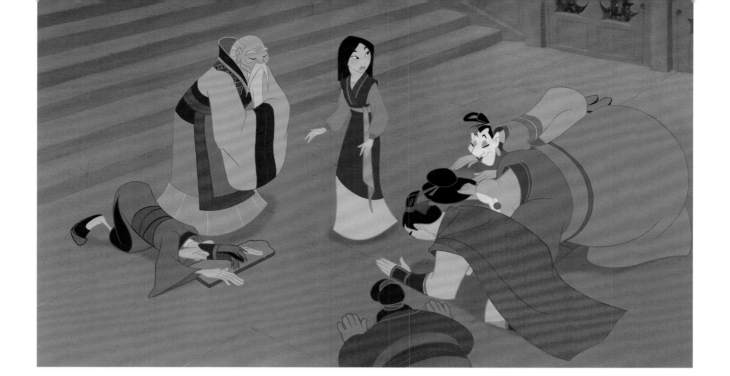

Following the Emperor's lead, everyone bows in gratitude to an astonished Mulan. Production still.

"So that went down the line. Every single person, we didn't even have to explain it, we didn't have to go in and argue about the validity of it. There was always Mulan, her spirit became the spirit of the film, and didn't, after a certain point, ever have to be explained or fought for anymore—it ran the show all by itself, and people just knew what they had to do to make it *be*."

For Matthew Wilder and David Zippel, capturing Mulan's spirit musically was a crucial step. "'Reflection' was the first piece I wrote for the film and a touchstone for what was to come," explains Wilder, "and the defining moment for me and for my contribution to the character."

Zippel continues, "It was during the writing of that song that Matthew and I began to develop our relationship, and our relationship, together, with Mulan. I like to think that that piece helped shape the tone of the film and perhaps make it a little clearer to everyone about the journey we were all about to embark on."

Thomas Schumacher says, "I'm very excited about the fact that we have a leading lady in a movie who does not rely on the convention available to her as a woman to achieve greatness, yet never in that process does she lose sight of the fact that she *is* a woman, which means she has been true to herself.

"Although the story does have a character impersonate the opposite gender—which has been done in literature throughout time—it is ultimately not about that. It really is about a search for who you *are*, not a search for what you *might* be. I find that very powerful."

Peter Schneider agrees that the identity of Mulan herself ultimately led the journey from folk tale to Disney animated feature. "I don't think about Mulan's mythic nature. We're all on individual, tortured trials to try to find ourselves.

"I think *Mulan* is a very intimate, personal story about a loyal and brave girl who's going to find *herself*."

Adapted from
Walt Disney Pictures' MULAN
Music by MATTHEW WILDER Lyrics by DAVID ZIPPEL
Original score by JERRY GOLDSMITH
Produced by PAM COATS
Directed by BARRY COOK and TONY BANCROFT

My work on this book is dedicated to
the memory of my father, Robert Kurtti.

In our cynical world, certain terms have become passé. Far from their original meaning and purpose, the use of these terms has become contemptuous, their intent arch, and their orators suspect. Among these phrases are "passion," "sincerity," and "labor of love."

The team that created *Mulan* was not only unabashed in these feelings for their project, they were fearless about sharing them with me. I am especially grateful to Peter Schneider and Tom Schumacher for affording me such an opportunity. I also wish to thank Producer Pam Coats and Directors Barry Cook and Tony Bancroft for sharing their creative energies.

Those talented artists who took time away from making a movie to spend time talking to me about making a movie include Sunny Apinchapong, Ruben Aquino, Hans Bacher, Tom Bancroft, Rob Bekuhrs, Aaron Blaise, Irma Cartaya, Chen-Yi Chang, Dean DeBlois, Jerry Goldsmith, Eric Guaglione, Jane Healey, Mark Henn, T. Dan Hofstedt, Rita Hsiao, Broose Johnson, Fran Kirsten, Alex Kupershmidt, Sai Ping Lok, Ruben Procopio, Pre Romanillos, Laurie Sacks, Chris Sanders, Lisa Smith, Ric Sluiter, Robert Stanton, Barry Temple, David Tidgwell, Jeffrey Varab, Robert Walker, Matthew Wilder, and David Zippel.

My appointed escorts through the halls of Feature Animation in the 1990s were my pal and fellow Disney fanatic Russell Schroeder, the ever-efficient-but-never-officious Kelly Slagle, my old friend Kim Piercy, and my new friend Sabrina Waterman.

It's rare to enjoy as much as I do collaborating on those projects that came from Wendy Lefkon at Disney Editions. She is a consummate professional and an essential colleague. There are too many good things about her to say here—and, as Wendy would tell you, I already over-write.

Thanks also to John Canemaker, Jean Cress, Shawn Hayes, Richard Jordan, Dan Long, Leonard Maltin, Sean Markland, Kenneth Martinez, Armistead Maupin, Betsy Richman, and Robert Tieman.

—J. K.

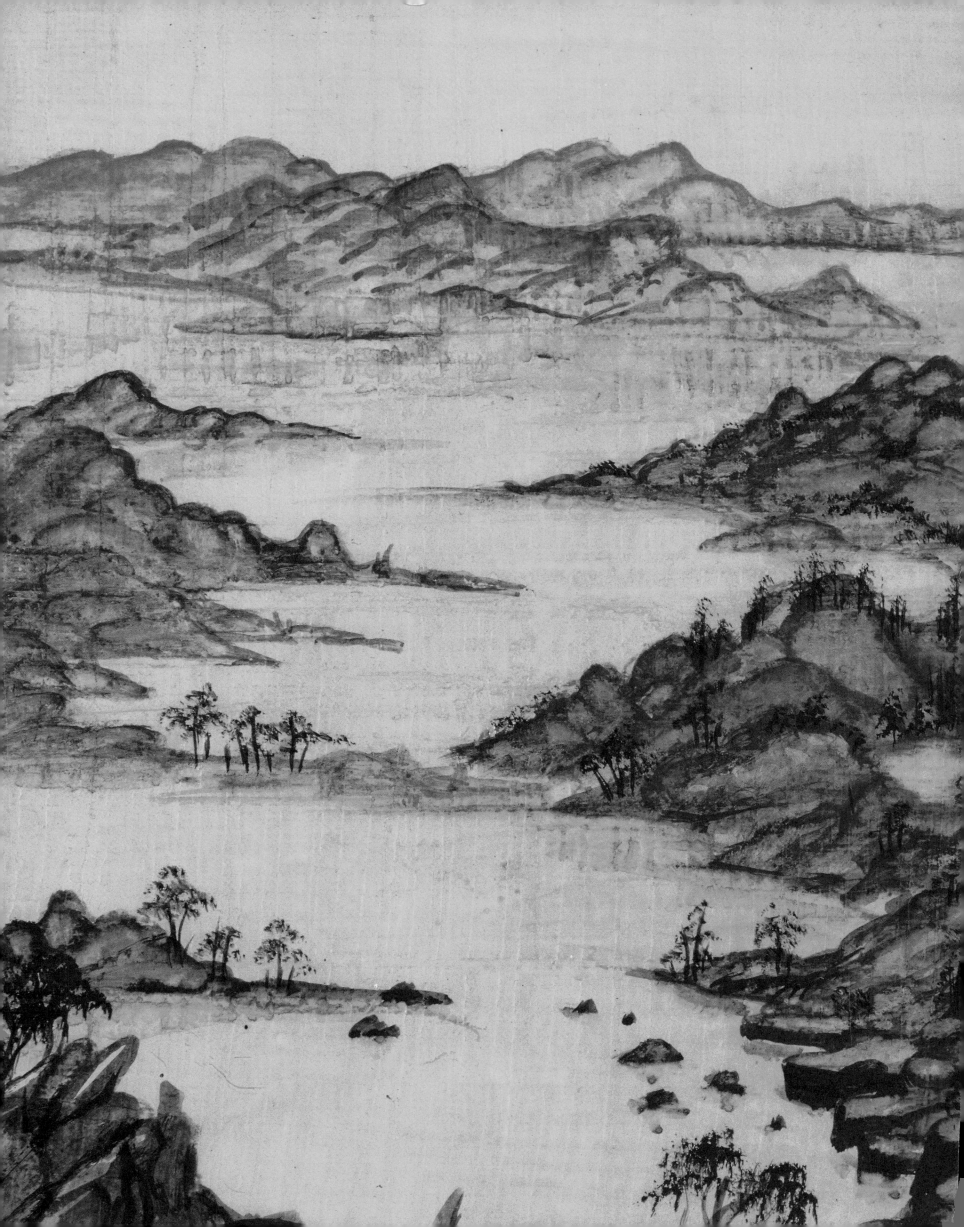